MANAGEMENT IN MUSEUMS

NEW RESEARCH IN MUSEUM STUDIES
An International Series

7

Management in Museums

Edited by Kevin Moore

THE ATHLONE PRESS
London & New Brunswick, NJ

First published in 1999 by
THE ATHLONE PRESS
1 Park Drive, London NW11 7SG
and New Brunswick, New Jersey

© The Athlone Press 1999

British Cataloguing in Publication Data
*A catalogue record for this book is available from
the British Library*

ISBN 0 485 90008 4

Library of Congress Cataloging-in-Publication Data
Management in museums / edited by Kevin Moore.
 p. cm. — (New research in museum studies: an international
series: 7)
 Includes bibliographical references and index.
 ISBN 0-485-90008-4 (cloth: alk. paper)
 1. Museums—Management. I. Moore, Kevin, 1960- . II. Series:
New research in museum studies: 7.
 AM121.M36 1999
 069—dc21 98-30552
 CIP

Distributed in the United States, Canada and South America by
Transaction Publishers
390 Campus Drive
Somerset, New Jersey 08873

Typeset by Acorn Bookwork, Salisbury, Wiltshire
Printed and bound in Great Britain by
Cambridge University Press

Contents

List of Figures

List of Tables

Editorial Introduction

KEVIN MOORE

> Good management may not be the measure of a good museum, but ... would most certainly appear to be one of its critical prerequisites.
>
> (Weil and Cheit, 1994, 289)

Management in museums has become a key issue in the past decade, a reflection of the challenges they face, in operating in a rapidly changing environment. Whereas once the notion of applying management techniques to museums was almost anathema, they now appear to be awash with an almost bewildering range of management approaches and buzzwords. The danger is that through the smoke screen of management jargon, approaches are sometimes rather inappropriately applied to museums from the business world, without adaptation, and museum staff may fail to see the benefits that effective management can bring. Management may be a key issue in museums, but sometimes for the wrong reasons, and the underlying suspicion of management techniques may remain unchanged.

The development of both management practice in museums, and of academic research into the specific management challenges museums as organisations raise, has been addressed by the author elsewhere (Moore, 1994a, 1997a). While there has been a good deal of literature on museum management published in recent years in the form of practical handbooks and manuals, it remains the least studied area of museum activity in academic terms. The pick of the relatively small quantity of high-quality research has been gathered in a single volume (Moore, 1994b, 1997b). Since that work was first published, research in the field has developed significantly, and this volume brings together some key contributions. This collection is a blend of research by academics in the

1

management field and by museum managers themselves, the latter reflecting either on museum practice in general, or utilising organizational theory to analyse their personal experience. The volume is greatly strengthened by the high proportion of papers by practitioners, whose work takes real-life situations as the starting point, and draws upon wider management theory as appropriate.

The papers by Janes and Spalding forcefully argue the need for museums to radically alter as organizations to survive in an apparently increasingly turbulent environment. Spalding offers a personal vision, Janes a reflection on the process of change, warts and all, in the museum of which he is director. Griffin and Abraham's paper provides a wider context for these two papers on organizational change, and the blocks to more effective management practice in museums in general, in terms of governance and organizational structures.

Leadership, which is subtly but significantly different to management (as discussed in Davies' paper) has unintentionally but perhaps subconsciously emerged as a key theme in this collection, reflecting its importance as both a research topic, and as a crucial and often controversial issue in museum practice. The papers by Spalding and Janes implicitly say a great deal about the importance of leadership. Fleming draws partly on his own experience to offer an insightful analysis of the role of the museum director. Davies' paper links this more closely to leadership theory, but also to primary research undertaken with senior managers, to stress the paramount importance of the leadership role in creating and promoting a vision, and a strategy to achieve it. The papers by Knowles and Osborne focus on specific leadership situations. Knowles' paper on project management is an invaluable contribution to a neglected topic, particularly given its importance. Osborne's work draws highly effectively on the literature on management in voluntary organizations, to analyse the specific issues in managing volunteers, in particular those of retirement age. A large number of museums could not continue to exist (or have come into existence) without the work of volunteers. Managing volunteers requires a different approach, and presents a particular challenge, for in museums with only one or two curatorial staff, there may be as many volunteers as paid staff in a major museum service.

Museum leaders remain largely male, with profound implications for the nature of museums. Blake's paper offers a fascinating and subtle argument to answer the simple question, 'Why are there not more women museum directors?'.

Management in museums has tended to lag behind developments in the business world. Many museums are currently emphasising the 'hard', 'scientific' approach to management of the business world of the 1970s, ignoring the shift to the 'soft' people-centred approach, management as an 'art', which is increasingly emphasised by the management gurus, and also in practice in at least some companies (Moore, 1994a, 6). Accountability is crucial, but not if it fails to emphasise the quality of the services offered by museums, as well as what can most easily be number-crunched. Similarly, getting the right staff structure, as if this in itself is a panacea to management problems, has been overemphasized in museums in recent years. Hatton's paper demonstrates that it is as important for a manager to understand the informal workplace culture as much as the formal structure, and that the former can very often over-ride the latter. Total Quality Management (TQM) sounds like the worst kind of latest management gobbledygook to be inflicted on museum staff. However, Bowsher's paper demonstrates that because TQM emphasizes teamwork and the involvement of staff from all levels within an organization, it is an appropriate approach for the specific nature of museum work, once museum staff get beyond the jargon.

Some of the papers in this collection represent work in progress, and research in the field continues to develop, particularly in the related areas of museum marketing, fundraising and sponsorship and commercial activities. Yet a great number of further research topics remain unexplored. It is to be hoped that, like the contributions in this volume, future work is not simply unworldly academic theorizing, but applied research, which can have a significant impact on the way in which museums are managed in the future.

BIBLIOGRAPHY

Moore, K. (1994a) 'Introduction: museum management', in Moore, K. (1994b) *Museum Management* (London: Routledge).

Moore, K. (1994b) *Museum Management* (London: Routledge).

Moore, K. (1997a) 'Introduction: museum management', in Moore, K. (1997b) *Museum Management* (London: Routledge).

Moore, K. (1997b) *Museum Management* (reprint with revisions) (London: Routledge).

Weil, S. and Cheit, E. (1994) 'The well-managed museum', in Moore, K. (1994b) *Museum Management* (London: Routledge).

1

Embracing Organizational Change in Museums: A Work in Progress

ROBERT R. JANES

INTRODUCTION

In addressing the subject of organizational change in museums, I cannot avoid the topic of management – a topic which is increasingly under fire from both staff and management pundits alike. A cloud has apparently settled over all leadership and management in any form (Greenleaf, 1996: 111).

Please consider this description of current management practices (Norfolk Group, 1995). A Japanese company and an American company had a boat race, and the Japanese won by a mile. The Americans hired analysts to figure out what went wrong. They reported that the Japanese had one person managing and seven rowing, while the Americans had seven managing and only one rowing. The American company immediately restructured the team. Now they had one senior manager, six management consultants and one rower. In the rematch, the Japanese won by *two* miles. So the American company fired the rower, who was later rehired on contract for twice the pay. I should add that the Canadian boat in this apocryphal race never left the starting line, because no agreement could be reached on which of the country's two official languages, French or English, should be used in the race.

It has also been observed (Farson, 1996: 117) that too many senior managers who may have been at the job thirty years don't necessarily have thirty years of experience – they have more like one year of experience, thirty times.

Seriously, a new and valuable message is emerging, which is that management is a curious phenomenon. It is generously paid, enormously influential, and often significantly devoid of common

7

sense (Mintzberg, 1996: 61). Although management, especially change management, can be at once impossible and absurd, it is not a lost cause. Lasting change comes only from the adoption of sound management principles that are practised on a continuing basis (Farson, 1996: 121). There are no quick fixes, no matter how big or small the organization is, or what the particular work happens to be.

In this era of management hype and flavour-of-the-month techniques, one thing cannot be overstated. That is – outside experts do not necessarily know the answers that an organization needs to solve its problems or improve itself (Keating, Robinson and Clemson, 1996: 34). In fact, an organization's members are often the real experts on the organization's problems, and on what is needed to improve it. Most museum workers already know the answers to many of their current organizational problems – the only difficulty being that much of this knowledge is tacit, or remains untested. The purpose of this paper is to provide a summary case study of our efforts at change at Glenbow, along with some reflections on what we have learned, all in an effort to make some of the tacit knowledge about change in museums more explicit.

All of us know that change and adaptation occur with great difficulty in museums. My most vivid testimony to this is the death threat I received during the most painful of our organizational initiatives – the reduction of 25 per cent of our staff (Janes, 1995). There could hardly be a more stark reminder of the impact of these events on individual human beings than such a threat. Nor is there a more cogent reminder of the responsibilities we have for the decisions we make and the actions we take to ensure the survival and prosperity of our museums.

Significant change requires a form of dying (De Pree, 1992: 35), and it is foolish to expect that organizational change will not anger, frustrate and disappoint people. This is especially true when the changes go far beyond cosmetic tinkering. At Glenbow, we are insisting upon new ways of thinking and acting which will make us more responsive to the communities we serve. Change in museums does not have to be a zero-sum game, where progress can come only at the cost of dearly held values (Traub, 1995: 60). The key to pushing, without the organization pushing back, is balanced inquiry and action. The indiscriminate use of trendy

solutions is as destructive as a stubborn reverence for tradition. Because organizational change is chaotic, uncertain and often mysterious, we have no choice but to try to be as intelligent and caring as we can. In a 1995 survey of 29 North American museums, conducted by Martha Morris (1995) of the National Museum of American History, fully 83 per cent of the respondents said they had recently undergone some degree of organizational change. We should not be surprised by this, nor disturbed, as it is in the nature of complex adaptive systems to change. This is also true of our families, our relationships and our lives (Flower, 1995: 1).

Please note that I do not question why museums exist or whether they should be replaced by something else. My main interest is in museums as organizations, a subject which has received remarkably little attention in the museum literature (Griffin, 1987: 389). These concerns should not be dismissed as mere process, however, for the manner in which a museum does its work will either permit or preclude innovation, inclusive thinking and the persistent questioning of the status quo, all of which are fundamental aspects of a museum's role. It is undoubtedly easier, and more useful, to try to fix situations, rather than people, by making structural changes in the organization. Circumstances are powerful determinants of behaviour. As someone once observed, nobody smokes in church (Farson, 1996: 130).

Most of the issues addressed in this paper are not particularly new or original. Despite this, it is best to view Glenbow's change process as a summary of an experimental work-in-progress, which may be useful in navigating the stormy seas between organizational realities and societal needs. We shall undoubtedly find it easier to change museums than to change the world (Phillips, 1995: 3).

A Brief Introduction to Glenbow
Glenbow's uniqueness lies in the sum of its four parts – a museum, art gallery, library and archives – all under one roof and under one administration. Glenbow's western Canadian research library is the largest of its kind in Canada. The Glenbow Archives is the largest non-government archives in Canada, with two million photographs and manuscript collections occupying two shelf miles. Our art gallery, with a permanent collection of

over 28,000 works, attracts almost one third of our annual visitors. Our museum includes the disciplines of ethnology, military history, cultural history and mineralogy, for a total permanent collection of 2.3 million objects.

Glenbow does not restrict its work to the city of Calgary. We also operate a rural and special loans program which makes objects available to non-museum environments, including the Calgary International Airport. These programs served nearly 900,000 Albertans last year, as well as visitors from all parts of the globe. To fulfill these responsibilities, we currently employ 86 full time staff and 33 part time. We are also deeply indebted to 300 active volunteers.

CONTINUOUS CHANGE

When I arrived as the new Executive Director in 1989, it was clear that major changes were in the offing. Although Glenbow is remarkably self-sufficient for a Canadian museum, we still require a major contribution annually from the provincial government of Alberta. An agreement to provide this funding had come to an end coincidental with my arrival, and we developed a corporate and strategic plan in 1990 as the basis for securing multi-year funding from the province. All of us were weary of the one-year-at-a-time, crisis management approach common to the funding of public agencies in Canada. Thus began our six years of continuous change, which is still unfolding.

Although financial concerns were a major stimulus for this initiative, there were other reasons which contributed to a perceptible, albeit largely unspoken, desire for change among Glenbow staff. To begin with, Glenbow had been without an Executive Director for a lengthy period prior to my arrival, and the institution was drifting. There was also a widespread belief among staff in 1989 that Glenbow's management was simply top-heavy. All these factors had created dissatisfaction with the status quo, so that even if stable funding from the province had been available, Glenbow was in need of a thoughtful overhaul.

Our corporate and strategic plan was a first for Glenbow, in that it enabled all staff to become involved. This plan was also a first for Canadian museums, in incorporating explicit performance measures and standards, as well as a set of principles outlining

how we would treat each other as individuals and as staff (Janes, 1995: 18–28). Unfortunately, the provincial government rejected both our plan and our request for multi-year funding out of hand, presumably because multi-year funding was not only a foreign concept to them, but would also mean a loss of provincial control over Glenbow. One cautionary note on planning. At its best, planning can be a synonym for collective learning. At its worst, it becomes a sterile preoccupation. Planning is a tool – no more and no less.

As infuriating as this was, in retrospect there was a hidden benefit to this impasse. It forced Glenbow's executive staff to confront the future with a vengeance, in the face of declining government support. We did some financial projections five years out, and glimpsed a huge deficit and eventual bankruptcy for Glenbow by 1998. A 20 per cent reduction in operating expenses was required. With this kind of massive budgetary reduction, it is impossible simply to tinker with the organization chart. In short, we were confronted with the responsibility and opportunity to renew Glenbow by increasing our capacity for change.

The Six Strategies
This realization spawned another staff and Board exercise, based on the assumption that people will become committed to that which they help create (Beer, 1988: 4). There is no doubt that openness to good ideas is the best assurance of organizational vigour (Boyd, 1995: 175). This work resulted in six strategies which are designed to improve our overall effectiveness, increase revenues and decrease expenditures. They continue to guide all our efforts at change. These strategies have been discussed elsewhere (Janes, 1995: 29–38), so they will only be summarized here. These strategies include:

1 Developing non-commercial partnership with other non-profit organizations – For example, our Library and Archives have developed an electronic database in partnership with nearly a dozen other archives in the province. This has greatly enhanced public access to our collections, in a cost effective manner.
2 A new form of organization – We recognize that organizational structure must embrace change, not just accommodate

it. We also accept the need to reposition ourselves continuously, and that this requires unprecedented organizational flexibility. I realize that this is a far cry from current museum practice based on boundaries and control, but consider the paradox that 'the more freedom in self-organization, the more order' (Jantsch, 1980: 40). Two attributes of our new organization are useful examples. We collapsed 22 functional departments into five multidisciplinary work units, and one of these units, the Library/Archives, chose to work as a self-managed team. The director of this unit is elected by his or her peers for a two year term, and staff observe that rotating their director keeps staff fresh, reduces the sense of hierarchy and promotes team work.

We are becoming increasingly comfortable with the idea of organizational asymmetry at Glenbow. An organization will include a variety of coherent groups within it, each of which is a unique entity with different requirements for learning and growing (Keating, Robinson and Clemson, 1996: 42). It seems sensible to recognize this.

3 Public Service – The main purpose of this strategy is to develop new and creative ways of serving the public, and this has become our most challenging task. We need to become more market-sensitive, not necessarily market-driven.

4 Business Processes and Cost Reductions – The purpose here is to continually examine how Glenbow can simplify and improve its work in order to reduce operating costs, bureaucracy and the weight of tradition. This work is never-ending and requires constant vigilance, whatever the sizes of the organization.

5 Deaccessioning – Or the removal of objects from our collections. We openly designed and implemented a multi-year deaccessioning plan to sell millions of dollars of high-value objects which are irrelevant to our mandate (Ainslie, 1996), in order to create a restricted trust fund which would generate income to be used exclusively for the care of collections. Needless to say, this initiative has been controversial. It has also been successful.

6 Commercial Activities – The focus of this strategy is developing business ventures to generate additional revenue, and we started a new business unit called Glenbow Enterprises, which exists solely for this purpose.

None of these strategies is sufficient by itself. Their strength lies in their interaction, and in the balance they bring to our work.

Lay-offs

In addition to adopting these strategies as our blueprint for change, we laid off 25 per cent of our core staff (or 31 people) as part of our plan to become sustainable, with all of the attendant individual and organizational injury. Despite the corporate celebration of legendary lay-off greats like 'Chainsaw Al' Dunlop of Scott Paper and 'Neutron jack' Welch of General Electric, laying off people is a traumatic and hurtful undertaking. It has taken Glenbow staff well over two years to reconcile the pain, and even so the experience has left an almost gun-shy quality in some otherwise healthy, competent staff.

Repeated lay-offs are not a long-term solution to the difficulties which currently bedevil our organizations, and recent news from the corporate world bears this out. Although lay-offs have apparently become a strategic business manoeuvre to be used in both good times and bad (Tough, 1996: 37), recent research in the United States (*The Economist*, 1996: 51) reveals that nine out of ten firms which outperformed their industries over a ten year period had stable structures, with no more than one reorganization and no change (or an orderly change) in the chief executive.

There are some lessons in these revelations for museums. To begin with, while downsizing may necessarily be thrust upon us, it must be part of a broader plan. Cuts must be made in the right places, so that the organization reinforces its most promising activities. In doing this, one must ask and answer the two most salient questions – what is the central purpose of the museum and what resources are required to achieve it?

The critically important resources, of course, are people and their knowledge. Once again, there are lessons to be learned from the private sector, where middle managers have endured a highly disproportionate share of the lay-offs. It is important to realize, however, that middle managers often serve as the synapses and memory within an organization's brain (*The Economist*, 1996: 51). We took a different approach and asked at the outset of our reorganization – who are the people who own the knowledge which makes Glenbow unique? It turned out that most of these individuals were our department heads – the museum world's

middle managers. I cannot imagine where Glenbow would be today without them.

It is imperative to pay particularly close attention to who the knowledge-owners are in a museum, especially if staff reductions are being contemplated as part of a reorganization. Avoid dumbsizing at all costs. This is a recently identified phenomenon wherein management does not realize a given job is necessary until it has been eliminated (Jackson, 1996: 87). Posterity will undoubtedly judge the value of corporate restructuring in the late twentieth century, as John Kenneth Galbraith (1994) observed in this regard, that 'generally, people have been very resistant to attributing a causal role in history to stupidity.'

Morale and Discontent
The individual and organizational injuries which accompany major change necessitate some comment on staff morale, an increasingly complex topic, fraught with both assumptions and paradoxes. Most managers and executives associate 'morale' with a happy and satisfied work force (Farson, 1996: 141). In fact, the Webster's Collegiate Dictionary (Mish, 1986: 771) says nothing about happiness and satisfaction. Rather, it talks about 'a sense of common purpose with respect to a group', or 'a sense of purpose and confidence in the future'. This indicates that measuring staff satisfaction, something we have done for several years at Glenbow, may not be all that useful. In fact, there is reason to believe that such surveys may foster staff dependence on Glenbow, as satisfaction surveys do not necessarily encourage staff to assume ownership of their problems and to take personal responsibility for effecting change (Janes, 1995: 71). It is too easy to answer the survey questions and then sit back and say that 'I've done my part. Now it's up to them'.

Even if this were not the case, one must question whether happiness or satisfaction is necessary to the task at hand. Research has revealed that remarkable and effective people are not necessarily comfortable or happy. They can be ruthless, boring, stuffy, irritating and humourless, and museums, as are all organizations, are dependent upon such people (Farson, 1996: 142). Our challenge as museum workers is to allow effective people to prosper in our organizations.

These thoughts lead to yet another remarkable phenomenon –

the paradox of discontent. The paradox is that improvement in human affairs leads not to satisfaction, but to discontent, albeit a higher order of discontent than existed before. The psychologist, Abraham Maslow (Farson, 1996: 93), advises managers to listen not for the presence or absence of complaints, but rather to what people are complaining about. In very healthy organizations, there would be complaints having to do with needs for self-actualization – such as 'I don't feel my talents are being fully utilized', or 'I'm not in on enough things around here'. These are high-order complaints, compared to complaints about such things as working conditions. This is the paradox. Only in an organization where people are involved, and their talents are being used, would it occur to someone to complain about these issues. Do I dare suggest that museum managers should judge their effectiveness by assessing the quality of discontent they engender? It is something we might well think about, if we recognize that improvement does not necessarily bring contentment, but often its opposite (Farson, 1996: 94).

Where have six years of continuous change at Glenbow left us? At first glance, the scorecard is not encouraging. For example, the provincial contribution to our operating budget has now decreased by 39 per cent since 1989/90. In addition, Glenbow's full-time, core staff has decreased from 137 in 1989/90 to 86 today, for a decline of nearly 40 per cent. There is no doubt that we have suffered some major setbacks.

It is also true that many museum employees throughout North America are feeling exhausted, and rightfully so. Six years ago, Glenbow staff and volunteers were thrust into what we believed was a temporary state of budgetary madness, from which we would emerge ready to return to business as usual. We have emerged – stronger, smarter and much leaner – but now there appears to be no rest for the weary.

There is some instruction in this seeming disillusionment, however, which might help us to approach the twenty first century more calmly and more productively. First, no matter how hard we might with it so, there will be no return to 'normal', whatever that might be. To idealize the past is all too human, even when that 'past' is largely responsible for the discontent which led to change in the first place (Janes, 1995: 153). Second, we must learn to live with the notion that we will never find that

mythical plateau where we can pause and say 'we have made it'. There will never be a final, desirable state when the change is over.

There may be some comfort, or at least understanding, in the idea that museums need continuous care, not interventionist cures. Henry Mintzberg (1996: 66–7), Canada's maverick management professor, suggests that nursing should be the model for management. This model implies the importance of steady and consistent nurturing and caring. These in turn must be rooted in mutual respect, common experience and deep understanding – not in quick fixes or off-the-shelf management solutions.

THE FUTURE: OPPORTUNITIES AND HAZARDS

Setbacks and fatigue aside, the future is upon us and what follows is a sample of the opportunities awaiting any museum which is poised to seize them. Predictably, these opportunities exist in a world of chaos and ambiguity, alongside a variety of hazards, each with sufficient potential to damage, if not derail, the museum enterprise. These, too, will be identified, along with some brief reflections on what can be learned from all of this.

Creating Meaning

Opportunities abound for all museums to fulfill their purpose. That is, to provide some answers to the fundamental question – what does it mean to be a human being (Postman, 1990: 50–8)? Our visitors, indeed North American society, are searching for answers. Museums can help; perhaps even show the way. For example:

- A local child attended Glenbow's new and innovative Museum School, the first of its kind in Canada. In an unsolicited letter from this child's parent, we learned that this family's dinner conversation had changed because of their daughter's new-found awe and excitement. The emotion is so palatable in this letter that I get a lump in my throat every time I read it.

Another example:

- At the conclusion of an exhibition commemorating the 50th anniversary of the Second World War, our exhibition team

hosted a reception for the war veterans who had served as interpreters throughout the show. Unscheduled and unannounced, a frail, 80 year old survivor of a Japanese prisoner-of-war camp rose and spoke. He said that, as a result of Glenbow's exhibition, he now felt recognized and valued as a citizen and a soldier for the first time in his life.

All museums must continually embrace the responsibility of providing meaning to people, and nothing is meaningful until it is related to one's own experience. Meaning, which is really a growth in one's experience (Greenleaf, 1996: 304), requires a leap of imagination from the individual's fund of experience to whatever is being communicated. Museums must tempt the listener to make that leap of imagination.

Growing People
The second and third examples are best described as opportunities which have yet to be fully realized, and they have more to do with museums as organizations and how we do our work. The first of these opportunities requires that we promote the growth and development of our intellectual resources more effectively. Most people would agree that museums are knowledge-based organizations, and that the knowledge of our staff, along with our collections, are the most important assets. Although collections management has evolved its own body of method and theory, surprisingly little attention has been given to nurturing professional intellect (Quinn et al., 1996: 71).

It may be that this current period of institutional struggle could result in greater concern for the development of this human potential (Greenleaf, 1996: 215). One aspect of this new ethic must be a greater concern for how staff think, feel, act and grow, because growing self-reliant and competent staff is the responsibility of all museums. This must begin with hiring the best people available, and then encouraging their development through repeated exposure to complex, real problems. Perhaps most importantly, leading organizations in various sectors are maximizing their intellectual capital by abandoning hierarchical structures (Quinn et al., 1996: 76), such as the departmental/divisional hierarchy, which is still the hallmark of so many museums. Many organizations are learning that scale can be the enemy of creativ-

ity (Farson, 1996: 104–5), and that creativity can be stimulated by organizing differently.

One alternative to hierarchy is in the project-based organization, where professionals use self-organizing networks to do projects and solve problems, and then disband when the job is done. This is the true meaning of interdisciplinary work, where the organization's capabilities exceed the sum of its parts. In an ideal world, the most effective organization would be one in which structure develops and changes as a natural expression of purpose (Owen, 1992: 138). We are not there, yet, but some Glenbow staff say that we are close at times. In any event, this is the thinking behind our multidisciplinary work units. These work units are actually flexible pools of knowledge and experience, whose members work individually, collectively and across the organization, depending upon the work to be done. There is a refreshing informality to all of this, and our challenge now is to develop a performance management and development system based on both collective and individual work.

The scope for creativity and initiative should be just about limitless in a well-run museum. There are very few other workplaces which offer more opportunities for thinking, choosing and acting in ways that can blend personal satisfaction and growth with organizational goals. These opportunities constitute the true privilege of museum work, and it is up to all of us to seize them. As Charles Handy (1994: 77) writes, 'if we wait around for someone to tell us what to do, we shall wait a long time.'

Collective Leadership
The third and last opportunity has to do with the nature of executive leadership in museums. My interest is in the idea of collective leadership, and I wonder if the time has come to experiment with this approach? There are basically two organizational traditions (Greenleaf, 1977). In the hierarchical tradition, one person is the lone chief at the top of a pyramidal structure. We apparently see no other course, be it a museum, corporation or university, than to hold one person responsible. All of us know, at least privately, that the 'great man' model of leadership increasingly resembles the emperor with no clothes.

There are many museums where something different is actually happening. A group of people at the top of the organization, with

shared responsibilities and clear accountabilities, are developing strategies together, and reaching decisions by consensus. Put another way, leadership is less the property of a person than the property of a group (Farson, 1996: 144). This is collective leadership and most closely resembles the second organizational tradition, *primus inter pares*, or first among equals. This tradition apparently goes back to Roman times, although there is little mention of it in the voluminous leadership literature, nor virtually any references to its use in modern-day society.

The principle is simple: there is still a 'first', a leader, but that leader is not the chief executive officer. The difference may appear to be subtle, but it is important that the primus constantly test and prove leadership among a group of able peers (Greenleaf, 1977: 61). Leadership is distributed among the members of a group, with each member playing a vital role, such as taskmaster, counsellor, joker, and so on. If one concedes that senior managers often act like self-interested feudal barons (Hout and Carter, 1995: 135), and further, that the chief responsibility of an effective CEO is to foster interaction and interdependence within the senior group, it may be that the primus model could move us one step closer to effective, collective leadership. Why not extend this opportunity and responsibility for collective leadership to all staff, or at least senior staff, to give them the opportunity to provide fresh perspectives and to learn more about the overall operation?

It might be difficult to identify the leader in a group that is working well. In fact, one writer (Mintzberg, 1996: 64) suggests that great organizations do not need great leaders – just competent, devoted and generous leaders, who know what is going on. He cites Switzerland as an organization that really works. Yet, hardly anyone ever knows who is in charge, because seven people rotate in and out of the job of head-of-state on an annual basis.

HAZARDS

In addition to these and countless other opportunities yet to be realized, there are also numerous hazards for museums as the century comes to a close. The term hazard, in this regard, denotes risks and dangers, not insurmountable obstacles or lethal threats. Nonetheless, the hazards discussed are real enough, and they

have already demonstrated their capacity to demoralize, demean and otherwise divert museum workers from the task at hand.

Paradoxes

The first of these hazards is the prevalence of paradox in contemporary museum work. Paradoxes are things which are simultaneously contradictory, unbelievable, and true or false. The problem is that they can wear us out, or at best, leave us discouraged and frustrated. Consider the following paradoxes:

* At a time of diminishing resources, museums must provide new and creative ways of serving a growing and diverse public, or;
* At a time when a concerted effort must be made to identify new ways of enhancing the sustainability of museums, it is all most can do to keep the wolf from the door. Designing and testing new ideas cost time, energy, and often money.

Some of the most useful thinking that deals with paradoxes is that of Charles Handy (1994: 12–13), who notes that paradoxes are like the weather – 'something to be lived with, not solved, the worst aspects mitigated, the best enjoyed and used as clues to the way forward.' He also observes that 'the secret of balance in a time of paradox is to allow the past and the future to co-exist in the present' (1994: 63). Museums can provide this unique perspective on behalf of society, but we are going to have to do a much better job of integrating the past, present and future in our programs and services.

Self-Reference

Avoiding the second hazard requires that all museums cultivate their capacity for self-reference (Wheatley, 1992: 95, 146–7). This is our ability to be guided by a strong sense of our own competencies as an organization, so that as the organization changes, it does so by referring to itself – meaning the skills, traditions, and values which have guided its operations. People in the business world call this 'sticking to the knitting'.

This idea of self-reference is an important one, especially when considering our current financial pressures. There is a growing belief among governments and the public that museums must become more commercial, and embrace the notion that the custo-

mer is always right. Although we at Glenbow are adamant about an absolute commitment to public service and maximum self-sufficiency, we must do this in a thoughtful and balanced way, as knowledge-based institutions, not commercial enterprises.

For example, Glenbow happens to host weddings to enhance revenues. However, if hosting profitable weddings means closing public galleries in order to do so, then we are losing sight of our purpose and are no longer engaging in self-reference. We do this at our own peril. The hazard here is a fuzzy sense of self-reference, which can destroy a museum just as surely as it has destroyed those many corporations which have strayed too far from their core business.

Marketplace Ideology
The importance of organizational self-reference leads to the third hazard, which Canadian author, John Ralston Saul (1995: 2), has dubbed the 'crisis of conformity', or more colourfully, 'the great leap backwards.' He is referring to North America's slavish adherence to the ideologies of corporatism and the marketplace, and to putting self-interest over public good.

The assumption that either business or the non-profit sector holds the exclusive keys to the future must be avoided. As we all know, business has never had a monopoly on virtue, effectiveness or accountability. Business has everything to say about value in the marketplace, but often has less to say on the subject of responsibility, except perhaps to shareholders. At the same time, business is rich in experience when it comes to organizing work, marketing and adding value. Why would we ignore these lessons, especially when we can choose what is most germane to our particular needs?

Having said this, we must not ignore our responsibility to make known the inherent limitations of marketplace ideology for long-term heritage preservation. All custodial institutions have enduring obligations to the dead and to the unborn, as well as to the live customer. Yet the dead and the unborn neither vote nor buy; they have no voice in the dynamics of the marketplace. We must make it known that museum collections are similar to other fundamental resources like the natural environment, in that they are collective property, essential to our identity and well-being, and unable to speak for themselves. There will always be a public

responsibility for their care – a responsibility which has no'thing to do with the marketplace. Collections are really about our humanistic consciousness (Saul, 1995).

Unfortunately, these complexities of time and collective memory seem to have escaped the imagination of many politicians and officials, who are increasingly judging museums by the sole criterion of the number of people through the door. High attendance induced by blockbusters, like profits, are momentary. Both can quickly disappear. It is things like reputation, name recognition and the trust of visitors and supporters which will allow museums to stand the test of time (Flower, 1995: 6). In the idiom of the marketplace, this means quality and market share. Museums are, in fact, diversified portfolios. Some of their work can be subjected to market forces, such as restaurants and product development. Other activities, such as collections care and knowledge generation, bear no relation to the market economy, and probably never will. As one famous entertainer observed (Livesey, 1996: 25), 'the point of life is not to sell things to make the most amount of money. It's to find your true calling and work that is purposeful.'

Stress
The fourth and final hazard concerns all museum staff, as it has to do with the cumulative stresses and strains of continuous change in our work. We must be aware of the inherent dangers and develop our own stress management programs. Emotions run extremely high when we talk about change in museums, and dealing with emotions, one's own and those of colleagues, is perhaps the most difficult part of the change process. We should always be alert to ideas and concepts that provide some comfort and hope amid all the stress, and several of them will be mentioned here. First of all, it is okay to make up solutions as you go along, because there is no 'right way' waiting to reveal itself or be discovered. This cannot be overstated, as it is fundamental to the creative process. I suggest, however, that it is useful to pay attention to other peoples' experiences.

Second, do not fear ambiguity. In the museum world, which has raised the practice of 'no surprises' to a high art, few things make us more frantic than increasing complexity (Wheatley, 1992: 109). We also have a hard time with questions that have no

readily available answers. It is not necessary to fear ambiguity or complexity, however, if we can just give up our preoccupation with details and refocus our attention on the bigger picture. Organizations need order, but they also need its opposite – spontaneity, some chaos and even messiness.

A third source of comfort may be the realization that it is okay to stir things up. it may even be our responsibility. We must do this in order to provoke questions and create challenges. One writer (Wheatley, 1992: 116) observes that when things finally become so thoroughly jumbled, we will reorganize our work at a new level of effectiveness. I do not know if this is true, but I am willing to accept it as a possibility. My challenges as President and CEO continue to be balancing the needs of the organization with those of the staff, and determining how deeply I should listen to the negative people whose voices I tend to hear the loudest. Perhaps the biggest challenge is to remain mindful of what we really need to do, rather than relying solely on the things that we are already doing well (Farson, 1996: 108).

Finally, it is okay to admit the discomfort one feels as a result of organizational change. I see in retrospect how silly I was about this during the low points of Glenbow's change process. I was too embarrassed to tell my colleagues that I was going to see a counsellor to deal with the distress I was feeling. Stress becomes a hazard when you do not deal with it openly and constructively.

AFTERTHOUGHTS

Whether it is continuous change, opportunities or hazards, the most important constant for all of us is our attitude towards learning. In the final analysis, all our efforts at change are about learning. This means learning from experience, learning from people, and learning from successes and failures. Learning organizations, as is true of individuals, are those which are skilled at creating, acquiring and sharing knowledge, and then using this knowledge to modify their behaviour (Garvin, 1993). Learning really means collectively increasing your capacity to do something that you could not do before (Walmsley, 1993: 40). We must consider the very real possibility that we, as individuals, are the predominant creative forces in our own lives, as well as in the lives of the organizations within which we work.

Yet, despite all our efforts at learning, museums are many things at once and none of us will ever know them completely (Morgan, 1986: 340–1). Irrespective of the details in this paper, I can claim only a partial understanding of Glenbow. We can only know organizations through our experience with them, which means there can be a huge difference between the rich reality of an organization, and the knowledge we are able to gain about that organization. This continuous learning may help to explain the roller coaster ride which best describes museum life in the 1990s.

At the risk of oversimplifying, three necessities which may help to distill all our efforts at change and growth at Glenbow are worthy of note:

• The first is the need for shared purpose. Every employee must have an understanding of the museum's purpose, and how he or she contributes to it.

• Second, is the need for active experimentation. Most innovation occurs from hundreds of small changes and ideas which add up to enormous differences, and we must encourage such thinking in all that we do.

• Last, is the vital importance of openness. We recognize that there will always be tension between the individual and the organization, but that we must deal with this conflict openly, creatively and in non-manipulative ways. There is no doubt that candid communication requires a balance of power.

These three imperatives are really the test of authenticity in our work.

It might be useful to think of your museum as a Gothic mansion of sorts (Emberley, 1996: 278). It is filled with secret rooms and hidden staircases, as well as surprises, some horrors and many unanticipated discoveries. It is full of clutter, sometimes verging on the intolerable, along with a certain amount of rot and decay. At the same time, it is replete with hopes of renovation and renewal. It is both a safe haven and a landmark, and beckons people to come inside – not knowing what they may find. They may even be offended, but surely this is a good thing – is not being offended part of learning how to think (Emberley, 1996: 240)? The message is clear – our work in museums is full of

possibilities and pitfalls, most of which can be used, adapted, or confronted.

So, if reality is the pawn of ideas, and there are few, if any, assurances about the outcome of our efforts at change, where does that leave us? Personally, I take heart in the words of Charlotte, the gray spider, in E.B. White's wonderful book, *Charlotte's Web* (1952: 64). Charlotte said:

> Never hurry,
> Never worry,
> Keep fit
> And don't lose your nerve.

We at Glenbow can only aspire to Charlotte's advice, because we hurry all the time, we worry a lot, and I have no idea how fit each of us is. But, we have not lost our nerve, and we have no intention of doing so.

ACKNOWLEDGEMENTS

This paper is a revised version of two keynote addresses presented at the 'Museums in the New Millennium Symposium' (Smithsonian Institution, 1996) and at Museums Out of the Box (Midwest Museums Conference, 1996). I am grateful to both of these organizations for inviting me to these stimulating meetings.

I also wish to thank Barry Agnew, Gerry Conaty, Richard Forbis, Michael Fuller, Terrence Heath, Melanie Kjorlien, Mike Robinson and Ron Wright for their invaluable comments on several of my papers and presentations. I continue to benefit from their perspectives. I am particularly grateful to Denise Savage-Hughes for her editorial assistance and sage advice on this paper, and to Evy Werner for typing the various drafts.

Glenbow's Board of Governors has been consistently supportive of my efforts to record and share Glenbow's efforts at organizational change. I thank them for this, as well as their collective commitment to learning. I must also acknowledge Glenbow's executives for their ongoing support and encouragement – Joe Konrad, Patricia Ainslie, Donna Livingstone, Lindsay Moir and Sharon Gutrath. Because this paper builds upon my recent book, *Museums and the Paradox of Change*, I must also thank all the individuals who contributed to that work, most notably Glenbow

staff. They have shaped my thinking and enriched my experience in ways too numerous to mention.

BIBLIOGRAPHY

Ainslie, Patricia (1996) 'The Deaccessioning Strategy at Glenbow, 1992–97', *Museum Management and Curatorship* (Elsevier Science Ltd.) 15 (1): 21–35.

Beer, Michael A. (1988) 'Leading Change'. *Harvard Business School* Note 9-488-037 (Cambridge MA).

Boyd, Willard L. (1995) 'Wanted: An Effective Director', *Curator*, 38 (3): 171–84.

De Pree, Max (1992) *Leadership Jazz* (New York: Bantum Doubleday Dell Publishing Group, Inc.).

Emberley, Peter C. (1996) *Zero Tolerance: Hot Button Politics in Canada's Universities* (Toronto: Penguin Books Canada Ltd.)

Farson, Richard (1996) *Management of the Absurd* (New York: Simon and Schuster).

Flower, Joe (1995) 'The Change Codes'. Internet address: http://www.well.com/user/bbear/change_codes.html.

Galbraith, John K. (1994) Interview, *The Financial Post*, Toronto, 2 July 1994.

Garvin, David A. (1993) 'Building a Learning Organization'. *Harvard Business Review* July–August: 16–31.

Greenleaf, Robert K. (1977) *Servant Leadership* (Mahwah, NJ: Paulist Press).

——— (1996) *On Becoming a Servant–Leader: The Private Writings of Robert K. Greenleaf* (D.M. Frick and L.C. Spears – editors) (San Francisco: Jossey-Bass Inc.).

Griffin, D.J.G. (1987) 'Managing in the Museum Organization I. Leadership and Communication'. *The International Journal of Museum Management and Curatorship*, 6 (4): 387–98.

Handy, Charles (1994) *The Age of Paradox* (Boston, MA: Harvard Business School Press).

Hout, T.M. and Carter, J.C. (1995) 'Getting it Done: New Roles for Senior Executives', *Harvard Business Review*, November–December, pp. 113–45.

Jackson, Tony (1996) 'Corporate America is Dumbsizing'. *The Financial Post*, 25 May 1996, p. 87.

Janes, Robert (1995) *Museums and the Paradox of Change* (Calgary: Glenbow).

Jantsch, Erich (1980) *The Self-Organizing Universe* (Oxford: Pergamon Press).

Keating, C., Robinson, Thomas and Clemson, Barry (1996) 'Reflective Inquiry: A Method for Organizational Learning', *The Learning Organization*, 3 (4): 35–43.

Livesey, Bruce (1996) 'Gimme, Gimme'. Financial Post Review, *The Financial Post*, 28 September 1996, pp. 24–5.

Mintzberg, Henry (1996) 'Musings on Management'. *Harvard Business Review*, 74 (4) July–August: 61–7.

Mish, F.C. (Editor-in-Chief) (1986) *Webster's Ninth New Collegiate Dictionary* (Springfield, MA: Merriam-Webster, Inc.).

Morgan, Gareth (1986) *Images of Organization* (Newbury Park, CA: SAGE Publications, Inc.).

Morris, Martha (1995) 'Survey on Strategic Planning, Organizational Change and Quality Management', Unpublished report available from the Deputy Director's Office, National Museum of American History, Smithsonian Institution, Washington, DC.

Norfolk Group (1995) *Norfolk News*, Fall/Winter, Calgary, Canada.

Owen, Harrison (1992) *Riding the Tiger: Doing Business in a Transforming World* (Potomac, Maryland: Abbott Publishing).

Phillips, Will (1995) 'Red Alert For Museums: A Crisis in Response Ability'. Part I, Extended Version. Unpublished paper available from the author.

Postman, Neil (1990) 'Museum as Dialogue', *Museum News*, 69 (5): 55–8.

Quinn, J.B., Anderson, P. and Finkelstein, S. (1996) 'Managing Professional Intellect: Making the Most of the Best', *Harvard Business Review*, March–April, pp. 71–80.

Saul, John Ralston (1995) *The Unconscious Civilization* (Concord, Ontario: House of Anansi Press Limited).

The Economist (1996) 'Fire and Forget?' *The Economist*, 20–26 April, pp. 51–2.

Tough, Paul (1996) 'Does America Still Work?' in Forum, *Harper's Magazine* (May), 292 (1752): 35–47.

Traub, James (1995) 'Shake Them Bones', *The New Yorker*, 13 March 1995, pp. 48–62.

Walmsley, Ann (1993) 'The Brain Game'. *The Globe and Mail Report on Business Magazine*, April, pp. 36–45.

Wheatley, Margaret J. (1992) *Leadership and the New Science* (San Francisco: Berrett-Koehler Publishers, Inc.).

White, E.B. (1952) *Charlotte's Web* (New York: Scholastic Book Services).

2

Creative Management in Museums

JULIAN SPALDING

The main management problem in museums is that they are incoherent internally. They are a frustrating, though often entertaining, bundle of warring factions, each jealously guarding its own territory against all comers, particularly other colleagues. These factions identify with their own disciplines more than with the museum itself. The result is that it is very rare for a museum, as a whole, to decide what it is going to do, let along combine its forces to work creatively together to achieve that goal. Yet I believe museums have to be creative if they are to make a creative contribution to society, especially in a time when bids for public resources, on which museums depend, are becoming increasingly competitive. Museums have, quite simply, to get their act together.

To work creatively museums have to have clear and create objectives. The current internationally accepted definition of a museum doesn't help here. A museum is defined as a 'non-profit making, permanent institution in the service of society and its development and open to the public which acquires, conserves, researches, communicates and exhibits for purposes of study, education and enjoyment material evidence of man and his environment.' That is not an aim, but a list of functions. Museums need an aim on which they can focus their creative attention and which will help them prioritise their resources.

In Glasgow's museum service we have transformed this definition into an active mission statement: 'We will continue to make Glasgow Museums more interesting, enjoyable, accessible and responsive to our public and staff.'

There is no mention here of the collections or their preservation, because these are the means by which we communicate to our public. They are not an end in themselves. Museums only exist for people. Their job is communication. Only when a

museum recognises this as its ultimate goal will it be able to see its different functions in perspective and prioritise its resources. If a museum keeps its eye on the people it is there to serve, it can steer itself to where they are and play a really creative role in people's lives.

Once the aim is clear, good management it is just a question of making sure that everyone in the museum is contributing his or her utmost to achieving that goal. I use the word 'just' with a little irony. Even in Glasgow, where our new mission statement has been in place now for nearly five years, and is widely discussed in the context of everything we decide to do, even here there are still many in the organisation, who, while accepting the mission in principle, do not think it means that they have to change their practice. There can be a world of difference between changing what you think and changing what you do. This can be a very difficult transition especially if you have spent a life time doing something one way and are then asked to do it another way. Failure to achieve change is as much the fault of those directing the change as those responding to it. It can be a result of genuine misunderstanding as to what the changes mean.

Conservation staff, for example, happily accept, of course, that their job is to preserve the collection so that it can give interest and enjoyment. But in the new management structure we have introduced in Glasgow, the conservation staff have to help their colleagues in the museum provide this interest and enjoyment.

This means that it's the conservator's sole responsibility to resolve any conflict that may arise between preservation and access. But it is as difficult for conservators to assume this responsibility as it is for curators to delegate it to them.

A caricature of a conservator is one who doesn't want to allow any public access because he or she knows it always involves a risk to the object. A caricature of a curator is one who wants to show everything to the public because he or she knows that's what the collections are there for. The conventional museum response to this fundamental conflict is to find a balance. That may be reasonable enough but only until one comes up against a situation where a balance can't be found. In such a case, the conservator will argue that the object will be at risk if it is used in

the way proposed, while the curator will argue that this risk is worth taking. Who then, in this situation, decides what should be done – the 'museum' itself – represented by the Director – or its governing board? In the new museum I envisage this decision will be taken by the conservator whose job it will be not to just make the object safe but make it accessible, too. Because the conservators are responsible, like everyone else in the museum, for the museum achieving its goals. The 'museum' doesn't begin when the job of any one in it ends; all staff are responsible for the delivery of the museum's work right up to its end product – the flowering of understanding in the visitor's mind.

The key to good management in museums is to make sure that all staff have clear roles in helping to deliver the museum's goals so that everyone can partake of the satisfaction in seeing it achieved. I will now describe what each of these roles are and how they combine together to create a unified team that is capable of leading the museum and responding to the changing needs of its public.

THE ROLE OF CONSERVATION AND COLLECTION MANAGEMENT

The job of a museum conservator is to make the objects in the museum's care, whether in its collection or on loan, more safely accessible. To do this properly museum conservators have to be totally responsible for the collections at all times. This includes being responsible for the stores, where, statistics show, most damage to objects occurs. Above all, it means that the conservator is responsible for deciding under what conditions an object will be made accessible. They don't have to ask anyone about this: it's their job to decide this for themselves. They have to make the object more safe *and* more accessible – and the museum will give them targets for both; for ensuring the increasing safety of the collection and for increasing its accessibility.

To meet both these needs the museum conservators will sometimes have to make difficult decisions about what levels of risk they are prepared to take. It's right that they should do this because they will have to repair any damage that may occur. They have to balance the risk against the needs for access and determine the acceptable level of risk. They will have to estimate the significance of the risk in relation to the meaning of the object

and may well be prepared to accept deterioration to insignificant parts of an object to ensure meaningful access to an object. They will have to consider the concept of acceptable levels of deterioration.

Some conservators may hold their hands up in horror at this and cry that objects should on no account be exposed to *any* risk. But that is not the real world – certainly not the real museum world. Museums have the difficult job of providing widespread access to unique, valuable and often fragile things. All access exposes objects to risk. The museum conservator has to assess the significance of this risk in light of the museum's aims – which is to give interest and enjoyment to its public, both now and in the future. The museum conservator's job is to find ways of doing this, and to take responsibility for the appropriate decisions involved.

For a museum to function efficiently, everyone in it has to be clear what his or her area of responsibility is, and has to be free to take decisions and initiatives in this area. No-one should feel they are just obeying orders. But that's exactly what conservation officers in most museums today do feel. They usually have to ask the curators for permission to do something even when they know this has to be done.

Conservators are frequently ·more highly qualified than curators; they have first degrees and postgraduate qualifications and certainly know more about the construction of an object than the curator – and they often know a great deal about its significance too in ways the curator may not. But still they have to ask the curators' permission before they can do their job. No wonder many become frustrated with the museums profession which pays them less than they deserve and treats them as technical assistants rather than as knowledgeable contributors.

There is no reason why a curator should have any say over what a conservator does – after all, the curator won't be able to do anything about it if something goes wrong. I'm a firm believer in people being responsible for their actions *and* for the consequences. Moreover, there is a good reason why the conservator should play an active rather than just a passive role in a museum. The museum needs to know the overall condition of its collection. It needs to be able to prioritise resources to make this collection safe, irrespective of more immediate needs. The

conservation department has to argue for and manage these long term needs, in addition to the museum's displays and exhibition programmes.

The museum conservator however, is not just a behind-the-scenes worker; he or she also has a role to play in communicating directly to the public. Conservators know a great deal about the constitution of objects, and I foresee them taking over the role of researching (and communicating to a wider public) specialist curatorial subject areas such as those defined by techniques and materials, like glass, ceramics, furniture or metalwork. But if the conservator is looking after the collection, managing its storage, deciding on its conservation and providing access to it and even giving information about it directly to the public, what then will the curator do?

THE ROLE OF THE CURATOR

Currently curators are mini-directors. They sit over 'their' part of the collection like a hen over a brood and dictate what's to be done with it, where and how it's to be stored, how it's to be conserved and displayed, what's to be added to it, where it's to be lent and to whom even if – perhaps especially if – they are colleagues in the same museum. They regard directors as superfluous – only there to provide them with resources. The museum becomes like a spider with a brain in each leg, each wanting to go in a different direction. Pity the poor woolly body in the middle – the administration and service staff and the helpless director sitting on top! Such museums would be better either to split up, or combine properly into one organisation unified by one overriding aim. Whichever happens, the job of the curators has to change. They have to work for the museum as a whole, not make it work for them.

The key function of the curator is to be responsible for the meaning of the museum – to be responsible for what actually occurs when a visitor looks at an object and gains understanding. The most successful curator will be one who achieves this most profoundly and most often to the greatest number and range of people. To do this curators have to know two things: they have to know about their collections (both their existing and potential collections) and to know their public (both their current and

potential visitors) and to bring these together in ways that make the sparks of understanding fly.

This is enough responsibility for one job, and to concentrate on this, the curator has to give up other responsibilities. Above all curators have to give up their 'ownership' of their part of the collection. The collection doesn't belong to them; it belongs to the museum as a whole – and to the people who own the museum. The curator is only one user of a collection, at a particular time. There are other users, such as researchers from outside institutions, or other professionals, such as teachers, or other curators – just members of the public. These people shouldn't have to go through a curator to get permission to have access to a collection. The museum itself gives them permission – because it, not the curator, owns the collection and its job is to provide access to this collection not just for the few people that a curator may approve of but for everyone.

If the policy of a museum is to increase access to its collection, it will seek every way possible to do this. Conflicts of use will need to be resolved in the light of this aim. For example, if someone wants to borrow a popular item normally on display in the museum, the increased access which will result from the loan has to be assessed against the loss of access that will be suffered by the object's absence. Lending is an important means of widening access for all public museums, and these should establish key policies and targets in such matters rather than leaving these decisions up to individual curators whose personal likes and dislikes may well affect a decision in a way which reduces the museum's overall effectiveness. Curators should have no reason for objecting to a loan other than on the grounds that the loan, if agreed, would reduce the museum's effectiveness in achieving its goals.

Having lost the ownership of their collections, curators will automatically lose their responsibilities for its conservation. This will no longer be their concern, except in those instances where what the conservator proposes to do could affect the significance of the meaning of the object, such as in those cases where an object is to be restored to a former, conjectural appearance.

Having lost the ownership of his or her part of the collection, the curator will now be free to look at the whole collection of the museum in refreshing, new ways and, in particular, in the light of what interests the museum's public. It will, of course, be the job

of the curator to spend a good proportion of his or her time researching what interests the public. This research will be as important as his or her research into his or her specialist subject.

The museum curator will not be a specialist in a purely academic way, researching a subject for its own sake in the hope that something significant might emerge from this study. This is a valid activity, of course, and one that any civilised society should be able to support. Such pure research posts need to be attached to, and evaluated by research institutions with access to libraries and museums. These are likely to be based in universities, though they could be housed in some of the larger museums. But such pure research cannot be the main function of the curator in the museum. It must, of course, ensure that it benefits from the findings of such research, even if the individuals who carried it out are not on the museum's staff.

Museum research is different from this, it is not pure, but applied to the museums needs – whether its the development of the collection, or the work needed to put on a new display. The museum curator's main job is to make sure the museum makes maximum use of its unique role in society, which is to communicate understanding to as many people as possible by making its objects come alive in people's imaginations.

Curators need, of course, to be able to identify authenticity – not just whether or not an object is what it appears to be – but whether its meaning is authentic, which is a much subtler and more interesting area of study. This will no longer involve the identification and description of materials and techniques, for the conservators in the museum will provide this information from their knowledge of the collection. Nor will the curator be involved in the valuation of objects. Museum professional Code of Ethics prevents them from giving these, but in any case the financial value of an object will rarely be of any significance in relation to its deeper meaning, which will be the curator's main concern.

Nor will the curator be concerned primarily with cataloguing the collection. Much documentation is already on museum databases and the curator will play a part in helping to ensure that this information is updated or added to, from whatever source, in conjunction with the museum's documentation staff. The archival function of the museum, which is, essentially how the museum

serves all its users both within and outwith the museum, has to
become distinct from the role of the curator. For the curator is
not a records clerk; his or her main job is to communicate the
meaning of the museum's collection to the public.

Freed from their narrow specialist confines, curators will now
be able to look at everything in the museum in fresh ways, from
the perspective of modern-day interests and concerns, so that they
can reveal new meanings in the rich collections we have inherited
from the past. It is often difficult for curators to do this in
museums now, because their collections are broken up into spe-
cialist areas, each 'owned' by a different curator. These subject
areas reflect the interests and categorisations of the past: such as
ethnography (usually collections of curios from the native popu-
lations of colonised countries); palaeontology (dealing with the
study of fossilised bones, crucially interesting to the Victorians, as
discoveries about the past undermined their scientific and moral
view of the world); and of technical subjects such as glass, furni-
ture, ceramics and metalwork, developed as part of the Victorian
idea that a museum collection could act as an inspiration to con-
temporary craft manufacture.

There are always disputes over borders, and museums are full
of stories of these; the hours of discussion as to whether, say, an
Italian Renaissance tapestry design should go into the Depart-
ment of Textiles (which looks after tapestries) or the Italian
Renaissance Department because of where it was designed, or the
English Decorative Art Department because of who commis-
sioned it and where it was used, or the Prints and Drawings
Department because of its medium and material. In Glasgow
Museums until recently, if a piece of pottery was broken it went
to Archaeology, if it was complete it went to Decorative Arts.
Still today in the Louvre, if a piece of plastic art is small enough
to hold in one's hand it goes to Decorative Arts, if it is bigger, it
goes to Sculpture.

All such divisions are not just silly; they're serious, too, because
they limit the potential meaning of the objects in each collection.
It means that one object which could convey a great deal when
shown with another may well never be able to be used in this way
just because a curator won't let it be or is simply not aware of
the significance of the object to a subject area outside his or her
field.

This is not to say that curators will not develop special interests of their own. Of course they will but these will need to change over time. The specialist interests will need to reflect changing interests in the museum's public. It is very unlikely that natural history curators will in the future be interested, as their predecessors were, in collecting examples of stuffed, exotic animals from around the world. They might, for instance, be much more interested in displaying evidence of the effects of man-made pollution and in using the exotic animals already in their collection to show how many species have been driven into extinction during the last few decades. This wouldn't be a use they were originally collected for, but this doesn't mean that these objects can't be used to communicate these ideas today. Changing ideas, changing research, changing public interests do not necessarily mean changing collections.

A curator's specialist knowledge about the meaning of a museum's collections will change and develop over time. It must be allowed to do so and not be constrained by, or itself restrict the growth of a particular collection. New growth will not be achieved by dividing the collection into separate units, but by managing it as one, and treating the specialist interests of the curators only as changing perspectives on the one collection.

There are three main ways of looking at an object. One can look at it from an artistic, a scientific or historical point of view. A car, for example, can be understood as a piece of design in itself and an influence on design (particularly urban design), or as an achievement of engineering, or as a pollutant and danger to health or as a symbol of social class. It's difficult to understand a car as all of these at once, for the knowledge required to understand each perspective fully is very different. But each of these view points, if communicated well, can provide a totally valid and equally authentic experience for the visitor. However, none of these experiences of a car are provided by the way a car is usually presented in a museum – as an example of a means of transport.

Art, science and history provide three general categories for curatorial specialisations, but curators should always be free to explore interest areas that embrace all of these or other perspectives. Curators in the museum of the future therefore won't be at war with each other but will work happily together with the collections to achieve the museum's goals.

THE ROLE OF DESIGNER

The designers are responsible for how the collection is communicated to the public. These are the people who create the displays and the stimulating environment in the museum. It is they who control what happens in the space between the visitor's perceptions and the object itself. Museums have only just begun to develop their own language of communication through objects. The designer's job is to develop this language, through experiment and evaluation. They have to feel free to do this, to contribute their skills to the museum without the curator breathing down their necks and attempting to design the display for them. Displays designed by curators, usually only display the curator's taste and social background. They rarely succeed in catching the imagination of a wider public. The curator should only be concerned with *what* is finally communicated, not with how it is communicated. It is the designer's job to decide how to communicate but they have to evaluate the success of their efforts. Their art is to hide their art so that objects communicate their meaning clearly to each visitor. The designer, too, like all the museum's staff, serves the museum's goals. He or she is not there to display his skills. The effectiveness of a designer's work and of a curator's work will emerge from the evaluation of the display they have developed together.

EVALUATION

Evaluation is vital to the management of any organisation. One can only progress by first evaluating where one is, then deciding where one wants to get to, then working out how one is going to get there, then getting there, then evaluating where one is, and so on. This process has to be incorporated into the management process of the museum (Figure 2.1).

Evaluation is expensive and difficult for museums. There is no easily defined 'bottom line' for a museum – nor can the cost of market research be added to the price of the product. Numbers are important for museums but they're not everything: social reach is equally important. But most important of all, in the end, is the quality of experience, the depth of understanding the visitor gains from his or her experience of the museum. This is very difficult to assess. Museums will I'm sure in future, develop

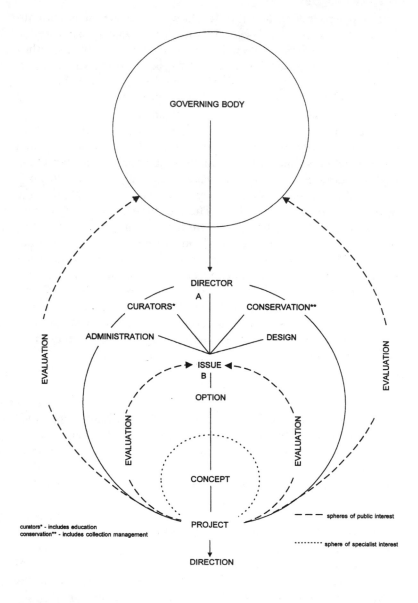

Figure 2.1: Museum management chart

systematic ways of evaluating the visitor's experience. But at present still the best way to assess these elusive but important 'outcomes' is by personal observation, particularly by talking to people.

Museums have a major resource that can enable them to do this, but one which is hardly ever used for this purpose: the attendant, or security guard. These staff meet the public, they are there at the cliff face, so to speak, of the museum experience, where the public actually responds to what the museum has put on. They see and observe people's reactions; whether they get bored or not and, if so, how quickly. They know what interests visitors most, what works and what doesn't. But they are hardly ever even asked their opinion, let alone invited to play a part in what the museum does so that their knowledge and experience can enable the museum to improve in the future.

THE ROLE OF THE MUSEUM ASSISTANT

The development of the role of the attendant is crucial to the improvement of management in museums. Attendants are a vital human resource who have to contribute fully to the museum. If they are going to do this, they need to feel part of the museum. They have to understand what the museum is about and want to contribute to its development. They won't do this if they're bored out of their minds or treated as second class citizens. If a museum wishes to communicate with the whole of society, it should ensure that it communicates with its attendant staff, who are drawn mainly from the less advantaged sectors of society. A museum can't expect to reach these sectors outside the museum if it fails to reach their representatives within.

The way to ensure that attendants become fully part of the museum service is to change the nature of their job and give them a clear area of responsibility. They need to become 'museum assistants', assisting the museum in the delivery of all its work, in curation, conservation and design. They need to have training in handling, identification, communication and installation of objects. They need a multi-skilled job that makes them feel part of and responsible for the museum. They will then form ideal recruits for more senior posts in any aspect of the museum's work, because their job will give them a grounding in the real

work of the museum, and this will be an excellent basis for the work of any specialist department.

To ensure such progression happens, the career structure and training programme in the museum needs to be organised so as to allow promotion through all salary levels. It is my ambition to see, in time, a museum assistant rise to become a director of a museum. Such a director would have the advantage of experiencing the whole work of the museum and seeing its effectiveness with the public, at first hand. A director so trained could achieve great things because it is only on real experience that real imaginative achievement can be based. The admittance of the museum assistant into the management of the museum means that, at last, we can establish one coherent, creative museums profession.

As well as contributing to the work of the museum as a whole, museum assistants should have a clear area of responsibility and, as with all areas of responsibility, delegated authority within it: museum assistants will be responsible for the success of the public's visit. Their job is to make the visitors feel welcome, help them to enjoy their time spent in the museum and to take full advantage of what's on offer, encourage them to use the services available, and make them feel as they leave, that they want to come back again, and tell their friends all about what an interesting and enjoyable time they have had.

This will involve the development of customer and interpretation skills. Of course museum assistants must still have a security function. Their mere presence in the galleries contributes to this. Statistics show that the safest gallery is the fullest gallery; the most insecure is the one with fewest visitors. Merely by encouraging visitors, the museum assistant helps with security – because the majority of visitors will help keep the collections safe, especially if they feel they are welcome in the museum, and that the collection belongs to them.

We had an incident not long ago in our Museum of Religious Art and Life, when a very powerful man took it upon himself to try to pull to the ground a seven foot high bronze statue of Shiva. Clearly he was too big and dangerous for the museum assistant to stop him, and the statue crashed over (fortunately only damaging one of its arms). The other visitors rushed to help the museum assistant and together they managed to keep the man talking – until the police arrived. It took four policemen to get

the man out of the building. Such incidents are unpredictable and difficult to prevent – but had not the visitors felt welcome in the museum and on the side of the museum assistant, further damage might have been done. Visitors can potentially be a help to a museum; they are not, as many museums give the impression, a potential enemy, or at best a nuisance. The museum assistant's job is to encourage visitors to become more helpful to the museum. Security should be kept discreet – preferably backed up by the presence of plain clothed staff.

If they are to serve the whole of the museum, museum assistants need to be part of the central administration of the service, which supplies all financial, personnel, information, documentation, planning and marketing services. These can be unified under a Department of Corporate Services, whose head needs to sit alongside the senior management of the museum when any decisions are being made about its future direction.

CREATIVE DECISION-MAKING IN MUSEUMS

How then, does this new museum decide what it does? I have described each section as being clearly responsible for its own area of work and contributing to the decision-making of the whole. No section can, unilaterally, make a decision that is binding on the whole organisation, for each is dependent on the others for the fulfilment of that decision. So how does decision-making work?

The chart shows this process in diagrammatic form. The director is responsible for the performance of the whole service to the governing body that has appointed him or her. He or she chairs a management team on which are represented all the main functions of the museum: its curators (who include specialist curators, such as those serving educational or community needs), its conservators (who include in their duties management of the collection), its designers and its administrators. Their agenda is divided into three sections: issues, options and concepts.

The Management Team considers the issues the museum service needs to address. These may be internal or external to the museum. It may be, for example, that a new law has been passed which will mean that the museum could have less money for this activity or more for that. Or it may be that an internal evaluation

has revealed that a project which the museum has undertaken has failed in its objective to interest more young people, but an aspect of it has proved surprisingly successful to the elderly.

Having decided which issues the museum needs to address the Management Team then delegates the matter to an Option Group, consisting (or led by one) of its members, which then researches the options which are available to the museum to address this issue, and at the agreed time reports back to the Management Team recommending which option it favours. The Management Team then discusses these, and if everyone agrees, allocates the resources to the project and delegates it to a Concept Team. Only at this stage does a project become a full commitment of the museum.

The Concept Team's job is to realise the project. It is managed by a project team which contain the curatorial, conservation, design, administration and museum assistant skills necessary. It is very important that enough time is allocated for project development at this stage. There has to be time for creative thinking. There is never only one way of doing something. Often a second or third way will be more effective and economical in achieving one's goals, than one's first idea. The Concept Team therefore have to consider at least two different ways of realising a project. They then present these in a concept presentation to anyone who is interested in the museum service as a whole. This ensures that sufficient time is spent at the thinking stage before any money and resources are spent to ensure that the project will be realised as effectively and, efficiently and imaginatively as possible, and that its aims are clear and its evaluation process is agreed.

Once the concept is accepted, by the representative of the Management Team who has been delegated this task, the project proceeds to its realisation and evaluation. This evaluation may throw up another issue that the museum needs to address, and so the cycle continues. Since the continuing aim of the museum is to improve what it does and to reach further into the wider community, this process of evaluation is crucial in enabling the museum to make a steady and effective progress in the direction it requires.

The museum's governing body will be interested in the effectiveness of the museum's work. They will receive reports of this

from the museum itself. But they will also receive reports from the public direct. This wider sphere of public interest is indicated on the chart. Independent reports such as these often weigh very significantly with a governing body. The museum, if it is to earn the support it needs from its governing body, needs to do all it can to ensure that the public it serves are advocates for the direction in which the museum is going. Politics becomes involved here. If the governing body is elitist and only cares about the opinions of its friends in privileged circles, the museum will inevitably be biased in this direction. If the governing body is non-elitist and has members who represent less advantaged people in the community, then the museum will be influenced in this direction.

THE ROLE OF THE DIRECTOR

The job of the director is entirely contained between the letters A and B on Figure 2.1. A represents the director's position as a channel for the wishes of the governing body and as a channel back to them for the needs of the museum. B represents the director's contact with the issues that the museum needs to address, and the decisions that the museum needs, as a whole, to take. There, at B, drawn up close for the director and the whole Management Team to see, is the reflection, in miniature, of the public work of the museum, its real activity in the hearts and minds of its visitors. The authority of the director lies solely in his or her ability to assess the real value of this work and to convince others within the museum and within the governing body of the way in which this work can be developed. The articulation of this is the director's vision of the service which itself provides direction for the museum. This direction is focused and developed by the contribution of the whole Management Team through the issue, option, concept decision-making process.

Figure 2.1 also indicates a sphere of specialist interest as well as spheres of public interest. It is important to distinguish between the two. Most museums have specialist advisers either on a permanent or sporadic basis – academics and others who have a particular, sometimes a vested interest in what the museum does. Such people are, of course, important, but they are not solely or even mainly who the museum is for. Public museums exist to

reach a wider public and new audiences who may well have as yet
no knowledge of or interest in the museum's work.

It is important therefore that specialist advisers are used to
serve the museum rather than the museum being used to serve
them. Their circle of influence is purposely drawn on the manage-
ment chart in a way that ensures that their influence will be con-
tained within the museum while allowing them, too, to contribute
a small part of its audience.

Specialist advice is particularly useful in the development of a
project, and should be taken full advantage of at this stage in the
management process. But specialists are not museum people: they
know about their subject but now how to communicate it
through museums. They have a role helping to ensure that what
the museum communicates is, as far as possible, true, but their
role beyond this has to be contained. One of the most frequent
reasons why museums fail to communicate to a wider public
today is that specialists within and outside them have too much
influence and produce displays for themselves and their small,
peer groups. The museum, itself, has to have a broader agenda.
The chart attempts to illustrate this in diagrammatic form.

A museum's job is to reach as many people as possible. To do
this it has to reach out to new visitors. It will only do so by being
capable of change and development. To achieve this, everyone in
the museum will need to feel motivated and be able to take the
initiatives when necessary to achieve this development. When this
happens, when all the people in museums are pulling together,
then the museum will achieve remarkable things and realise its
full potential as a creative force in society.

3

Management of Museums in the 1990s: Governments and Organizational Reform

D.J.G. GRIFFIN and M. ABRAHAM

CHANGES IN MUSEUMS

Museums are often regarded as specialised kinds of organizations, staffed by scholars and other professionals who deal with what are sometimes seen as esoteric matters. They are professional bureaucracies (Mintzberg, 1983, 1989, 1991), dominated by professionals hired from outside who are influential in setting the agenda of the organization, often by appeal to professional values shared with people outside the museum rather than colleagues in the organization (Newlands, 1983; Griffin, 1987, 1988). As such, museums often are considered to be in need of the application of 'good business practice'.

Governments are frequently involved in funding or managing museums or both, and have often introduced organizational reforms into museums. (In this paper the term 'organizational reform' is intended to refer to changes affecting the organization as a whole; Government spokespersons use the term 'government reform agenda' to refer to changes intended to deliver better service to the taxpayer at a reduced cost.) Although such reforms allegedly have been based on reform in commercial business (for-profit) organizations, in reality they mostly emphasize rational economics and its attendant managerialism. Sometimes non-government museums and similar organizations, for which Boards alone are accountable, have adopted the same reform agendas.

Thus the recent history of museums is characterized by reductions in funding leading to attempts to diversify the funding base as well as downsizing and restructuring. Boards have brought people with business backgrounds more frequently to their mem-

45

bership and, at the extreme, redefined the role of the chief execu-
tive to concentrate on fundraising more than the core business
(Nowlen, 1994). A number of accounts of changes in museums
have been given by Janes (1995), Emery (1990a, 1990b) and
Gurion (1995). Various essays on aspects of management in
museums (for instance Moore, 1994; Griffin, 1991a *et seq*), eco-
nomics (Pearce, 1991) and public programs concerning cultural
issues (Karp and Lavine, 1991) elaborate current concerns.

Science centres differ from museums in not having collections
of objects but importantly do not differ in one of their principal
aims, education (Friedman, 1996); there is argument that some of
them have moved too far towards the theme park end of the edu-
cation/entertainment continuum but that is not necessarily a criti-
cism confined to science centres. Aquaria, like zoos, resemble
science centres in many features. As newer organizations more
focussed on the visitor, science centres and aquaria may not be so
strongly dominated by the professional bureaucracy as are the
more traditional museums.

The recent past has also involved greater attention by museums
and similar organizations to visitors (or customers), with many
studies and evaluations undertaken of the total visitor experience
and of public programs (Falk and Dierking, 1992; Silverman,
1991); staff now commonly receive customer service training.
Education and understanding the nature of the learning experi-
ence are major issues (Falk and Dierking, 1995). Family visits, an
important component of all visits, are dominantly social experi-
ences undertaken for enjoyment and undoubtedly are experiential.
Museum visits lead to learning (Hein, 1995; McManus, 1987,
1988; Hooper-Greenhill, 1994; Bicknell and Farmelo, 1993;
Borun, Chambers and Cleghorn, 1996) but how is not always
clear; intrinsic motivation is an important factor (Csikszentmiha-
halyi and Hermanson, 1995).

Some of the changes in museums have led to accusations of
excessive movement towards entertainment through blockbuster
exhibitions, neglect of the collections through separation of cura-
tors from collection management and their replacement by collec-
tion managers. Assertions have been made that these changes are
driven by people not qualified in any of the functional disciplines
forming the core business of the museum and that such a change
by itself is a matter of great concern. Controversy over exhibi-

tions have also dominated some agendas and intervention by pressure groups have aroused considerable interest world-wide. Recent events at the Smithsonian Institution's Air and Space Museum concerning the Enola Gay exhibition (Archibald, 1996) and National Museum of American History and its 'Science in American Life' exhibition (Lewenstein, 1996) illuminate those particular controversies.

AIMS OF THIS PAPER

This paper aims to demonstrate that government-driven reform is based upon philosophies and requirements which are often diametrically opposed to those which characterize effective management practices in museum organizations. Indeed, that government-driven reforms often limit the potential establishment of these effective practices. We would thus hypothesize that there would be a significant difference between government and non-government museum organizations in their practices. In this paper we therefore review and contrast the prevalence of effective management practices across both government and non-government museums and similar organizations through a study of 30 organizations in four countries.

REFORMS IN THE COMMERCIAL SECTOR

There are now a plethora of papers and books – too numerous to cite – on organizational change and the role of leaders in effecting change. Although some of the material (such as Peters and Waterman's best selling *In Search of Excellence*) is anecdotal, on the whole there has been genuine understanding of the processes needed to bring about successful organizational change. These processes highlight such factors as the role of leadership and of the board of directors, vision and ideology, emphasis on people and focus on teamwork, flexibility, competence building and learning from past experience and other organizations rather than attention principally to traditional structural forms. (The literature cited below, whilst focussing on the commercial (or forprofit) sector, for the most part implicitly relates also to the nonprofit sector.)

THE LEADERSHIP ROLE

In a series of papers, Bartlett and Ghoshal (1994, 1994b, 1995a, 1995b) examined the changing role of top management through a study of 20 leading European, US and Japanese companies over five years. They identified the necessity for organizational leadership to (a) move beyond focussing on strategy to defining purpose for the organization (b) beyond structure to process and (c) to a focus on people rather than systems. Leaders need to model behaviour which aims at managing meaning and at developing the appropriate culture (Bennis and Nanus, 1985; Nanus, 1989; Schein, 1983; Kouzes and Pozner, 1995). For example, Schein (1983: 21) makes the point, 'the process of embedding a cultural element – a given belief or assumption – is a 'teaching' process, but not necessarily an explicit one: only if the group shares the perception that the solution is working will that element be adopted and only if it continues to work will it come to be taken for granted and taught to newcomers. It is only through modelling the desired behaviours that culture can become embedded.'

Burke and Litwin (1992) provide a model of organizational performance and change. Their model distinguishes between transformational and transactional variables. By transformational they mean 'areas in which alteration is likely caused by interaction with environmental forces (both within and without) and will require entirely new behaviour sets from organizational members'. Transformational change emanates from astute leaders 'who scan their organization's external environment, choose the forces they wish to deal with and take action accordingly' (Burke and Litwin, 1992: 529–30). Burke and Litwin highlight three transformational variables – leadership, purposes and culture. Effective transformational leadership in times of change involves defining and shaping the other two variables. Leadership is therefore associated with transformational change through executives providing overall organizational direction and serving as behavioural role models for all employees. Transactional variables based on short-term reciprocity among people and groups is more within the purview of management than leadership.

Dunphy and Stace's (1992) study of Australian organizations in transition found that transformational leaders created a new vision for the future of their organization, communicated the vision powerfully to stakeholders and implemented the vision

throughout the organization (p. 154). Further, Dunphy and Stace suggest that the leadership needed for organizational transition must be a combination of transformational and transactional leadership (p. 204).

THE ROLE OF BOARDS

The situation of Boards of Directors must be one of the most intractable problems facing government and business alike. Firms succeed or fail, inquiries are held and reports written. Yet the same problems emerge and the same solutions are advocated. The serious problems in both commercial business and nonprofits mostly seem to concern the way people behave. Business, like other organizations, finds it difficult to minimize risk and cut costs at the same time. Townsend (1970: 92) observed that boards 'are supposed to be a tree full of owls – hooting when management heads into the wrong part of the forest. I'm still unpersuaded they even know where the forest is'. We deal more extensively with boards elsewhere (Griffin and Abraham, in press), but some points are worth emphasizing here.

Aram, Cowen and Weatherhead (1995) argue that the role and effectiveness of the corporate board are largely functions of the relationship between the directors and the firm's CEO. 'The difference between an effective and an ineffective board is often evidenced by a difference in the openness of directors and CEO's to each other's influence.' Duleqicz, MacMillan and Herbert (1995) conducted a major study aimed at providing some guidelines for boards to become more effective. They say, 'An effective board is more than the sum of its individuals; it must work together effectively as a group, even as a team. It is not only a matter of individual skills, knowledge and competencies – their attitudes and values need to "gel" and there must be sufficient mutual trust and respect for the necessary objectivity and constructive conflict to take place.' (Duleqicz, MacMillan and Herbert, 1995: 8) Similar observations have been made about nonprofits (see below).

VISION AND IDEOLOGY

It is clear that the best companies, rather than desperately seeking efficiencies, have instead concentrated on values and been driven by a shared vision, even a capacity to uniquely envision the future

(Vaill, 1993). Collins and Porras' (1994) intensive six year study of the founding, growth and development of successful companies that have stood the test of time, found visionary companies (in 17 of the cases) were guided more by a core ideology – core values and a sense of purpose beyond just making money – than were the comparison companies. This core ideology gave the company a strong sense of identity and a thread of continuity that held the company together in the face of change. The architects of vision- ary companies did not trust the good intentions of value state- ments alone but built an almost cultlike culture around their core ideology. Visionary companies set audacious goals and adopted all sorts of strategies and approaches to stimulate the drive for pro- gress and creation of an environment that encourages people to experiment and to learn – to try things and to keep what works.

Experimentation was encouraged so that continuous improve- ment became a way of life. 'Companies that enjoy enduring success have core values and a core purpose that remain fixed while their business strategies and practices endlessly adapt to a changing world' (Collins and Porras, 1996: 65). Harmon's (1996) study talks of upgrading values in all aspects of the business in order to sustain growth, of value-driven driven planning uniting quantitative and qualitative aspects of the business, of embedding values in the performance appraisal system and of business units defining their own values.

Bartlett and Ghoshal (1994: 79–81) talk about changing the focus of top management from strategy to purpose. They empha- size that,

> A change in management doctrine is needed ... senior managers must change their own priorities and ways of thinking. Beyond designing corporate strategy, they must shape a shared institutional purpose.... This means creating an organization with which members can iden- tify, in which they share a sense of pride, and to which they are willing to commit. In short, senior managers must convert the con- tractual employees of an economic entity into committed members of a purposeful organization.

Successful organizations actively seek to understand the indus- try they are in, a point made very strongly by Hamel and Praha- lad (1989, 1994) who talk of 'industry foresight'. 'A visionary company is like a great work of art. You can't point to any one

single item that makes the whole think work; it's the entire work – all the pieces working together – that leads to enduring greatness.... In business, as in art, what distinguishes leaders from laggards, and greatness from mediocrity, is the ability to uniquely imagine what could be' (Hamel and Prahalad, 1994: 27).

In visionary companies customers are the focus and may even be involved in strategic planning (Wall and Wall, 1995; Porter, 1996). Certainly they are the focus of the benefits: Hamel and Prahalad (1994) talk of the unmet needs of yet unserved customers. Companies may compete, collaborate or both (Burton, 1995; Bowman and Carter, 1995) but above all they are interested in learning from others and their own past experience and in continuous improvement (Beer and Eisenstat, 1996). Successful organizations benchmark their performance not only against others in the same industry but others involved in similar processes: there is management intervention when needed to, amongst other things, 'prove' that the required gains can be met (Cooper and Markus, 1995).

Smirchich and Morgan (1982) stress the role of leadership in the management of meaning and the shaping of organization culture. They indicate that the person most easily recognized as an organizational leader is one who rises above and beyond the specification of formal structure to provide members of the organization with a sense that they are organized, even amidst an everyday feeling that at a detailed level everything runs the danger of falling apart. Thus 'successful corporate leaders who give direction to the organization in a strategic sense frequently do so by providing an image or pattern of thinking in a way that has meaning for those directly involved' (Smirchich and Morgan, 1982: 260). Effective leadership thus depends upon the extent to which the leader's definition of the situation serves as a basis for action by others. Goals that *are cohesive, understood and supported by staff* provide such an operating definition of the situation and a basis for action.

It is also most important for goals not to be focused merely on quantitative outcomes. Scholtes (1988: 1–4, 5), speaking of managing by results, says,

> Frequently, the measured goals are unattainable because they lie beyond the system's real capability. People are thus forced to play the

game or *fudge* the figures to look good. The charade fosters guarded communication and sometimes minor, sometimes major, dishonesty. The worst shortcoming of management by results is *fear of what will happen if the goals are not met* – losing a job or promotion. The more rigid the controls, the deeper the fear. Management by results encourages *blindness to customer concerns*. Use of this approach focuses an organization inward, rather than outward at the world in which the customer operates. Accomplishment comes from meeting a numerical goal, rather than delight in providing a product that works and satisfies customers.

EMPHASIS ON PEOPLE

Prominent writers in the management field have emphasized the importance of regarding people as the prime resource of the organization. Bartlett and Ghoshal (1995b) stress the importance of focussing on people rather than systems and Pfeffer (1988) argues that achieving competitive success through people involves fundamentally altering how we think about the workforce and the employment relationship. It means achieving success by working with people, not by replacing them or limiting the scope of their activities. It entails seeing the workforce as a source of strategic advantage, not just a cost to be minimised or avoided. Firms that take this different perspective are often able to successfully out-manoeuvre and outperform their rivals. Heller (1994: 42) maintains that, 'managers will need to practice co-operation and collaborations with everybody inside and outside the firm ... the environment will encourage this by devolution of power and delegation of duties – right down to the empowered, self-managing worker near the top of the inverted pyramid.' Similarly, Carnegie *et al* (1993: xxxv) found, in a survey of Australian businesses, that, first and principally, 'innovation ... in the 1990s is about people and enterprises, not about science and technology ... the outcome of productive employee relations is higher performance standards by the enterprise, not lower wages. Innovation is largely the result of employee relations, not exploitation'.

Successful organizations manage to achieve an alignment between organizational and staff values (Attracta Lagan reported in *Business Review Weekly* September 26, 1994: 84). There is attention to recruiting people with the appropriate skills and with attitudes that match the organization's values – part of the

approach referred to as Theory Z (Pascale, 1978; Pascale and Athos, 1981) – as well as to socialisation processes that develop appropriate behaviours and attitudes in staff within the first three to five years of their employment with the organization. This is less of an issue in professional bureaucracies where the drive of individual 'professionals' overrides all. (Whilst most academic organizations would eschew employment and promotion approaches which emphasize 'fit' of the staff member with the organization's culture, such an approach is followed by a number of the best organizations in this study; certainly disregard for such 'fit' can lead to the kinds of disruptive behaviour in the face of change seen in a number of natural history museums in particular.)

There is also an emphasis on recruiting managers from inside the company: Collins and Porras (1994) found only four individual incidents in the combined 1700 year history of the 18 top companies when a CEO was recruited from outside.

Successful companies (and nonprofits) set goals which are not easy to achieve. They value the creativity of their staff and are often very informal and very flexible. Trust is important to everyone and so is support. Ghoshal and Bartlett (1994: 92) conclude that the primary dimensions of organizational context are the four behavior-forming attributes of discipline, stretch, trust and support. 'In turn, these four dimensions affect the three behavioral features that are central to management activity: distributed initiative, mutual cooperation and collective learning.... Managers must expand their focus from devising formal structures to developing organizational processes. And more than just managing systems, they must develop people'.

> While there will never be job security, people will have a job with the company as long as they add value to the organisation, and they are continuously responsible for finding ways to add value. In return, the employees have the right to demand interesting and important work, the freedom and resources to perform it well, pay that reflects their contribution, and the experience and training needed to be employable at that company or elsewhere. (O'Reilly, 1994)

Pfeffer (1996) has pointed out that although there is little disagreement that high performance work practice including contingent compensation, highly selective recruitment, substantial

investment in training, employee participation, higher wages and reducing status differences produce outstanding results, few organizations adopt these practices. These ways of managing fall outside the 'point of view' or 'focus of attention' of most managers because of four factors in particular:

- a concern with strategy and financial affairs – the latter influenced by investors and CEOs with financial rather than operating or marketing background who focus on the short-term and the fact that changes require a substantial investment for returns that take time to appear and cannot be measured by typical means;
- the model of management that has evolved which places emphasis on the CEO as the chief source of strategic vision and wisdom rather than the actions of employees:
- the 'tough person' model of the CEO and the associated difficulty in changing existing practices because recognizing the need to change can be considered acknowledgment of shortcomings of the CEO; and
- the lower status and narrow career paths of human resource managers who would be involved in implementing these practices.

Pfeffer suggests a number of approaches to overcome barriers to change:

- benchmarking and understanding the contributing processes in other organizations;
- changes in structure, workplace or systems;
- aligned rewards;
- career paths which give wide experience; and
- understanding that doing what is easy, or what others are doing, are seldom ways to earn substantial returns.

STRUCTURE

Empowerment has long been regarded as a desirable structural/ management characteristic of successful organizations (Kanter, 1983; Conger and Kanungo, 1988; Randolph, 1995) as has the use of self-managing teams (Kolodny and Stjernberg, 1993; Scholtes, 1989). In recent writings on organizational forms, particularly network organizations and strategic alliances, there is a

recognized need for flexibility and responsiveness (Limerick and Cunnington, 1993). The creative potential of staff is recognized as the driving force of change and success and innovation is a frequent focus as organizations try to grapple with ambiguity (Drucker, 1992).

Lower wages and decline in employee conditions are, according to many, counter productive (Binder, 1993; Reich, 1991). Indeed, Reich (in Binder, 1993) asserts all nations have suffered more wage inequality but countries with wage setting institutions, such as collective bargaining, have suffered less. The real key is to add to collective bargaining a strong commitment to training and education and to institutionalise labour/management co-operation in improving skills and productivity which would pay off in higher profits and higher wages. Deschamps (1995) emphasizes careful consideration of what the company wants to stand for, what it wants its products to look like and mean to the customers it wants to serve. Small companies like the small R&D firm IDEO obviously are more flexible than large firms. IDEO emphasizes smallness, flexibility, multiple disciplines and cross fertilization (Perry, 1995).

Bartlett and Ghoshal (1995: 86) say,

> The hierarchical organization based on the strategy-structure-systems doctrine of management no longer delivers competitive results. Top-down structure ... gives managers tight control and allows companies to grow [but] also fragments resources and creates a vertical organization that prevents small units from sharing their strengths with one another. The job of management will be to promote three core organizational processes: frontline entrepreneurship, competence building, and renewal. Companies must shift from top-down direction by managers who set the company vision and instead should encourage bottom-up initiatives from operating units, which are closest to customers.... To prevent their companies from becoming too rigid, they must create an environment that asks employees to challenge conventional wisdom.

Successful companies emphasize teamwork (Hitchcock, 1992; Bradford, 1993; Guzzo and Dickerson, 1996; Dunphy and Bryant, 1996) and the 'learning organization' managed for performance so as to result in desired organizational outcomes (Senge, 1990; Garvin, 1991; Koffman and Senge, 1993; Hitt, 1996). A study of 553 global manufacturers across a wide variety of indus-

tries found that what really separates the best performers from the rest was how people worked together, how decisions got made and how leadership was practiced (Lublin, 1993), in other words, the role that senior executives played (Hout and Carter, 1995).

DOWNSIZING, OUTSOURCING AND THE DRIVE FOR EFFICIENCIES

Much of corporate life is reported as driving for efficiencies and emphasis on the financial bottom-line through downsizing (with attendant reductions in the conditions of employment) and outsourcing. However, these trends have brought mixed results. The results of downsizing have been poor. Right Associates (1992) found that some 66 per cent to 75 per cent of companies which downsized did not achieve increased profitability or productivity: companies must investigate alternatives, define the new organization, plan the downsizing, develop a communication plan and nurture the survivors. 'In a nutshell', by downsizing, 'managers were looking for a "quick-fix" solution to declining productivity.... Downsizing by cutting people was often the only strategy used, and it has been found wanting' (Horin, 1994: 14). James (1996: 70) observed, 'cutting a swathe through management is a fad that has done a lot of damage and is a characteristic of low-quality thought, a tendency to bring together concepts that sound similar yet are very different.'

Outsourcing may seem a way to increase efficiencies but there are hidden costs: if core competencies, the skills and knowledge that contribute significantly to the organization's competitive advantage, are outsourced then the real significance of the loss will be obvious in the longer term and could well be highly critical (Hendry, 1995). Careful procedures need to be in place to deal with outsourcing productively (Quinn and Hilmer, 1994).

APPLICABILITY OF EFFECTIVE MANAGEMENT PRACTICES TO NON-PROFITS

Notwithstanding the different environment in which nonprofit organizations work and their different nature, many of the factors which distinguish successful companies seem to be equally relevant for them. There are several major treatments of them.

Herman and Heimovics (1991) emphasize Board-Executive relationships: they quote Brian O'Connell, President of Independent Sector, observing that 'the greatest source of friction and breakdown in voluntary organizations ... relates to misunderstandings and differing perceptions between the board and staff directors'. Knauft, Berger and Gray (1991: 1) list the four hallmarks of excellence as a clearly articulated sense of mission, a leader who truly leads the organization and creates a culture that leads the organization to achieve its mission, an involved and committed volunteer board and an ongoing capacity to attract sufficient resources. Herman and Associates (1994: 139) observe that the normative literature on nonprofit boards assume that they conduct the organization's affairs as a steward of the public interest in a manner consistent with the wishes and needs of the larger community. 'The actual performance of boards often falls short of the ideal ... [and boards] seldom completely fulfil their assigned duties and roles'.

Carl and Stokes (1991 et seq), in a study of a small group of community service organisations, found keys to organizational excellence to include commitment to a focused vision, innovation, respect for and commitment to the people served, a nurturing work environment, high standards for outcomes, a high-functioning board of directors and high levels of collaboration. Moreover, a high value was placed on line staff, feedback, teamwork, trust and rewards and the celebration of achievement. Each of the eight organizations they studied emphasized accountability and high standards. Krug (1992) found successful arts organizations in North America to have simple, clear and flexible management and operational systems and action-oriented and realistic strategies which are community-oriented and flexible.

GOVERNMENT APPROACHES TO REFORM

Governments in western industrialized nations have probably always been heavily dominated by attention to financial issues. In the last two decades they have adopted classical or rationalist economic approaches leading to reductions in outlays achieved by downsizing, outsourcing services, corporatizing and so on. Limited tenure contracts for senior executives are commonplace. Restructuring, near inevitable at times of changes of government,

has become more commonplace and invaded by the internals of departments and agencies. In some cases the aim has been to increase communication by removing unnecessary layers of organizations. This strategy has often been implemented with limited sophistication and with little consideration of co-ordinating mechanisms other than supervision (Mintzberg, 1983) or of situation appropriateness.

Performance assessment and performance indicators, accrual accounting and strategic planning have been introduced. There has been above all a push for increased accountability – or 'value for money'. As well, customer service is emphasized (such as the 'Citizens' Charter' in the UK), policy formulation and service delivery have been separated and various measures to exert downward pressure on wages have been adopted such as decentralized bargaining, reduced pay and employment protection, performance-related pay, abolition of automatic pay increases and increased use of part-time staff and temporary contracts (Flynn, 1995a, 1995b).

Since governments have to satisfy a huge range of interests and the central purpose is to achieve adherence to policies across all domains, compliance is still a dominant issue and central government is still involved in seeking that, even so far as corporatized and privatized entities are concerned. The new jargon is 'products for customers' rather than 'services for citizens'. However, governments have generally not tried to find out what it is that actually makes organizations successful in Europe or Japan or even the USA. Rather, the simple view appears to be that efficiency produces growth, cutting costs is therefore the medicine and managers need to be made accountable for it. In continental Europe few of these reforms have been followed and, in the UK at any rate, there has been no evaluation of the impact of these procedures (Flynn and Strehl, 1996).

Apart from the compliance issue there has been considerable change in the role of government with respect to the provision of services to the community. The UK position has involved the privatization and splitting up of utilities such as transport, water and energy. The philosophical position is that government should be small: no inherent merit is seen in government owned enterprises and there should be no different rules for the public and private sectors except in respect of community service obligations;

government trading enterprises should be as efficient as the best of any utilities in the world. Government is more and more inclined to the view that public goods are few and individuals should pay for their own private gains. Moreover, the view has been that what government ought to be about is the increase of wealth 'for all'.

These approaches have been heavily criticized in some quarters as driven by the economists or accountants from business-oriented educational backgrounds so encouraging particular perspectives on economic problems to the exclusion of alternative points of view. Labour market deregulation is seen as appropriate, trade unions as inimical to progress and wages and salaries as being excessive compared with profits (Pusey, 1991). Staff are treated as resources for deployment without recognition of their development potential or support needs and commitment to social services may decline (McInnes, 1990). Baker (1989a, 1989b) has also commented on the Australian situation.

> The key concepts of economics, such as marginal utility, resource costs, prices as a determinant of demand and so on, which together with the assumption implicit in many economic models that "other things are equal" underpin a world of economic rationality. In turn this underlies so much of our managerialist thinking in common with other hard disciplines such as the pure sciences and engineering and supports a world view in which the richness of the variations, and foibles of human behaviours often have little place. (Baker, 1989a: 55)

Stewart and Walsh (1992), reviewing various change and reform initiatives in the UK public sector such as competitive tendering, separation of the purchaser role from the provider role, the growth of contractual arrangements and the creation of [internal] markets or quasi-markets, point to the danger of supplanting the public sector 'model' with that from the private sector and outline the limitations of approaches such as performance measurement and the language of consumerism. Dixon (1996) argues that public management education has focused too narrowly on the skills and knowledge needed by public services managers and has failed to tackle the challenge of preparing managers to manage in an environment which contains a number of contradictions and paradoxes. Hoggett (1996) believes that the combination of bureaucratic and post-bureaucratic elements is

politically and organizationally dysfunctional: the move towards contracting services has been driven by the need to get 'more for less' and has led to a highly productive workforce but with less commitment to the organization.

The problem with government reform is not that the instruments of change are wrong in themselves but that 1, change is driven from a distance without understanding of the specific context for a particular organization; 2, the nature of the desired change is conveyed in writing and the feedback on whether the change has occurred is also conveyed in writing; and 3, there is no incentive to change because the benefits, if any, are returned to central government.

MUSEUMS AND GOVERNMENT REFORMS

These attitudes have flowed over to museums resulting in declines in government allocations and demands for restructuring and repositioning the business in line with the new philosophies. Governments seldom concentrate on properly defining the business of the agency. Instead of real understanding of the business, statements of aims and powers in the museum's enabling legislation may be relied on as defining the role, in spite of the fact that such statements are seldom any more helpful than general definitions of museums. Governments have mandated strategic planning and attempted to ensure that accountability is reflected in the contents of annual reports; they have also sought to introduce performance indicators (Ames, 1985, 1991; Jackson, 1991; Weil, 1994, 1995) which principally concern operations (or efficiency) rather than strategy (or effectiveness). Governments may introduce new procedures or tinker with the organizational structure without any real assessment of how the charges may contribute to organizational effectiveness. Yet an assessment of the right change action and its contribution to effectiveness requires both a knowledge of the business and tailoring of the change strategy to the specific demands of the situation. It is doubtful whether the reform agendas which have been introduced produce any significant improvements in effectiveness and may well have the opposite effect.

In the UK, Canada and Australia, Boards are established to ensure that the performance of the museum meets its legislated

goals and to represent community interests. However, members may not be clearly informed as to their role and the staff, including the senior management, may be employed by government and not the Board, so blurring the lines of accountability and responsibility. The reductions in annual allocations are applied to museums as they are to all of government with the same demand to live within the means. Rearrangements of funding and control, such as 'untying' in the UK which allows museums to determine their wages and salaries structures, may be introduced without concern for the financial consequences including the additional strains on the budget. This in general follows the notion that the restructured and empowered museum is perfectly capable of – and certainly responsible for – managing its own resources within the funds available.

In the UK, substantial funds – for capital outlays only – from the Heritage Lottery Fund are being distributed to cultural and heritage organizations. Funding for the additional operational load generated by the capital developments are not usually supplied (*Museums Journal*, March 1996: 5 and 7). Similar approaches, although not always as extreme, are being applied in Canada (where the reductions in funding are more severe) and in Australia (where mostly the reductions in funding have been less severe). US organizations, on the other hand, are almost all private nonprofits operating in an environment distant from government where community support is expected and government funding has been a recent arrival. However, to the extent that government funding is important, reductions at Federal and State levels have caused problems similar to those in other countries.

DESCRIPTION OF THE STUDY

The study involves 30 museums of all kinds including science centres and aquaria from Australia, Canada, the United Kingdom and the USA chosen because of their representative nature as to subject – science, history and art. Assessments of each organization were undertaken by 'experts' (see Griffin, Abraham and Crawford, in press). This paper is concerned principally with the differences between government and non-government organizations in the study and the assessments are therefore not dealt with further here.

A 75 item questionnaire was filled out by staff at each partici-
pating institution and face to face interviews were conducted with
managers and with staff in most of the organizations. In con-
sidering the scores for all questions a low score is treated as posi-
tive or good. Low scores on questionnaire items characterize the
best organizational practices.

The survey
The survey comprises a questionnaire of 75 statements or items
arranged in ten groups or sections; the first eight were demo-
graphic in nature. Respondents (staff) were asked to indicate a
level of agreement with the statements ranging from strongly
agree scored as 1 through strongly disagree scored as 5; don't
known was scored as 6. A narrative section of four questions at
the end asked respondents to comment on any part of the ques-
tionnaire and any item not raised and to identify three issues
important in the future and three areas in which the organization
lacks sufficient knowledge and/or skills to deal effectively with
future opportunities and problems.

Distribution of the survey
At each participating organization, up to 25 staff in the ratio of 1
senior manager (CEO or persons reporting directly to the CEO)
to 2 middle managers (others with line responsibilities) to 2
operations people were asked to fill out the questionnaire. The
respondents were chosen by each organization's management;
responses were confidential.

A total of 531 responses to the questionnaire were received
from the 30 organizations.

Analysis of the results
The responses to the questionnaires were also averaged for each
item for each organization. The responses to the questionnaires
from two groups of organizations – non-government and govern-
ment – were compared using a one-tailed t test on the basis that
the assumption being tested is that the non-government organiza-
tions will achieve a better (i.e. lower) score. (The analysis of dif-
ferences in *questionnaire responses* between government and non-
government organizations discussed *in this paper* does not include
two Canadian organizations which have changed their association

with government in the last 10 years. One organization in the USA and one in Australia which also have had a varied history are likewise not included.)

Results

Of the entire sample five of the nine best assessed organizations are non-government (and all are from the USA) – whilst a further two (both Canadian) have been independent of government in the lats ten years or are now. Of the 10 worst organizations, eight are government (and only one is from the USA). This difference is significant!

Comparison of those organizations which are part of government with non-government organizations across all items reveals no less than 31 items which significantly distinguish the latter as performing better. (Tables 3.1–3.3 show the average responses to the questionnaire statements from the two groups of organizations.) The items distinguishing government and non-government organizations come from all sections of the questionnaire including information technology (which usually does not feature as a distinguishing attribute). However, five of the 12 significant items distinguishing the best from the worst organizations in the entire sample (Griffin, Abraham and Crawford, in press), including one Communication item (surprisingly) – rapid information transfer (42), three Public Program items – attention to problems with exhibits (51), contribution of evaluators to future programs (56) and the basis of allocating advertising resources (60) – as well as the level of commitment (training, 70), are not amongst the items distinguishing non-government organizations.

The 31 items with significant differences between government and non-government organizations have been arranged in Tables 3.1, 3.2 and 3.3. A complete list of all items in the questionnaire is shown in tables 3.4 through 3.8 which compare the items distinguishing the two groups. An examination of these tables follows:

Table 3.1 – Leadership, The Board and Purposes
- Significant Leadership items relate to senior management a) developing a vision, b) working effectively as a top management team and c) modelling appropriate behaviour. This is very much in line with writings on leadership discussed in this

TABLE 3.1: Non-government (NGOVT) and government (GOVT) organizations compared: means (avge) and standard errors of eight non-government and 18 government organizations for 9 items concerning leadership, the Board and Purposes. PROB (t) is the probability that the two samples are the same as measured by student's t test. The column at the right (AVGE ALL) is the mean for the entire sample of 30 organizations. Two of the items (18 and 67) shown in **bold**, are also items distinguishing the best and worst organizations in the entire sample.

QN SECTION	QUESTION DETAIL	NGOVT AVGE	ST ERR	GOVT AVGE	ST ERR	PROB (t)	AVGE ALL
8 LEADERSHIP	Senior managers have championed a vision for the organization	1.88	0.172	2.26	0.089	0.0379	2.10
11 LEADERSHIP	Senior managers work together effectively as a team to achieve the goals of the organization	2.36	0.226	3.10	0.141	0.0079	2.84
13 LEADERSHIP	Senior managers model appropriate behaviour for the rest of the organization	2.48	0.230	3.16	0.111	0.0125	2.94
66 LEADERSHIP	The CEO and senior management group set a clear vision with long planning horizons	2.22	0.204	2.63	0.096	0.0511	2.55

14	THE BOARD	New members of the governing Board are chosen in consultation with the Chair of the Board and the CEO	1.31	0.129	2.39	0.172	0.0001	2.08
17	THE BOARD	There is substantial and visible trust between the Board and the CEO	1.89	0.164	2.51	0.128	0.0044	2.60
18	THE BOARD	**Members of the Board contribute actively to fundraising**	2.24	0.202	3.35	0.177	0.0003	3.01
67	THE BOARD	**Board members actively use their knowledge, skills and commitment to further the organization's mission**	2.42	0.211	2.99	0.120	0.0180	2.82
19	PURPOSES	Goals and objectives are devised to ensure that those who should benefit from the organization's activities are satisfied with what we produce	2.05	0.128	2.31	0.103	0.0702	2.19
	AVERAGE		2.09	0.185	2.75	0.126	0.0225	2.57

TABLE 3.2: Non-government (NGOVT) and government (GOVT) organizations compared: means (avge) and standard errors of eight non-government and 18 government organizations for 11 items concerning purposes, structure and training. PROB (t) is the probability that the two samples are the same as measured by student's t test. The column at the right (AVGE ALL) is the mean for the entire sample of 30 organizations. Three of the items (22, 25 and 38) shown in **bold**, are also items distinguishing the best and worst of the entire sample.

QN	SECTION	QUESTION DETAIL	NGOVT AVGE	ST ERR	GOVT AVGE	ST ERR	PROB (t)	AVGE ALL
20	PURPOSES	Objectives for divisions/departments/sections clearly integrate with those for the organization as a whole	2.28	0.198	2.65	0.123	0.0722	2.49
22	**PURPOSES**	**Goals and objectives for the organization are understood by staff**	2.59	0.189	2.89	0.092	0.0479	2.80
23	PURPOSES	The organization's goals and objectives are supported by staff	2.26	0.172	2.75	0.084	0.0131	2.56
25	**PURPOSES**	**There is encouragement in goal setting to pay attention to the quality of the process as well as to quantifiable outcomes**	2.21	0.137	2.55	0.086	0.0282	2.45
68	PURPOSES	The goals and objectives of various departments/sections are cohesive and well integrated with those of the organization as a whole	2.59	0.243	3.03	0.095	0.0620	2.85

30	STRUCTURE	Staff are able to go to people in other sections to get help in fixing problems affecting their work without having to go first to a supervisor or manager for permission	2.25	0.156	2.55	0.109	0.0709	2.35
32	STRUCTURE	Staff are encouraged to develop respect for the skills and contribution of others in the organization	2.14	0.189	2.52	0.090	0.0490	2.39
33	STRUCTURE	There are well-developed opportunities for management and staff to work in a variety of different jobs	2.82	0.223	3.43	0.112	0.0157	3.15
69	STRUCTURE	Structure is flexible, responsive and shows co-operation between its parts	2.55	0.174	3.02	0.086	0.0180	2.84
38	**TRAINING**	**There is an established system for induction of all new employees**	2.05	0.215	2.74	0.165	0.0113	2.62
39	TRAINING	Performance of staff is assessed at regular intervals	1.50	0.119	2.41	0.233	0.0010	2.14
	AVERAGE		2.30	0.183	2.78	0.116	0.0354	2.54

TABLE 3.3: Non-government (NGOVT) and government (GOVT) organizations compared: means (avge) and standard errors of eight non-government and 18 government organizations for 11 items concerning training, communication, public programs and information technology. The column at the right (AVGE ALL) is the mean for the entire sample of 30 organizations. PROB (t) is the probability that the two samples are the same as measured by student's t test. Two of the items (72 and 53), shown in **bold**, are also items distinguishing the best and worst organizations in the entire sample.

QN	SECTION	QUESTION DETAIL	NGOVT AVGE	ST ERR	GOVT AVGE	ST ERR	PROB (t)	AVGE ALL
40	TRAINING	Rewards are based on contribution to pre-established and known standards rather than vague opinions on the worth of individual effort	2.64	0.158	3.24	0.134	0.0047	3.09
41	TRAINING	Staff have been trained to operate effectively in teams	2.95	0.194	3.34	0.088	0.0480	3.21
71	TRAINING	Good work is recognized and equitably rewarded	2.67	0.200	3.14	0.095	0.0313	2.99
43	COMMUNI-CATION	Staff take an active interest in the information that is communicated to them	2.20	0.125	2.48	0.098	0.0533	2.40
44	COMMUNI-CATION	We have learned a great deal from past experiences and practices in this organization	2.44	0.173	2.74	0.089	0.0750	2.59

#	Category	Description						
45	COMMUNI-CATION	We are very interested in learning from what other organizations do well	2.05	0.126	2.33	0.099	0.0510	2.19
72	**COMMUNI-CATION**	**High sense of awareness, involvement and feeling part of the team**	2.62	-0.219	3.11	0.079	0.0317	2.92
53	**PUBLIC PROGRAMS**	**Visitors are provided with a variety of ways (interpretive strategies) in which to understand the meaning of the exhibits/programs**	1.94	0.117	2.29	0.117	0.0242	2.19
57	PUBLIC PROGRAMS	Exhibits and other public programs are developed by education, exhibition and other staff as well as research and curatorial staff working together	1.66	0.144	2.00	0.100	0.0360	1.89
62	PUBLIC PROGRAMS	Public program staff are accepted by others including research and curatorial staff as important contributors to the future of the organization	2.13	0.132	2.60	0.100	0.0046	2.41
64	INFO-TECHNOLOGY	Management of the collections makes maximum use of information technology to improve access by the public and other interested parties to knowledge of the collections	2.58	0.137	3.02	0.119	0.0138	2.93
	AVERAGE		2.35	0.157	2.75	0.102	0.0340	2.62

paper which stress the necessity for top management to develop and communicate a vision and to model behaviour which aims at managing meaning and at developing the appropriate culture in an organization (Bartlett and Goshal, 1994; Bennis and Nanus, 1985; Nanus, 1989; Schein, 1983; Kouzes and Pozner, 1988; Vaill, 1993).

• What distinguishes the significant from the non-significant Board items is the capacity of the board members to work closely with the CEO as an integral part of the top management team (Aram, Cowen and Weatherhead, 1995; Duleqicz, MacMillan, and Herbert, 1995; Herman and Heimovics, 1991; Herman and Associates, 1994).

• Significant Purposes items stress the devising of goals to benefit stakeholders.

In summary, the significant items on leadership, the board and purpose, stress a theme of cohesion. The board and senior management act as a cohesive team, setting a vision and direction which are integrated across all parts and levels of the organization. The board pulls its weight as members of the top management team through such activities as fund-raising. The organization members understand and accept these goals and do not experience any discrepancy between pronouncements and action since senior management 'walk the talk' and actively model desired behaviour for the organization.

Table 3.2 – Purposes (continued), Structure and Training

• Significant Purposes items stress understanding and support of goals by staff and the integration/cohesion of goals and objectives, both of which are crucial in defining direction for the organization (Smirchich and Morgan, 1982) and the focus on quality (Scholtes, 1988).

• Significant Structural items stress respect for the skills and contributions of others – which emphasizes teamwork rather than isolationism; empowerment (Conger and Kanungo, 1988; Randolph, 1995) and flexibility (Limerick and Cunnington, 1993). The prevalence of these characteristics in effective organization have been discussed in depth earlier in this paper.

• Significant Training items emphasize socialization of new employees and effective performance appraisals.

Table 3.3 – Training (continued), Communication, Public
Programs and Information Technology

- Significant Training items emphasize teamwork and rewards that are based on contributions. Such HR practices (including those in table 3.2) have the effect of building a performance based culture and on emphasizing fit between this culture and individual action in the workplace (Pascale, 1978; Pascale and Athos, 1981).

- Significant communication and learning items stress staff feeling part of the team and actively interested in the information transmitted; and the encouragement of a learning orientation. Again the theme of cohesion seems to emerge as far more important than items which stress 'innovation' (items 46, 48) or a rational decision making perspective (items 47, 49).

- Significant Public Program items again emphasize the theme of cohesion and working together to produce public programs (items 57 and 62) and providing avenues for the visitor to understand the collections through interpretative strategies (and use of IT – see next section on Information Technology). It is worth commenting that based upon the theme of cohesion, item 58 perhaps ought to be significant but is not.

- Significant Information Technology (IT) items seem to relate to satisfaction of the public and other interested parties who wish to gain knowledge about collections. IT expenditure or development philosophy does not seem to be a distinguishing feature.

Summary comments for Tables 1–3

It is obvious from these tables and the above comments that items which distinguish government from non-government organizations relate primarily to the transformational variables of Leadership, Purposes and Culture described in Burke and Litwin (1992). These authors maintain that these three variables have the greatest impact in shaping organization in times of change.

The importance of the Leadership and Purposes categories are directly evident. Through other categories of the questionnaire what is really significant is culture and cohesion. For example in Structure, the significant items do not concern the *type* of structure, use of teams, centralization/decentralization, etc. They really relate to cultural concerns for people – trust, self development,

and learning. This is directly in line with Bartlett and Goshal's (1994, 1995a, 1995b) comments on changing the role of top management from focusing beyond strategy to purpose; beyond structure to process and beyond systems to people. That a number of these features coincide with the kinds of points made by Pfeffer (1996) about successful organizations is also clear. Given these comments, the desirability of focusing on the quality of the process as well as the quantifiable outcomes (item 25) becomes fairly obvious.

Similarly, HR practices relate to all the attributes which go to shape an effective performance based and cohesive culture – induction, socialization, performance-based rewards, teamwork and recognition for contribution. The communication items emphasize cohesion through rapid transfer of information, involvement, teamwork and encouragement of a learning orientation. Even public program items stress the culture of working together.

DISCUSSION

From our analysis it is clear that non-government organizations are far more capable of developing the kind of attention to transformational variables than are government organizations. Given the comments which have been previously made about the functioning of government organizations this is perhaps not surprising. Government organizations have had a history of interference in leadership appointments, the appointment of Board members and the development of a 'compliance' culture – all features which are at odds with the significant themes emerging from the above comparisons.

Governments have mandated certain practices or forced their adoption through well known strategies and tactics tied to funding and ministerial responsibility. The argument advanced has been that these practices are appropriate: they increase accountability and they are the ones used by forprofit (commercial) businesses which after all are inherently more efficient (it is said). Apart from the fact that unlike governments, business does not have to satisfy all constituents all the time, the question is whether, if the practices are indeed ones which have been used by forprofits, they are the ones which have achieved improvements. In respect of that we can turn to the studies of successful compa-

TABLE 3.4: Leadership and Board items: those significant in distinguishing government from non-government are shown on the left; those not significant are shown on the right. (The items which distinguish the best organizations in the entire sample are shown in **bold**.)

QN	QUESTION DETAIL	QN	QUESTION DETAIL
8	Senior managers have championed a vision for the organization	9	Senior managers are concerned mainly with long-term, strategic issues
11	Senior managers work together effectively as a team to achieve the goals of the organization	10	The CEO spends substantial time seeking support from outside the organization in order to improve this organization's standing
13	Senior managers model appropriate behaviour for the rest of the organization	12	Senior managers give time and support to those staff who have trouble adapting to the new ways of doing things
66	The CEO and senior management group set a clear vision with long planning horizons	15	Knowledge and skills in industry practice and standards are important criteria for choosing members of the Board
14	New members of the governing Board are chosen in consultation with the Chair of the Board and the CEO	16	The Board concerns itself mainly with the long term vision of the organization
17	There is substantial and visible trust between the Board and the CEO		
18	**Members of the Board contribute actively to fundraising**		
67	**Board members actively use their knowledge, skills and commitment to further the organization's mission**		

TABLE 3.5: Items concerning Purposes and Structure: those significant in distinguishing government from non-government are shown on the left; those not significant are shown on the right. (The items which distinguish the best organizations in the entire sample are shown in **bold**.)

QN	QUESTION DETAIL	QN	QUESTION DETAIL
19	Goals and objectives are devised to ensure that those who should benefit from the organization's activities are satisfied with what we produce	21	Allocation of resources to projects is based on a careful assessment of the value of the outcomes to the future of the organization
20	Objectives for divisions/departments/sections clearly integrate with those for the organization as a whole	24	Staff are expected to understand/recognize the appropriate quality standards to be achieved in their work
22	**Goals and objectives for the organization are understood by staff**	26	We aim to ensure that completed projects meet the required standards first time
23	The organization's goals and objectives are supported by staff		
25	**There is encouragement in goal setting to pay attention to the quality of the process as well as to quantifiable outcomes**		
68	The goals and objectives of various departments/sections are cohesive and well integrated with those of the organization as a whole		

TABLE 3.5 (*continued*)

27	Some of the tasks now undertaken by the organization should be outsourced to some other agency or company
28	People at all levels are encouraged to take responsibility for the decisions they make
29	Senior managers refrain from making decisions which should and can be made at lower administrative levels
31	Many of the activities and projects in the organization are carried out by teams
34	Decisions that affect me and my work are discussed fully with me by my supervisor
30	Staff are able to go to people in other sections to get help in fixing problems affecting their work without having to go first to a supervisor or manager for permission
32	Staff are encouraged to develop respect for the skills and contribution of others in the organization
33	There are well-developed opportunities for management and staff to work in a variety of different jobs
69	Structure is flexible, responsive and shows co-operation between its parts

TABLE 3.6: Items concerning Training and Communication: those significant in distinguishing government from non-government are shown on the left; those not significant are shown on the right. (The items which distinguish the best organizations in the entire sample are shown in **bold**.)

QN	QUESTION DETAIL	QN	QUESTION DETAIL
38	**There is an established system for induction of all new employees**	35	There are genuine opportunities for staff to improve their skills and knowledge
39	Performance of staff is assessed at regular intervals	36	Staff to receive training/development are involved in formulating the nature of the training/ development program/priorities
40	Rewards are based on contribution to pre-established and known standards rather than vague opinions on the worth of individual effort	37	There are adequate and clear procedures in place for hiring appropriately qualified/skilled new staff
41	Staff have been trained to operate effectively in teams	**70**	**High degree of commitment, resources, and planning**
71	Good work is recognized and equitably rewarded		

TABLE 3.6 (*continued*)

42	**Information is transferred quickly and efficiently through the organization to all those who need to know**
46	Senior managers are interested in new ideas and are keen on trying them out in this organization
47	Problems are carefully explored and their nature agreed on before solutions are developed and applied
48	Most people in different sections try to work on new ways of doing things rather than being stuck in fixed patterns
49	We systematically review projects, programs and practices in this organization
73	A learning orientation is encouraged
43	Staff take an active interest in the information that is communicated to them
44	We have learned a great deal from past experiences and practices in this organization
45	We are very interested in learning from what other organizations do well
72	**High sense of awareness, involvement and feeling part of the team**

TABLE 3.7: Items concerning Public Programs: those significant in distinguishing government from non-government are shown on the left; those not significant are shown on the right. (The items which distinguish the best organizations in the entire sample are shown in **bold**.)

QN	QUESTION DETAIL	QN	QUESTION DETAIL
53	**Visitors are provided with a variety of ways (interpretive strategies) in which to understand the meaning of the exhibits/ programs**	50	Senior managers show their active interest in visitors and public programs by their frequent presence on the floor of public galleries
57	Exhibits and other public programs are developed by education, exhibition and other staff as well as research and curatorial staff working together	**51**	**Problems experienced by visitors with public programs are speedily and appropriately attended to by staff of the relevant section**
62	Public program staff are accepted by others including research and curatorial staff as important contributors to the future of the organization	52	There is a clear commitment by relevant staff to ensuring that exhibits are in working order at all times
		54	Educational offerings attempt to address the full range of knowledge, attitudes and understandings which visitors bring with them
		55	Marketing staff use the results of market research to help program staff develop effective programs
		56	**The staff/consultants who undertake evaluation of public programs co-operate to improve program effectiveness by contributing the results of their work to decisions about programs**
		58	Ideas for public programs are contributed by staff from throughout the organization
		59	All those involved in public programs clearly understand the criteria for program choice

60	**The amount of money allocated to advertising and promoting public programs is based on knowledge of what expenditure is required to reach the desired proportion of the target market**
61	Staff responsible for conservation of collections work to ensure that wherever possible the objects will be available for use in public programs and scholarship
74	Public program development and marketing are clearly focused on visitors as important stakeholders

TABLE 3.8: Items concerning Information Technology; those significant in distinguishing government from non-government are shown on the left; those not significant are shown on the right. (The items which distinguish the best organizations in the entire sample are shown in **bold**.)

QN	QUESTION DETAIL	QN	QUESTION DETAIL
64	Management of the collections makes maximum use of information technology to improve access by the public and other interested parties to knowledge of the collections	63	Appropriate resources are allocated to the continual improvement of information technology
		65	The development of the use of information technology is being done in the context of an overall policy which focuses on how the organization may benefit in meeting its service to the public
		75	Technology is up to date with market development and usage is widespread

nies rather than the rhetoric of the marketplace or the assertions of Treasury and like Departments. As Professor Mark Lyons (of the University of Technology, Sydney's School of Management says (*pers. comm*), 'the government reform agenda has been driven by [economists and accountants in] central agencies, treating the various operating components of government as divisions ... they have adopted from business only the cost cutting models and not the (more successful) envisioning/consumer focussed models'.

The recent literature quite clearly demonstrates that the best organizations are concerned about issues of cohesion and values and focus on the longer term, teamwork and attention to customers. Analysis of the total sample in the study shows these factors to be important (Griffin, Abraham and Crawford, in press). The analysis of the results for government and non-government organizations in this paper shows that the latter are distinguished in an even greater number of important areas relevant to the same factors. Whilst there are some areas such as structure and components of communication items and public programs where there is no difference between the two groups, there are on the other hand no items in which government organizations perform significantly better! The conclusion must be that government involvement contributes something negative to the way the organization works. At the very least one must say that government intervention does not contribute positively to good performance by museums and similar organizations. Were it to be so then we should expect the majority of those organizations with better scores to have close connections with government!

The proposition advanced from this study is that the more distant museums and similar organizations are from government the more they are likely to be characterized by features that contribute significantly to effectiveness. However, the majority of the non-government organizations are from the US. An alternative explanation might therefore be that it is simply that US organizations are better. Three lines of thought suggest that this is an inadequate interpretation.

First, when organizations are clustered on the basis of their scores for the questionnaire responses, US organizations do not all group together: indeed the clusters for the most part contain

very mixed groups of organizations by country, type of organization, age or principal source of funding.

Second, two organizations in Canada, Science North and Glenbow, are now distant from Government or have been in the recent past. Science North is a science centre in the mining city of Sudbury in northeast Ontario, Canada. It opened in 1984, four years after it was first conceived, as a private nonprofit corporation but now receives significant funding from the Ontario Provincial Government. Glenbow, a history and art museum, library and archives in Calgary, Alberta was established in 1966 by provincial legislation following the gift of a substantial collection by a private donor; it suffered substantial declines in Provincial Government support in 1989 and is now a private organization. Both show considerable degrees of innovation and participation: their scores in the questionnaire are very good, both being in the top eight.

Science North, recognized for innovation in its public programming, is a leader also in communication and learning as well as scoring well in the leadership area. A particular example of distinct difference from government organizations is given by Science North when faced with likely reductions in funding around the time of its move to greater involvement with government. Director James Marchbank asked staff to suggest ways in which funds might be reduced: the result was savings in several areas and a small salary rise for staff. In contrast, the staff of Provincial government organizations received no salary rises and in addition were required to pay a social dividend (staff working for a week or so without pay).

Glenbow is a leader in issues of purpose and structure. The 'remedial' actions following decline of government support included not only examination of future financial sources but both downsizing and reorganization. Janes (1995) emphasizes a two-part approach to the future including planning – both a corporate and strategic plan – and a set of management principles. The latter were developed through development of values by discussion with staff. Trust and integrity, freedom and responsibility and respect for the individual are principal values. Leadership was placed at the centre of the organization rather than at the top. An environmental scan involved analysis of trends and issues in the community including social, political and economic issues. Identi-

fication of critical issues led to the framing of a mandate for the organization and a statement of vision as well as statements of accountabilities or role and responsibility statements. Performance targets and monitoring were incorporated in the planning.

Third, it might be speculated that cultural differences between the USA and other countries (rather than differences in practice between government and non-government organizations) account for the differences reported in this study. The question is whether the differences in culture are likely to significantly influence the characters investigated here. One of the largest studies of this is the well known one by Geert Hofstede (1980) who analysed the large number of opinion surveys of the IBM Corporation around the world. The data were clustered and the four principal clusters – termed power distance, uncertainty avoidance, individualism and masculinity – analysed. The pertinent point to emerge is that USA, UK and Australia appear together in these clusters, in contrast to Japan, Scandinavia and Germany, and are particularly individualistic and rather more masculine than Scandinavia. The point is that, based on Hofstede's study, there would not appear to be any reason why US organizations should stand out on the basis of any cultural difference.

Much of government reform focuses on structural reorganization. However, structural change does not go very far at all. As Burke and Litwin have pointed out, structure is a transactional not a transformational variable. Unlike the transformational variables of leadership, purposes and culture change no deep seated and long lasting impact on effectiveness is likely.

In any case, structural interventions which attempt to move the structure from mechanistic to more organic forms through such approaches as de-emphasizing the hierarchy, use of structural integrating mechanisms such as interlocking flexible groups and so on are characteristic of what Limerick and Cunnington (1993) call the 'Third Blueprint' (pp. 26–34). The assumptions underlying the third blueprint have been challenged since the late 1980s. Limerick and Cunnington outline the emergence of the Fourth Blueprint (p. 37) which emphasizes discontinuity, loose coupling, synergies and alliances, collaborative individualism, the management of meaning, mission and vision and transformational leadership. The new mindset calls simultaneously for both loosely coupled structures and higher levels of synergy in the

organization. The authors indicate that a loosely coupled system is 'less of a state or a structure and more of a deliberate strategy, a process for dealing with complex and discontinuous environments; it is something organizations do, rather than something they have.' The point is that such a blueprint can under no circumstances be mandated by externally imposed structural arrangements any more than can a desired culture.

In line with the new blueprint, three models provide some interesting insights. Worth (1993) examines organizational synergy parallels between being a member of a jazz ensemble and administering a service-motivated nonprofit organization. (Drucker (1993) also says, 'To be effective, companies must learn their limitations and contract out work that they cannot do effectively themselves. Increasingly, management will be arranged like a jazz combo, in which leadership is constantly shifting and is independent of the rank of each member. ... Managers will lead their companies the way conductors lead orchestras.' Handy (1995) recounts a conversation about the way a rowing team is organized with leadership being a function of the context – sometimes the stroke, sometimes the coach, sometimes the manager: it all depends on trust. Ames (in Janes 1995) advances the flexibility of the response of the Native American hunting band to organizational structure, a structure radically different from the orthodox, where people are multiskilled and engaged as principals in those situations in which their specific skills are most relevant.

CONCLUSIONS

Successful organizational reform emphasizes transformational leadership, attention to vision and mission (including quality in customer service) and to the shaping of organization cultures, not to downsizing, restructuring, centralized control, compliance and an obsession with the bottom line. Our study demonstrates that government intervention, where it has emphasized compliance and cost-cutting, makes a negative difference to the performance of museums. Non-government organizations which have not been faced with compliance and cost-cutting requirements have been free to develop the sort of leadership which enables them to focus on the purposes, culture and management practices characterizing long term success and effectiveness.

The study also highlights the importance of management and their Boards working together in a partnership to clarify aims and objectives and to identify core values and competencies. Boards that focus on the long term and use their skills, knowledge and networks to actively advance the organization's goals are much more likely to see the organization's they have responsibility for, succeed and flourish.

Governments (like Boards) need to sponsor and orchestrate attempts by Boards and management to encourage attention to purpose, and shared values. They need to take a long term view, to lend support and to nurture (at least not to oppose) management initiatives which emphasize genuine reforms for long term success.

Appropriate financial controls and performance indicators will not be enough. These emphasize short term gains and relate to *operational rather than strategic* concerns. For example, income-generating activities certainly enhance the visitor's experience and provide needed revenue but are not the core-business of the museum. Most importantly, the organization's core skills must be built on and opportunities grasped. Attention by governments mainly to efficiency or to 'good business practice' misconstrued will not lead to success in the long-term.

As for museums and their management, success in the longer term depends on more than money. It depends primarily on the ability of leadership to harness the creativity of the staff and a shared culture through focus on a common vision and a common commitment. To succeed, museums and science centres must address what the organization might become through understanding trends in the industry and genuine concern for visitors and other users. At their best, museums and science centres can make a difference to people's appreciation of life's meanings through the way they increase people's understanding. Many already have!

ACKNOWLEDGMENTS
Funding for travel and other costs of this study have been provided by the Australian Museum Trust. The project is partly supported by the Canadian Museum of Nature, Ottawa which assisted travel to all Canadian organizations included in

this project (by DJGG in 1995). We are especially grateful to Dr Alan Emery, former President of the Museum, for his encouragement.

We also wish to thank the numerous Chief Executives, Directors and staff members at the 30 museums, science centres and aquaria who agreed to complete questionnaires and participate in interviews. In particular, we wish to thank the following who participated in two visits and interviews for the project: Dr Neil Chalmers (Natural History Museum, London), Ms Gillian Thomas (Museum of Science, London), Mr Max Hebditch (Museum of London), Dr David W. Ellis (Museum of Science, Boston), Dr Jerry Schubel (New England Aquarium, Boston), Dr John McNeill and colleagues (Royal Ontario Museum, Toronto), Dr Alan Emery (former President, Canadian Museum of Nature, Ottawa), Dr Robert Macdonald (Museum of the City of New York), Dr Roy Shafer (former President of COSI, Columbus, Ohio), Ms Julie Packard (Monterey Bay Aquarium, Monterey, California) and Dr Donald W. Duckworth (BP Bishop Museum, Honolulu, Hawaii).

As well we wish to thank the following for very helpful discussion: Professor Michael Ames, Ms Kersti Krug, Ms Anne-Marie Fenger (Museum of Anthropology) and Professor Robert Kelly (all of the University of British Columbia, Vancouver). We thank Professor Mark Lyons and Ms Janette Griffin (both of the University of Technology, Sydney) and Ms Gwen Baker (Australian Museum) for critical reading of the ms.

Ms Gail McCarthy of the Australian Museum prepared, distributed and collated the assessments and questionnaires and Ms Lynda Kelly of the Australian Museum undertook analysis of some of the questions in the questionnaire. Drs Douglass F. Hoese and Alan Jones and Ms Anna Murray of the Australian Museum provided statistical advice.

The questionnaire was devised in consultation with Dr John Crawford, of the University of Technology, Sydney, who conducted the first analyses of the data on which this report is based. We are grateful to him for his advice and assistance with interpretation.

The contribution of Ms Jan Brazier and her colleagues in the Research Library of the Australian Museum in locating relevant literature has been invaluable!

BIBLIOGRAPHY

Ames, Peter J. (1985) 'Guiding museum values', *Museum News*, August 1985: 48–54.

―――― (1991) 'Measuring Museums Merits', in Kavanagh, G. (ed.) *The Museums Profession: Internal and External Relations* (Leicester: Leicester University Press) pp. 57–8.

Aram, John D., Cowen, Scott S. and Weatherhead, Albert J. (1995) 'Reforming the Corporate Board from Within: Strategies for CEO's and Directors', *Journal of General Management* 20 (4): 23–39.

Archibald, Robert R. (1996) 'Epilogue to "The Last Act"' [review of 'An Exhibit Denied: Lobbying the History of the Enola Gay' by Martin Harwitt] *Museum News*, November–December 1996: 22–3, 56–7.

Baker, John R. (1989a) 'Management Improvement, The Human Dimension', *Canberra Bulletin of Public Administration* 59: 54–61.

―――― (1989b) 'From Management to Leadership: a comparative perspective on leadership in the Australian Public Service', *Australian Journal of Public Administration* 48 (3): 249–64.

Bartlett, C.A. and Goshal, S. (1994) 'Changing the role of Top Management: Beyond Strategy to Purpose', *Harvard Business Review* November–December 1994: 79–88.

―――― (1995a) 'Changing the role of Top Management: Beyond Structure to Process', *Harvard Business Review* January–February 1995: 86–96.

―――― (1995b) 'Changing the Role of Top Management: Beyond Systems to People', *Harvard Business Review* May–June 1995: 132–42.

Beer, Michael and Eisenstat, Russell A. (1996) 'Developing an Organisation capable of Implementing Strategy and Learning', *Human Relations* 49 (5): 597–619.

Bennis, W. and Nanus, B. (1985) *Leaders – the Strategies for Taking Charge* (New York: Harper and Row).

Bicknell, Sandra and Farmelo, Graham (1993) *Museum Visitor Studies in the 90s* (London: Science Museum) p. 168.

Binder, Alan S. (ed.) (1993) *Paying for productivity: a look at the evidence* (Washington, DC: The Brookings Institution).

Borun, Minda, Chambers, Margaret and Cleghorn, Ann (1996) 'Families are Learning in Science Museums', *Curator* 39 (2): 123–38.

Bowman, Cliff and Carter, Simon (1995) 'Organising for Competitive Advantage', *European Management Journal* 31 (4): 423–32.

Bradford, David L. (1993) 'Building High Performance Teams', in Alan R. Cohen (ed.) *The Portable MBA In Management* (New York: John Wiley and Sons) Chapter 3.

Burke, W.W. and Litwin, G.H. (1992) 'A Causal Model of Organization Performance and Change', *Journal of Management* 18 (3): 523–45.

Burton, John (1995) 'Composite Strategy: The Combination of Collaboration and Competition', *Journal of General Management* 21 (1): 1–23.

Carl, Janet and Stokes, Gary (1991) 'Ordinary People, Extraordinary Organizations', *Nonprofit World* 9 (4): 8–12; *Nonprofit World* 9 (5): 18–26; *Nonprofit World* 9 (6): 21–6.

Carnegi, Roderick, Butlin, Matthew, Barratt, Paul, Turnbull, Andrew and Webber, Ian (1993) *Managing the Innovating Enterprise. Australian companies competing with the world's best* (Melbourne: The Business Enterprise).

Collins, James C. and Porras, Jerry I. (1994) *Built to Last. Successful Habits of Visionary Companies* (London: Century).

—— (1996) 'Building Your Company's Vision', *Harvard Business Review*, September–October 1996: 65–78.

Conger, J.A. and Kanungo, R.J. (1988) 'The Empowerment Process: Integrating Theory and Practice', *Academy of Management Review* 13 (30: 471–82.

Cooper, Robin and Markus, M. Lynne (1995) 'Human Reengineering', *Sloan Management Review* Summer 1995: 39–50.

Csikszentmihahalyi, Mihaly and Hermanson, Kim (1995) 'Intrinsic Motivation in Museums: What makes visitors want to learn?' *Museum News* 74 (3): 34–7 and 59–61.

Deschamps, Jean-Phillippe (1995) 'Managing Innovation: From Serendipity to Process', *Prism* Second Quarter 1995: 35–55.

Dixon, J. (1996) 'Reinventing civil servants: public management development and education to meet the managerialist challenge in Australia', *Journal of Management Development* 17 (7): 62–71.

Drucker, Peter F. (1992) 'The New Society of Organizations', *Harvard Business Review* September–October 1992: 95–108.

—— (1993) 'Tomorrow's manager', *Success* 40 (8): 80.

Duleqicz, Victor, MacMillan, Keith and Herbert, Peter (1995) 'Appraising and Developing the Effectiveness of Boards and their Directors', *Journal of General Management* 20 (3): 1–19.

Dunphy, Dexter and Stace, Doug (1992) *Under New Management, Australian Organisations in Transition* (Sydney: McGraw-Hill).

Dunphy, Dexter and Bryant, Ben (1996) 'Teams: Panaceas or prescriptions for improved performance?' *Human Relations* 49 (5): 677–99.

Emery, Alan R. (1960a) 'The Management of Change: The Case of the Canadian Museum of Nature', *Muse* Autumn 1990: 76–9.

—— (1960b) 'Museum Staff; Defining Expectations', *Museum Management and Curatorship* 9: 265–72.

Falk, John and Dierking, Lynn (1992) *The Museum Experience* (Washington, DC: Whalesback Books).

—— (1995) *Public Institutions for Personal Learning. Establishing A Record Agenda* (Washington, DC: American Association of Museums).

Flynn, Norman (1995a) 'Alternatives to the Conservative Agenda'. Talk at the Evatt Foundation, Sydney, 18 October 1995 (ms).

—— (1995b) 'The future of public sector management: are there some lessons from Europe?' *International Journal of Public Sector Management* 8 (4): 59–73.

Flynn, Norman and Strehl, Franz (eds) (1996) *Public Sector Management in Europe* (London: Prentice Hall.)

Friedman, Alan J. (1996) 'Vive la difference. Differentiating science-technology centers from other leisure-time enterprises', *ASTC Newsletter* January–February 1996: 7–10.

Garvin, David A (1993) 'Building a Learning Organisation', *Harvard Business Review* 71 (4): 78–92.

Goshal, S. and Bartlett, C.A. (1994) 'Linking organizational context and managerial action: the dimensions of quality of management', *Strategic Management Journal* 15: 91–113.

Griffin, D.J.G. (1987) 'Managing in the Museum Organisation I. Leadership and communication', *International Journal of Museum Management and Curatorship* 6: 387–98.

—— (1988) 'Managing in the Museum Organisation II. Conflict, Tasks, Responsibilities', *International Journal of Museum Management and Curatorship* 7: 11–23.

—— (1991a) 'Management and leadership in museums', *Australian Library Journal* 40 (2): 125–51.

—— (1991b) 'Museums – Governance, Management and Government, or why are so many of the apples on the ground so far from the tree?' *Museum Management and Curatorship* 10 (3): 293–304.

—— (1993) 'Ideas – Heresies Even – For Museum Futures', *Museums Australia Journal* 2–3, 1991–2: 33–48.

—— (1994) 'The Proper Business of Museums', *New Zealand Museums Journal* 24 (1): 5–11.

Griffin, D.J.G., Abraham, M. and Crawford, J. (in press) *Effective management of Museums in the 1990s.*

Griffin, D.J.G. and Abraham, M. (in press) *Management of Museums in the 1990s: Governance and Leadership revisited.*

Gurion, Elaine Heumann (1995) *Institutional Trauma. Major Change in Museums and its Effect on Staff* (Washington, DC: American Association of Museums).

Guzzo, Richard A. and Dickerson, Marcus W. (1996) 'Teams in Organisations: Recent Research on Performance and Effectiveness', *Annual Review of Psychology* 47: 307–38.

Hamel, Gary and Prahalad, C.K. (1989) 'Strategic Intent: To revitalize

corporate performance, we need a whole new model of strategy', *Harvard Business Review* May–June 1989: 63–76.

—— (1994) *Competing for the Future* (Cambridge, MA: Harvard Business Review Press).

Handy, Charles (1995) 'Trust and the Virtual Organisation', *Harvard Business Review*, May–June 1995: 40–50.

Harmon, Frederick G. (1996) *Playing for Keeps* (New York: John Wiley).

Hein, George (1995) Evaluating teaching and learning in museums', in Eilean Hooper-Greenhill (ed.) *Museum, Media, Message* (London: Routledge), pp. 189–203.

Heller, T. Robert (1994) 'The Manager's Dilemma', *Management Today* January 1994: 42–7.

Hendry, John (1995) 'Culture, Community and Networks: The Hidden Cost of Outsourcing', *European Management Journal* 13 (2): 193–200.

Herman, Robert D. and Heimovics, Richard D. (1991) *Executive Leadership in Nonprofit Organisations* (San Francisco: Jossey-Bass).

Herman, Robert D. and Associates (1994) *The Jossey-Bass Handbook of Nonprofit Leadership and Management* (San Francisco: Jossey-Bass).

Hitchcock, Darcy (1992) 'Overcoming the top ten team-stoppers', *Journal for Quality and Participation* 15 (7): 42–8.

Hitt, William D. (1995) 'The Learning Organisation: some reflections on organisational renewal', *Leadership and Organisation Development Journal* 16 (8): 17–25.

Hofstede, Geert (1980) *Culture's consequences: international differences in work-related values* (Beverley Hills, California: Sage Publications).

Hogget, P. (1996) 'New modes of control in the public service'. *Public Administration* 74 (1): 9–24.

Hooper-Greenhill, Eilean (1994) *Museums and their Visitors* (London: Routledge).

Horin, Adele (1994) 'Cutting your people down doesn't work', *Sydney Morning Herald* 16 February 1994: 14.

Hout, Thomas M. and Carter, John C. (1994) 'Getting IT Done: New Roles for Senior Executives', *Harvard Business Review* November–December 1995: 133–46.

Jackson, Peter M. (1991) 'Performance indicators: promises and pitfalls' in Pearce, Susan (ed.) *Museum Economics and the Community. New Research in Museum Studies* 2 (London: The Athlone Press) pp. 41–64.

James, David (1996) 'Forget downsizing, now it's participative redesign', *Business Review Weekly* 25 November 1996: 70–8.

Janes, Robert R. (1995) *Museums and the Paradox of Change. A case study in urgent adaptation* (Calgary: Glenbow Museum).

Kanter, R.M. (1983) *The Changemasters: Corporate Entrepreneurs at work* (London: Counterpoint).

Karp, Ivan and Lavine, Steven D. (eds) (1991) *Exhibiting Cultures The Poetics and Politics of Museum Display* (Washington: Smithsonian Institution Press).

Knauft, E.B., Berger, Renee A. and Gray, Sandra T. (1991) *Profiles of Excellence. Achieving Success in the Nonprofit Sector* (San Francisco: Jossey-Bass).

Kofman, Fred and Senge, Peter M. (1994) 'Communities of Commitment: The Heart of Learning Organizations', in Chawla, Sarita and Renesch, John (eds) *Learning Organizations: Developing Cultures for Tomorrow's Workplace* (Portland, Oregon: Productivity Press) pp. 14–43.

Kolodny, Harvey and Stjernberg, Torbjorn (1993) 'Self Managing Teams: The New Organisation of Work' Chapter 10 in Cohen, Allan R. (ed.) *The Portable MBA in Management* (New York: John Wiley).

Kouzes, James M. and Pozner, Barry Z. (1995) *The leadership challenge: how to keep getting extraordinary things done in organizations*, 2nd ed. (San Francisco: Jossey-Bass).

Krug, Kersti (1992) 'Excellence in Arts Management: In Search of Characteristics Common to Well-Run Arts Organisations', *Muse* Spring 1992: 48–53.

Lewenstein, Bruce V. (1996) 'Shooting the Messenger: Understanding Attacks on *Science in American Life*', 4th International Meeting on Public Communication of Science and Technology, Melbourne, Australia, 11 November 1996 (ms).

Limerick, David and Cunnington, Bert (1993) *Managing the New Organisation: A blueprint for networks and strategic alliances* (Chatswood: Business and Professional Publishing).

Lublin, Joann S. (1993) 'Best Manufacturers found to triumph by fostering co-operation among employees', *Wall Street Journal* 20 July 1993: A2.

McInnes, Marion (1990) 'Public sector reform under the Hawke government: Reconstruction or deconstruction?' *The Australian Quarterly* 62 (2): 108–24.

McManus, P. (1987) 'It's the company you keep. The social determination of learning related behaviour in a science museum', *International Journal Museum Management and Curatorship* 6: 263–70.

—— (1988) 'Good companions: more on the social determination of learning related behaviour in a science Museum', *International Journal Museum Management and Curatorship* 7: 37–44.

Mintzberg, H. (1983) *The professional bureaucracy. Structure in Fives* (New York: Prentice Hall).

—— (1989) 'The Professional Organisation'. Chapter 10 in Mintzberg, H. *Mintzberg on Management: Inside our Strange World of Organisation* (New York: Free Press; London: Collier Macmillan).

—— (1991) 'The effective organisation – forces and forms'. *Sloan Management Review*, 32 (2): 54–68.

Moore, Kevin (ed.) (1994) *Museum Management* Leicester Readers in Museum Studies (London: Routledge).

Nanus, B. (1989) *The Leader's Edge* (Chicago: Contemporary Books).

Newlands, David L. (1983) Stress and Distress in Museum Work', *Muse* Summer 1983: 18–33.

Nowlen, Philip (1994) 'Museums in Troubled Times', Keynote Address British Museums Association 100th Anniversary Meeting, ms.

O'Reilly, Brian (1994) 'The new deal: What companies and employees owe one another', *Fortune* 129 (12): 44–52.

Pascale, Richard Tanner (1978) 'Zen and the Art of Management', *Harvard Business Review* March–April 1978: 153–177.

Pascale, R.T. and Athos, A.G. (1981) *The Art of Japanese Management: Applications for American Executives* (New York: Simon and Schuster).

Pearce, Susan (ed.) (1991) *Museum Economics and the Community. New Research in Museum Studies* 2 (London: The Athlone Press) pp. 41–64.

Perry, Tekla S. (1995) 'Designing a Culture for Creativity', *Research Technology Management* 38 (1): 14–31.

Pfeffer, Jeffrey (1988) 'Producing sustainable competitive advantage through the effective management of people', *California Management Review* 36 (2): 9.

—— (1996) 'When it comes to "Best Practices" – Why Do Smart Organisations Occasionally Do Dumb Things?' *Organisational Dynamics* 25 (1): 33–44.

Porter, Michael E. (1996) 'What Is Strategy?' *Harvard Business Review* November–December 1996: 61.

Pusey, Michael (1991) *Economic Rationalism in Canberra. A Nation Building State changes it's mind* (Cambridge: Cambridge University Press).

Quinn, James Brian and Hilmer, Frederick G. (1994) 'Strategic Outsourcing', *Sloan Management Review* Summer 1994: 43–55.

Randolph, W.A. (1997) 'Navigating the Journey to Empowerment', *Organizational Dynamics* 23 (4): 19–32.

Reich, Robert (1991) *The Work of Nations* (London: Simon and Schuster).

Right Associates (1992) *Lessons learned. Dispelling the Myth of Downsizing* (2nd ed.) (Philadelphia: Right Associates).

Schein, Edgar J. (1983) 'The Role of the Founder in Creating Organisational Culture'. *Organizational Dynamics* 12 (1): 13–28.

Scholtes, Peter R. (1988) *The Team Handbook how to use teams to improve quality* (Madison, Wis: Joiner Associates).

Senge, Peter M. (1990) 'The Leader's New Work: Building Learning Organisations'. *Sloan Management Review* 32 (1): 7–24.

Silverman, Lois (1991) 'Tearing down walls'. *Museum News* November–December 1991: 62–4.

Smirchich, Linda and Morgan, Gareth (1982) 'Leadership: The Management of Meaning', *Journal of Applied Behavioural Science* 18 (3): 257–73.

Stewart, J. and Walsh, K. (1992) Change in the management of public services'. *Public Administration* 70 (4): 499–522.

Townsend, R. (1970) *Up the organisation* (London: Michael Joseph Ltd.).

Vaill, Peter B. (1993) 'Visionary Leadership'. Chapter 2 in Cohen, Allan R. (ed.) *The Portable MBA in Management* (New York: John Wiley).

Wall, Stephen J. and Wall, Shannon Rye (1995) 'The Evolution (Not the Death) of Strategy', *Organizational Dynamics* 24 (2): 7–19.

Weil, Stephen E. (1994) 'Creampuffs and Hardball', *Museum News* September–October 1994: 42–3.

—— (1995) 'Progress report from the Field', in Weil, S. *A Cabinet of Curiosities: Inquiries into Museums and their Prospects* (Washington, DC: Smithsonian Institution) pp. 19–31.

Wolff, M. (1979) 'How to Find – and Keep – Creative People', *International Journal of Research Management* 22 (5): 43–5.

Worth, George G. (1993) 'Leadership jazz: Selected themes for orchestrating nonprofit quality', *Nonprofit World* 11 (2): 28–32.

4

Leadership

DAVID FLEMING

Armies lose battles, political parties lose elections, cricket teams lose matches, businesses go bankrupt – in most contexts, poor leadership ends in disaster. Conversely, effective leadership can turn failure into success, mediocrity into greatness. The value of leadership is most easily recognized in competitive situations, but it can be a factor in virtually any activity where more than one person is involved, no matter how mundane or routine. Because of this, leadership studies have become a widespread obsession, and the perfect leader has become the Holy Grail of business administration.

In his classic work, *The Prince*, Machiavelli dissected political behaviour and, in so doing, he analyzed characteristics of leaders. Machiavelli was not the first to do so, but he has a prime position in the history of political thought, partially because of his ready acknowledgement of the role of ruthlessness in politics and government. The Florentine diplomat concerned himself with matters of state, but the principles of government which he examined are essentially the same as those which can be applied to leadership generally. Analyses of leadership, once the preserve of politicians and the military, are nowadays more likely to be found filling the shelves of business sections in bookshops, and it is here that the mantle of Machiavelli has been assumed. As one writer puts it, 'In the corporate trenches, Machiavelli remains useful reading (Grainer, 1996: 179).

Leadership theorizing has become a business in its own right. The theories range from the Great Man (sic) Theory, which supposes that leaders are born not made; to the now-fashionable Transactional Theory, which emphasizes the relationship between leader and followers as based on mutual benefit; and the Transformational Theory, which emphasizes the visionary role of

leaders (Starrat, 1993: 7–10). As the theorizing has gathered pace since the 1980s, so the role of consensus has become more prominent and, instead of being viewed as the art of dictatorship, leadership is now portrayed as much more subtle. An emphasis on skills such as the ability to motivate now holds sway. This means that principles like communication, consistency and teamwork, for example, are at the heart of modern leadership theory.

It is quite possible to set out the standard essentials of leadership in checklist form. This is a common approach among the leadership primers. One example is *The Perfect Leader* (Leigh and Maynard, 1996), which presents the '7 I's' of Leadership: insight, initiative, inspiration, involvement, improvisation, individuality and implementation. In this article I shall pick out some of the commonly perceived key required qualities of leaders, and some of the key functions, before focusing specifically on leadership in the museum sector.

WHAT ARE LEADERS LIKE?

To lead effectively requires a complex of skills and attributes, attitudes and motivations but, above all, the leader must be driven by a desire to achieve things. If this desire is weak, or missing, then the wrong person is in charge. No matter what the context, strong beliefs are an absolute requisite in a leader. If there is a single good reason why leaders are not made, but born, it is that the passion needed to lead must be genuine and inherent – it cannot be affected or assumed. Only genuine passion will create inspiration in others, will provoke emulation, will win hearts and minds in followers, will earn respect from rivals; and only genuine passion will prevail when things get rough. It follows that though all leaders suffer from self-doubt at times, without self-belief it is impossible for a leader to inspire anyone else. If you have no dreams, if you have no compelling vision, do not try to lead. Those, especially socialists, who questioned Tony Blair's credentials for leading a Labour Government, have invariably wondered about the strength of his beliefs: time will be the test of whether Blair has a dream beyond winning power from the Tories.

What makes the difference between a dreamer and a leader, between an enthusiast and a successful activist, between an obses-

sive and a former of opinion? Effective leaders recognize that they can achieve nothing alone, and that they must mobilize, influence, motivate and involve others. The essence of leadership is the relationships which a leader must develop and maintain, not just with subordinates, but also with superiors, and with others outside one's own organization or sphere of activity. Such relationships are built upon the personal qualities that the leader has, and especially on the leader's ability to *communicate*.

When I have addressed museum students on the subject of leadership, I have often asked them to list the qualities they think good leaders need. Invariably, words such as 'honesty', 'trust', 'consistency', 'intelligence', 'courage', 'confidence', 'creativity', 'judgement', 'loyalty', 'energy', 'charisma', 'fairness', 'integrity', 'determination' and 'approachability' are prominent. Some attributes often require a little more prompting, such as a 'sense of humour', 'optimism', 'sensitivity', 'effective communication' and 'ability to listen'. Some may be acknowledged only with reluctance – 'ruthlessness', for example. Many of these qualities can be learned or developed, though others may be something you either have or you haven't. This is probably a good place to recognise that nobody, least of all the present writer, has the whole range of qualities. We all have weaknesses. It is in acknowledging the gaps in our armoury that we can aspire to being a truly effective leader.

Some of those qualities deserve a little more attention. Honesty comes more easily to some than others, and one person's honesty is another's bluntness, arrogance or naivety. Used carelessly, honesty can mislead, frighten or offend; but it is a fundamental building-block in the leadership edifice. Closely related to honesty is trust, another key element in leadership, albeit as a relationship rather than a virtue, which comes to the fore when the chips are down, such as when an organization is under threat. At such times is the leader trusted? If so, it will be because the trust has been earned; it must be won, it can never simply be expected.

Courage is an essential requirement in a leader, and courage in the face of adversity, or when risks need to be taken, is very often the difference between success and disaster. In particular, subordinates will demand courage of a leader in return for their loyalty, and lack of courage makes for weak and invariably unpopular leadership. Loyalty is an underrated virtue. Like trust,

it has to be earned. Loyalty to one's organization, including its governing body, is a straightforward and non-negotiable requirement of a leader. More challenging and complex, though no less of a basic responsibility of a leader, is loyalty to subordinates. It should not be blind, but a leader must display loyalty consistently to subordinates in order to expect any reciprocation. The buck must stop with the leader when things go wrong, and to betray this is to undermine any organization. With the power of leadership comes weighty responsibility, and loyalty to subordinates is the heaviest responsibility of all.

A leader's energy is a strong motivating force. Enthusiasm is infectious, but so are lack of vitality, weariness and laziness. All effective leaders energize their organizations through example. Some leaders are bored, or boring, or both. They will demotivate entire organizations given the time, even those where there is an intrinsic commitment to the vision and aims. Leaders need the stimulation of challenge and change so that they are able to maintain their own levels of enthusiasm, and so those of others.

Charisma is a dangerous attribute, important in leadership theory. Most people prefer to be led by a charismatic person, as a sequence of United States Presidential elections have proven, and as John Major found to his cost in 1997. We all like to look up to someone, to admire them. In the case of those with high charisma, such as John F. Kennedy, we are prepared to overlook weaknesses, so driven are we by a desire for strong leadership. Sometimes, as in Germany in the 1920s, we may even follow blindly. This is dangerous for the leader, who may come to believe what the led believe in terms of his or her reliability, even invincibility; as well as for the led, who may come to rely overmuch on the leader's judgement. Most totalitarian political regimes have suffered from placing too much power in too few hands in search of 'strong' leadership. In a work environment, the brilliance of a leader's charisma may overshadow the achievements of others, if the leader allows it to do so. It may also, especially in public service, offend a governing body if all credit is too readily accepted by the leader of the staff. And yet, nobody wants a nobody as their leader. Hence the need for a charismatic leader to find a balance which makes use of this blessing, internally and externally, without allowing tensions to grow, created through a sense of the leader soaking up all attention and credit.

Ultimately, successful charismatic leaders are those who thrive on teamwork, not those who believe themselves to be the Messiah.

Determination and confidence are other strengths in a leader which must not be allowed to distort behaviour too much. Deciding upon a course of action and then pursuing it vigorously is one thing. Not knowing when to call something a day, and when determination becomes stubbornness, is another. Good leaders are able to admit to mistakes, and to encourage others to do the same. No matter how assured a leader may be, he or she will err, and being both relaxed and open about this is a sign of the confidence which itself is so important. Indeed, successful leaders are well aware of their own weaknesses, and know when to give responsibility to others in order to compensate.

There is a darker side to leadership with which many are not comfortable. In competitive situations there are opponents to be out-fought, out-thought, confounded and, at the end of the day, defeated. While it is quite possible to behave thoroughly honourably during conflict, there comes a point where there has to be a winner and a loser. The primers tend to gloss over the role that ruthlessness, or duplicity, may play in leadership theory and practice. If ruthlessness is the same as a win-at-all-costs attitude, then it seems neglectful to exclude this quality from the list of those often associated with successful leaders. It is an omission that Machiavelli didn't make; it is quality missing from no successful political leader.

Despite all this, we cannot identify the true leader simply by tallying personal qualities. The answer to the question 'what are leaders like?' is 'they vary', because their personalities are different. Personality is intangible, and is just as much how people see us as how we 'actually' are. Leaders cannot really be judged on what they are like, but on what they do, and how they do it. And on results.

WHAT DO LEADERS DO?

Although the primers' checklists suggest that there are recipes for leadership behaviour, in reality, where personalities are involved, no two situations are ever the same. None the less, there is a range of challenges to which a leader will inevitably have to rise in any work circumstance.

Teambuilding is among the key leadership tasks. Weighty tomes are devoted to this subject, so central is it to leadership studies and practice. The essence of teambuilding is establishing a balance of skills and competencies; agreeing common aims; and fostering creative discussion. None of this is a guarantee of harmony and accord, especially where the organisation is complex, and where levels of ability or intelligence are uneven, but any leader who is unable to create teams will founder rapidly. The leader will have a cross-functional management team which will include the real strategic thinkers in the organisation, and those who are nearest to becoming leaders in their own right. At least, this is what we hope. Contrary to what the primers tell you, the leader cannot always assemble the best team or all the people who should be in it: life is never that straightforward, and often we simply have to do the best we can. I have yet to meet the museum Director who believes he or she has the perfect management team, and couldn't do better given a completely free hand (and inexhaustible resources).

A good leader teaches. Actually, poor leaders teach too, but less wittingly. We all study our bosses' behaviour, and we all have views on how they could do better. Good leaders think out loud, explore options, canvas opinions, encourage creativity – and they do this in front of subordinates, so that the staff can be involved in and understand the decision-making process. It is this, transparent decision-making, with the leader exercising judgement, broadmindedness, keeping cool, and, above all, communicating, which is so instructive to the staff. This does not mean that the start will always agree with the decision, but they will learn from the process. Poor leaders tend to be more closed and secretive, their decision-making less transparent and consultative, and less consensual as a result. Hopefully, aspiring leaders will learn better habits from observing such behaviour, though this may be of little immediate comfort.

One of the clearest marks of a true leader is the ability to identify, nurture and develop people's skills. This means encouraging people to grow, giving more responsibility, playing to their strengths, giving credit, recognition, reward. Leaders do this because it is good for their staff, which is good for their organisations. It is central to an organization's resource management, and is as creative a function as a leader can perform. This area of

a leader's responsibility demands a high level of judgement, even instinct and intuition. It is not mechanical, nor is it straightforward.

The leader must set standards, of behaviour and of achievement and levels of expectation. This extends beyond trying to create a relaxed, good-humoured environment where people feel able to voice opinion and chance their arm. It means making it clear what is unacceptable, especially to those who will intimidate others if they are allowed, thus stifling enquiry and ideas. This is a common breed, and the leader must be prepared to bully the bullies. Aiming high is something the leader can encourage, as this is a powerful motivating force. This usually means risk-taking, which the leader should welcome and promote if the organization is to be special and progressive. Vigorous leadership involves fostering commitment among staff, and declaring clear intent and direction. Combined with an encouraging atmosphere, respect for various views – wherever they originate – and an involvement culture, this will create a positive, ownership environment. It may also generate a need for the leader to guard against complacency: a threat to any successful organization.

In leadership theory, much is made of style, which is often viewed as being at the heart of leadership. In particular, styles of decision-making are analyzed. In simple terms, these range from participative/consensual at one extreme, to absolutism at the other. The issue of style revolves around the authority of the leader, and how it is exercised. Authority may be delegated to others, in part or even in whole; or it may be retained exclusively by the leader. While leaders may by nature incline towards one or the other extreme, effective leadership is about striking a balance. This does not mean simply adopting a position somewhere in the middle in the hope that this will work most of the time – using a leadership style requires more judgement than that.

On a tactical level, style should change according to circumstances. Furthermore, we need to distinguish between the tactical and the strategic use of style. Handling conflict for example, requires a different approach from that needed to deal with more mundane situations. On a more strategic level, leadership style may need to vary over lengthy periods. So, when an organization is in difficulties, a decisive, possibly autonomous style may be needed in order to set new directions and new methods, to breed

new attitudes and probably to create a new vision. Subsequently, in order to motivate others and build commitment and trust, a more consensual style may develop. Similarly, leading an organization through change will require a judicious blend of leadership styles, and the skill lies in exercising choice.

MUSEUM LEADERSHIP

British museums, traditionally, have not been run on particularly businesslike lines. For the most part subsidised from public funds, museums have not been under the same degree of stress as strictly commercial operations. We have not been honed by competition, we have not, generally, run the risk of going out of business. Although museums are complex entities, we have had a fairly cosy time. Consequently, museums have been notable for their conservatism, and museum Directors have tended to be noted not for their leadership skills, but for their scholarship, or their acquisitiveness, and sometimes for their eccentricity. Many of our larger local authority museum services, and a number of our great national museums, have suffered at the hands of such Directors, and it is the lack of leadership which has given museums a deeply-lodged reputation for being a bit of a luxury, a refuge from the real world.

Times are, of course, changing. Over the past two or three decades, as public funding has been subject to increasing pressure, museums have come under growing scrutiny, and many have been found wanting. It is this which has caused many museums, especially in local authorities, to lose status and influence. The tendency for curators who are ill-equipped for management, let alone leadership, to assume control of museums, is with us still, but there are least two discernible trends which are countering this.

Firstly, and not always helpfully, many museums are coming under the direct influence of other professions – leisure managers, librarians, educationalists and others. We are widely perceived as a profession which is incapable of managing itself in the fierce environment of local government, so leadership skills are being provided by others.

Secondly, new attitudes are abroad in museums, and there are people now leading museum services who would probably do well

running any organization. This has led in a number of instances to Directors reassessing the basic purpose and structure of their museums, tackling outmoded practices and attitudes, and inevitably to their coming under fire from those who would like to turn back the clock to the halcyon days of the 1950s. It will take more than a fondness for the good old days to improve the reputation of museums and defend them successfully in these dark days for the public sector.

In very many respects museums are organizations whose leadership needs are the same as any other, and certainly this is true with respect to the validity of the underlying principles. The need for museum Directors to give a sense of direction and purpose, to generate trust, to motivate, to get things done – all these are prime requirements of the Director as they are of leaders in other sectors. However, museums are not armies, or political parties, or (primarily) businesses, and there are issues which combine to make museums worthy of special attention. These issues derive from the purpose and functions of museums, as well as their structure, their history, and their position in society.

Despite the variety of types of museum, they are (basically) non-profit-making, educational institutions which have unusual custodial and scholastic responsibilities, something of an image problem, and little control over their own destiny except as exercised through a range of types of governing body. They are poorly understood by outsiders, and they are staffed by people who exhibit a variety of characteristics, with a bias towards individualism and creativity which is sometimes manifested as eccentricity. For these people, the rewards for high achievement are psychological rather than financial, as are the motivations.

Leading any type of learned institution is a singular challenge. The leader will be expected to exhibit intellectual prowess to match that of the staff, and yet at the same time to do all those things that scholars prefer to avoid, like ensuring that there are sufficient resources available. Leading a museum successfully means bridging the gulf between two worlds: the world of research and scholarship which is centred on collections, and which has a kind of cosmic inevitability; and the rest of the world which is full of people with problems and needs. Matching up the two is the essence of museum leadership, although a failure to do so is at the core of the difficulties confronting many museums.

If the museum Director's main job is to ensure that conditions prevail which enable museum staff to operate at maximum efficiency and effectiveness, within the terms of the museum's aims and objectives, then it should not, strictly speaking be necessary for the Director to be a scholar in his or her own right. Scholarship does not guarantee successful leadership.

None the less, there is no doubt that the best Directors do tend to have some academic, curatorial standing. However, they are also able both to direct internal operations as well as represent the museum effectively to the rest of humanity. Having the blend of skills necessary to understand and operate within the museum to the satisfaction of one's colleagues, but also to communicate with everyone else, is essential in a Director. It will be interesting to watch the frequency with which people not from a curatorial background – but with marketing, educational or other skills – come through to take charge of museums. As museums become more and more complex in response to changes in society, the primacy of the curator-director will wither, though the need for the Director to comprehend the nature and value of collections certainly will not.

The fact that museums are based upon collections throws up certain requirements of their Directors. Ensuring that the educational and social potential of those collections is unlocked throws up many more. The Director must align the museum in such a way that the museum not only performs its educational function, but is seen widely to do so. It is here that we begin to see the essential need for the Director to have the dream, the vision of what museums can be and can do. In clarifying the *purpose* of the museum, and the purpose of all that collections management and research, the Director provides the fundamental element of leadership. The importance of this cannot be overestimated. It is this that provides the basis for the whole museum mission and performance, compared with which most other leadership functions can seem to be no more than technical requirements.

Social change is the engine which drives museum leadership, and which demands leadership vision. While the internal features of museums remain largely inviolate, revolving around collections, their assembly, care and display, the same cannot be said for the rest of the world. The requirements of museums made by society have undergone rapid and radical change, and this process

shows no signs of slowing down. Museums have had their ups and downs, but never before have they been subject to such a range of social, educational, technological and economic demands as at present. Despite this, it is surprising, and rather dispiriting, how many try to perform much the same function as they did in the nineteenth century. It is in facing up to the responsibilities with respect to new social needs that many Directors have failed, by failing to bring about new corporate vision for their museums, and by failing to encourage new attitudes. Those who advocate a traditional role for museums are really proposing that museums turn their back on change. This is not good enough. Museums, through their Directors, must grasp their relationship with the wider environment, with the society which supports them. They must certainly not delude themselves into believing that museums are exempt from social change. By keeping up with change, and reshaping themselves accordingly, museums are actually fulfilling their function, not abandoning it. Directors must, moreover, communicate the vision, the mission, both internally and externally. The vision has to be widely shared.

It is true that the leadership vision will vary according to the type of museum, and rightly so. Museums with specialist collections may have no need of a mission beyond that of making the collections as available as possible. Big museums, and especially those in our cities, need much more than that. They should be driven by Directors who are committed to deriving the maximum public benefit from the collections. This does not simply mean maximising visitor numbers. It means making a difference in society through a commitment to using collections for the good of all, not just a few. It means forging partnerships, making contact, finding new ways of engaging new groups of people with the museum's activities. It does not mean leadership which is content to accept a sedentary role for museums as passive recipients of mild attention from predictable visitors. Neither does it mean leadership which has a tendency to succumb to pressure from those, usually based in London, who have no accountability, yet who are very ready to criticize, or who may threaten financial sanctions. There is an Establishment which believes that in opening up access to all, museums have become vulgar; that their Directors are betraying some kind of Masonic code which requires museums to float, serene in their complacency, above the

heads of all but the connoisseur, the scholar, the educationally
advantaged, the socially élite. Nowhere is this view held more
vehemently than in the art world, represented most openly by
newspaper art critics, who frequently launch splenetic attacks on
anyone in the museum sector who dares to try something new in
order to find a wider public (Dorment, 1992).

The clear implication is that in order to attract wider audiences
museums have to 'dumb-down' – populism equals vacuity, and
entertainment is something which should be left in the hands of
the broadcast media and the commercial leisure sector. This is
seen variously as a betrayal of learning and a prostitution of
scholarship, and as patronizing to people who don't use
museums, or who use them rarely. So, any museum which dares
to introduce features which may seem to threaten the traditional
museums air of reverence, such as physical interactivity, sound
effects, or any hint of levity and amusement, is instantly likened
to Disneyland and put to the critical sword (Sewell, 1997). There
is a wilful failure to accept that museums have a right to experi-
ment, to be different from each other, and to put effort into
making contact with people who do not use them. One way to do
this is to provide a variety of experiences, ranging from the
simple to the complex, the noisy to the peaceful, the colourful to
the severe, the everyday to the unusual. All good museums do
this and this is such a simple argument it is mystifying as to why
it seems so hard for some critics to understand. In many ways it
is technological advances which have enabled us to deliver this
variety, but it is social change which provides the imperative.

Tracking and working with change makes intense demands of
museum Directors, but in recent times we have also witnessed a
hostile and sustained attack on funding for the museum sector,
which has made the task of leading museums ever more challen-
ging. In order to survive and prosper, Directors have found
themselves reassessing the whole range of museum functions.
Good Directors have reshaped their organizations so as to max-
imize the support needed by their museums, from the public,
from politicians, from the private sector. Such reshapings have
taken many forms. Some Directors have built up marketing and
fundraising, or commercial functions. Others have placed greater
emphasis on their educational activities and on activities outside
the confines of the museum. Still others have enhanced their exhi-

bition programmes and permanent displays. Some of these changes have resulted from positive action in pursuit of a bigger social and educational role; others have been responses to intense financial pressure. Not all changes have been welcomed by staff fearful of change and fearing for their jobs. Indeed, Directors attempting to fight their way out of their financial troubles have not always succeeded. Some have found themselves facing impossible challenges. None the less, good Directors have given their museums a fighting chance by responding to financial pressure head on rather than attempting to ignore it; by ensuring that their museums are valued and supported, through making them supportable; by never accepting the status quo, and always questioning assumptions; by *thinking* all the time about the leadership challenge.

Successful museum Directors have a number of achievements in common. If they work in local government they will have won strong political support, with their museums high on the political agenda. Too many local authority museum Directors have been uncomfortable with the essential role of liaising and *working* with politicians. Directors need to be the interface between political agendas and the immense social and cultural value locked up in museum collections: if they can only do one thing well, it must be this. The Director needs to understand the political process, and to *believe* in it, especially in political accountability. Such belief ensures that political challenges can be met by the museum, and that thereby the potential of the museum can be understood, and so realised.

The successful Directors will have built extensive private sector networks in response to the growing need for identifying new sources of funding, but also because of the importance of business people being advocates of museums, which can bring numerous benefits. They will have good working relationships with the higher and further educational sectors. They will have good relations with the media. Their museums will have a wide variety of partners – other arts organizations, community groups, schools. They will have strong community support and high visitor numbers. They will have a reputation for vitality and innovation. They will have been brought in from the margins, and be central to local regeneration strategies. In short, the Directors have inspired people well beyond their own jurisdiction, and will have

built confidence in their museum. The successful Directors will have effective management structures, and first class, highly-motivated staff, who share and own the big vision. They will, by and large, have protected overall staff numbers without having bled dry their operating budgets. They will not have dazzled without substance.

Few Directors record uninterrupted success both because the job is so extremely complex, and because it is a very rare individual who possesses all the skills needed. Far more often, the successful Director is the leader of a successful team, and it is the synergy between the two which brings about achievement. Indeed, it may be noted that leadership does not always come from the Director: it may come from lower down the hierarchy in certain circumstances, which is not all that surprising bearing in mind that many staff may be leaders of their own units, albeit subject to a higher authority. Ultimately, of course, even the most independent Director is him- or herself, subject to a higher authority.

There have been many museum Directors who have risen to the extraordinary challenges which have confronted our sector in the past two or three decades. The relative health of the sector owes much to the qualities of leadership displayed by these people. However, the profession has not registered uninterrupted success, and the consequences of weak leadership in museums can be dramatic. There are museums spread fairly liberally around this country that have been put in trouble by their Directors: where morale is low, suspicion is rife, sectionalism is rampant, performance is poor, and where the blame for this is so often placed at the door of politicians. We have seen this happen time and again. Such Directors tend to share certain character traits. Prominent among these is a disdain for their staff, a failure to recognize talent and a failure to delegate effectively. One Director once said, when asked what happened at his museum in his absence, 'Nothing. Absolutely nothing.' This was said with no small sense of pride. Timidity is another characteristic of poor leaders: this is really simple lack of judgement, and in times of change it can be crippling. It is often linked with a defensiveness which is quite demoralizing. Worst of all is the contempt in which some Directors have held the process of local government – not just a lack of understanding, but a lack of respect. A Director with such a view will lead a museum service into oblivion.

What is the future of museum leadership? Because there will always be doubt and disagreement about the value of our cultural institutions when society is under stress, Directors will continue to have to fight very hard. Museums will never be regarded unquestioningly as indispensible parts of our society, and they will need quality leadership every bit as high as the political or business sectors. Striking a balance between encouraging what is best in museum practice, and encouraging outsiders to provide support for that best practice, will remain the central challenge confronting Directors.

How, though, will we find Directors with the right leadership qualities? We need to maintain the current trend of getting museums more involved in contemporary social issues, thus placing them on political agendas and winning real status. In this way the combination of the traditional appeal of museums with a sense of a high energy relevance will enable them to attract high calibre people. But we also need to create a new professionalism – beyond scholarship – through training in management and leadership skills, which is so lamentable at present. The museum profession is one of the last outposts of the gifted amateur, the manager and leader by default. Give museum people the skills, and the future of museums will be very bright, and professionally led.

ACKNOWLEDGEMENTS

I am grateful to Sharon Granville for her help in my writing this paper.

BIBLIOGRAPHY

Dorment, Richard (1992) 'Are Galleries Losing Art?', *Daily Telegraph*, 9 September 1992.

Grainer, Stuart (1996) *Key Management Ideas* (Pitman).

Machiavelli, Niccolo (1995) *The Prince*, transl. by George Bull (London: Penguin).

Sewell, Brian (1997) 'The Calamitous Decline of Our Museums'. *Evening Standard*, 22 May 1997.

Starratt, Robert J. (1993) *The Drama of Leadership* (London: The Falmer Press).

5

Visionary Leadership and Missionary Zeal

STUART W. DAVIES

INTRODUCTION

It is necessarily convenient that complex issue areas be divided up into management units for the purposes of teaching, training, and personal development. Each then proceeds to grow specialists and develop its separate literatures, its separate conferences and even its separate journals. But one significant problem in doing this is that important linkages between the units may be obscured or lost. Business management studies are no exception. In this paper two usually quite distinct 'topics' are covered – leadership and museum statements. Leadership is often seen as the domain of organizational behaviour or human resource management. All organizations need good leaders and academic enquiry has focused on 'what makes a good leader' and how good leadership relates to good organizational performance. On the other hand mission statements belong to the domain of strategic management (although they may be sometimes hijacked by marketing academics desperate to poach all the best ideas). Mission statements are placed at the pinnacle of a process designed to produce good strategies and if not to guarantee business success, at least manage or reduce the consequences of uncertainty in the environment.

This paper looks at both these topic areas in the context of museum and gallery management. It reviews the literatures, presents research findings and discusses the implications for the museum manager. The evidence for museums is drawn from four principal sources: interviews with managers; focus group discussions with managers; a questionnaire survey; and a contents analysis of mission statements. For the gathering and analysis of data

the author would especially like to thank Nichola Johnson and participants on the annual UEA Museum Leadership Programme, all the managers who have generously cooperated with the project and Helen Watts for assisting with the analysis of data.

LEADERSHIP: FINDING A DEFINITION

Studying leadership is difficult because of the vast amount of literature and the lack of generally accepted principles or undisputed models. This was recognized as a problem over ten years ago.

> Decades of academic analysis have given us more than 350 definitions of leadership. Literally thousands of empirical investigations of leaders have been conducted in the last seventy-five years alone, but no clear and certain unequivocal understanding exists as to what distinguishes leaders from non-leaders, and perhaps more important, what distinguishes effective from ineffective leaders and effective organisation from ineffective organisations. Never have so many labored so long to say so little. (Bennis and Nanus, 1985)

This rather pessimistic view can now be credibly challenged, but it remains true that leadership consistently denies the simple categorisations or models so beloved of business management academics and MBA teachers.

The first point to make is that leadership is recognized as being very important in an organization. Its importance can be overemphasized to the point of being romanticized and the link between leadership and organizational performance is difficult to demonstrate, but the importance attached to leadership by all stake holders (as well as leaders themselves) is a clear indication that we are dealing with a critical factor in organizational management and success.

Defining leadership, we have already been told, is difficult. This paper will adopt one of the simpler but effective definitions on offer (Shackleton, 1995).

> Leadership is the process in which an individual influences other group members towards the attainment of group or organisational goals.

It is an attractive definition because it places emphasis on the leader as an influencer, the relationship between him or her and

the group (or 'followers' as they are sometimes called) and the need to keep the attainment of goals clearly in focus. Much of this paper's discussion of leadership draws on Shackleton's excellent assessment of the issues.

Other definitions put emphasis on power, style, charisma, follower compliance, empowerment and transformation. The variations on the leadership theme are almost endless. Bennis and Nanus (1985), for example, considered that leadership was about path finding and 'about doing the right things'. The leader provides the vision and strategic thinking for an organization while the manager is much more of a 'doer', the one who implements the vision. Kotter (1990) suggested four key roles of a leader (as opposed to a manager):

1. Establishing direction
2. Aligning people
3. Motivating and inspiring
4. Changing outcomes

The leader, in this view, has considerable responsibility for challenging the order and stability apparently craved for by managers, and driving change in the organization. Shackleton (1995) emphasizes the influencing role of a leader, as seen in his definition which this paper adopts. This view is a useful reminder that leaders may not necessarily be linked to a particular function in the organization but may earn their spurs through the impact they have on others' actions rather than by their own. This may of course be particularly pertinent in organizations where stakeholder management is important, which will often include museums and galleries.

LEADERSHIP THEORIES: TRAITS, STYLE, CONTINGENCY AND ATTRIBUTES

A number of theoretical frameworks or approaches to explain leadership have been developed, none of which have proved to be entirely satisfactory when empirically tested. The main four have been traits, style, contingency and attribute theories. Each has something to offer towards our understanding of leadership in the context of museums and galleries.

Early research assumed that it would be possible to identify traits or characteristics which are shared by good leaders and therefore, of course, to identify future leaders. A considerable amount of research by psychologists and others have succeeded in identifying a few traits which generally distinguish leaders from non-leaders.

- Drive
- Leadership motivation
- Honesty and integrity
- Self-confidence
- Cognitive ability
- Knowledge of the business

However, attempts to identify a simple formula for leadership effectiveness foundered because so much depends on the situation, the nature of the organizational goals and who the 'followers' are.

Disillusionment with the traits approach led to researchers looking at leadership style, and seeking to establish which style was the most effective. Scales of style – typically ranging from authoritarian to democratic and consultative – were created and techniques developed to assess where leaders should be placed along it. Some scales were linear while others tried to balance two or more factors (such as being goal-orientated or people-orientated) in a grid arrangement. Unfortunately all the models turned out to be flawed by the fact that leaders often act differently depending on the situation they find themselves in. Good leaders have no one style; they are often style chameleons.

The response to this has been to develop contingency theories. These recognize that leadership style and behaviour is dependent (contingent) upon the context. Contingency theorists have explored the relationship between situation (context) and behaviour. Unfortunately it is difficult to agree on which of the many contextual variables or factors are most important and what impact they have on leadership anyway. What has emerged is that context must be important but so too is the relationship between leader and follower. This has been the major concern of attribution theorists.

Attribution theory suggests that any event can have a variety of causes, and is concerned with how people react to events and

each other. We should be able to observe the behaviour of leaders and followers and then attribute causes to that behaviour. However, 'cause and effect' may not be simple or clear cut and attribution theories fall down when the boundaries between perception and reality are blurred or not understood. 'Effective leadership lies just as much in recognizing the perceptions of the parties involved, as it does in the reality of what actually takes place' (Shackleton, 1995: 57).

If none of these four theoretical approaches have provided 'the answer', the research associated with them has helped to clarify the general nature of leadership. Most importantly leadership is now understood not to be a single entity applicable on all occasions, but rather to have a number of variations which may be more applicable or appropriate depending on circumstances. In other words the research suggests that we should move from focusing solely on the qualities and skills we expect leaders to display towards a more rounded view which includes the environmental factors influencing leadership.

It does however appear to be possible to identify seven groups of factors which make significant contributions to the existence of effective leadership in an organization. Not all organizations (or leaders) will display all of these at once but together they seem to offer a tenable framework. These seven may be described thus:

1. Self-awareness leadership
To be effective, leaders must want to be leaders. They must want the power, influence and status it brings, even if their reasons for wanting it may vary enormously. They must also have the energy, drive and self-confidence that is necessary to both achieve leadership and to be effective leaders. Self-awareness of their own ambition encourages – it is contended – the development of self-awareness in others.

2. Strategic leadership
Leaders have cognitive ability and can use their intelligence in a practical way to observe, understand and assess what is happening around them. Above all else, this enables them to develop a vision for the organization which many researchers have recognized as a significant part of leadership.

3. Charismatic leadership
In Greek, the word 'charisma' means 'divinely inspired gift'. However research suggests that charismatic leaders are those who have developed the ability to motivate and inspire followers, although they are often helped if the values of leader and followers are similar.

4. Relationship leadership
The relationship between leaders and followers is clearly important. Crucial to this may be the leader's use of power. Is he or she sensitive to the needs and feelings of others? Is power used appropriately and sparingly while influence is the main tool of leadership? Effective leaders will probably possess 'referent power' – they will possess qualities admired by their followers.

5. Professional leadership
Effective leaders 'know their business' and are professionally respected by their followers. They influence their followers through their possession of 'expert power'.

6. Situational leadership
The ability of the leader to 'read', understand and adapt to the situation he or she is operating in at any one time may be crucial to effective leadership. The leader needs to react and adapt intelligently to the situation, being flexible in style and approach.

7. Transformational leadership
An effective leader will recognize the need for change and make it happen. The vision will be set and communicated to the whole of the organization. The leader will set the agenda, monitor the change process and set a good example, ensuring constancy between the vision (and its underlying values) and the leader's own actions. A review of the evidence suggests that 'most researchers agree that transformational leadership involves creating a new vision which points the way to a new state of affairs for a desirable future' (Shackleton, 1995: 129).

LINKING THEORY TO PRACTICE
So what does all this management theory tell us that might be helpful in understanding leadership in a practical museum man-

agement context? The answer is partly dependent on what question you ask. If we wanted to know what makes a good leader we might get the answer that it all depends on what you want!

We have seen that leaders usually have certain traits or characteristics, such as drive, motivation (the desire to be leaders), self-confidence, cognitive ability and knowledge of the business. But they will also be aware of the advantages and disadvantages of the type of style they adopt, whether it be autocratic, consultative, people-orientated, or goal orientated. The intelligent leader will also understand that the same style is not appropriate at all times for all occasions and with all people. Flexibility of style would seem to be important. That flexibility would also be a recognition that the qualities required of a leader may vary according to the context in which he or she is operating and the same leader may need to change his or her approach as the situation changes. And in all this the leader will be aware that his or her effectiveness depends upon his or her relationship with the 'followers' and his or her ability to 'read and understand' their needs and expectations. This necessary skill is not made any easier to acquire by the fact that perception may be more important than reality. What people believe to be so may matter more than what is actually so and therefore a 'good' leader may have to understand those perceptions in order to effectively lead the organization. In short, leadership is complicated.

Much of the academic management research has started from the 'what makes a good leader' viewpoint because it is assumed that good leaders are important in business, capable of making the difference between success and failure. Furthermore, despite the emphasis laid on 'knowledge of the business' and 'situational context' in the academic literature, many practitioners retain the assumption that leadership consist of a bundle of skills which can be readily transferred. By implication, therefore, the results of many decades of leadership research in a business context, ought to enlighten issues surrounding museum leadership. Is this actually so?

MUSEUM LEADERSHIP RESEARCH

What should be the agenda for research in this area? It would certainly be possible to add to the existing literature by examining any of the theories or testing any of the models in a museum

context. This would make a useful contribution to the leadership literature. However, it would imply that the most appropriate research should focus on 'the leader' as an individual and accept the agenda already developed in business and psychological research. It would also imply an assumption that leadership in public or not-for-profit organizations is similar to that of organizations in the for-profit sector.

Recent research focused on the University of East Anglia's annual Museum Leadership Programme (for senior museum managers) has taken a different approach. It has asked the question 'what do museums need in leadership' and attempted to create a 'photofit' of a good museum leader from an organizational needs perspective rather than identify effective leaders and analyze them. In this the research has been influenced by Meindl who has called for the 'reinvention of leadership', changing research from being 'leader-centred' to being follower-centred. The principle here is that we should try and determine what the followers (or the organization) need and leadership should fulfil this only to the extent that it is necessary. In other words, organizations and followers only subscribe to the leadership that they need rather than being driven or dragged along by a leader acting out established perceptions of what role he or she should be fulfilling.

The first research exercise was a focus group of twelve senior managers from a variety of museum organizations (including National, local authority and independent museums). None of the managers were the head of their organization. The objective of the exercise was to explore whether or not there were any 'special' features of leadership in museums and galleries which could be identified and subsequently used as a 'blueprint' for 'good' leadership. No knowledge of the academic literature was assumed or offered, reducing the likelihood that this approach would be challenged at the outset.

The group began by identifying a list of current issues facing museums and galleries in the UK. It was assumed that these issues would probably form the key agenda of most museum leaders – thus also assuming the leader's strategic role. The issues identified were:

• Declining public funding
• Constant change

- Demand for accountability
- National Lottery
- Increasing expectations
- Market forces
- Costs
- Productivity/VFM
- Politics

There was general agreement that change was endemic in museums and that good leadership was needed to deal with it. Discussion then turned to what exactly a museum leader was.

The group started off down the 'function' route. It was suggested that the museum leader was a 'captain of the ship'. This analogy worked quite well, up to the point where they began considering the relationship of the ship to other ships. The problem here is that we all tend to think of leaders of an organization being the person 'in charge' and with whom lies some ultimate authority. In reality, in few cases – if indeed any – leaders actually have full control of 'their' organizations. Things tend to be much more complicated, with many 'stakeholders' having a say or influencing (directly or indirectly) what happens within and to an organization. Furthermore, what is the relationship between the captain and the ship's culture? Is one determined by the other? And if so, which is which?

Undeterred, the group identified a number of leadership functions in museums and galleries:

- Responsibility
- Takes informed decisions
- Allocates resources
- Motivates
- Negotiates
- Instigates
- Represents
- Delegates
- Obtains resources
- Unifies
- Is accountable

But it was quickly observed that these functions may not necessarily be attributed to only *one* person in the organization

('the person at the top'), Some or many of them may be functions exercised by other people within (or even possibly outside?) the organization. This led to discussion about what may be the difference between 'the person at the top' and other leaders. How many 'other leaders' an organization may have is usually determined by each organization's unique circumstances: size, structure, objectives, the existence of clearly defined special projects, and so on.

This led naturally to some discussion about how these 'leaders' related to each other and particularly what role this left for 'the person at the top' – the traditional leader. It was rapidly realized that having many leaders could be beneficial in terms of organizational dynamics and the achieving of objectives; but, equally, many leaders operating with little reference to each other – or even as rival loci of power within the organization – could be disastrous. At this point the group set aside this knotty problem and addressed the issue of leadership attributes.

In discussion the group were cautious about the personal qualities required of a leader. They were not convinced that 'personality' was necessarily especially important. To them 'personality' was too closely associated in popular thinking with someone who is believed to have 'charisma' or is 'a character' 'or is 'bubbly'. To them it was much more important that the leader had the ability to 'make things happen' and that they had a 'management style' appropriate to the organization. As one member of the group said: 'The leader doesn't have to "speak" but somebody does!' The most important leadership skills may be in recognizing this and facilitating it. The leader had a very important 'overview' role: identifying what were the KEY SUCCESS FACTORS for the organization and ensuring that they were addressed, deploying the appropriate resources (including people) to achieve it.

This inevitably led the group back to the question of what distinguishes 'the leader' from other leaders within the organization. To facilitate discussion, the session leader offered 10 possible roles for a museum leader and some functions or activities which might be associated with them (Table 5.1). The group used these as a basis for trying to identify those leadership role/functions which were uniquely those of the head of the organization. This exercise, it was suggested, is essential to ensuring that the leader is effective. The leader needs to be focused or he or she may not

TABLE 5.1 Roles of the museum leader

- An individual
- Visionary
- Advocate and Ambassador
- Professional
- Mentor
- Empowerer
- Communicator
- Manager of Learning
- Strategic Manager
- Executive

only be personally ineffective but will also undermine the effectiveness of others (i.e. the boundaries of the leader's role need to be defined, communicated and accepted by everyone in the organization).

The group's discussion's lead to the identification of a number of specific (and possibly generic) roles for the museum leader:

1. Consideration of the long-term future of the museum/gallery organization
This should include attention to:

(a) vision/mission
(b) strategies (related to market/stakeholder changes)
(c) structures

2. Systems and framework
The leader must ensure that the museum 'works', including ensuring the appropriate deployment of resources, the existence of efficient work systems and the existence of clear communication channels.

3. Stakeholder management
Many – perhaps all – members of the museum will have contact with external stakeholders. But it is the leader's particular role to ensure their aspirations are satisfied (as far as possible) and that the museum benefits from its stakeholders rather than is endangered by them.

4. Exemplar

The leader has to 'set the tone' for the museum; his or her example is an important influence on both its external image and its internal motivation. To do this effectively the leader has to be equally respected by peers, less experienced colleagues and stakeholders alike.

5. Ultimate arbitration

'The buck stops here'. Not withstanding our earlier conclusion that no leader is in sole command of an organization, the museum will need someone to arbitrate on difficult issues, situations etc. Only the leader can – or should have this role.

6. Recruitment

This was added to the group's list on the insistence of a very experienced observer and led to a discussion about how influential the leader could be – or indeed should be – in recruitment matters. One thing was clear, however; the leader has a crucial role in changing the culture of the museum – whether by judicious recruitment or by releasing existing staff.

This concluded the session. The group had successfully identified the key areas where they – as museum leaders – should be focusing their thinking and action. They could then identify any shortcomings in their own skills or attributes and remedy them as part of the process of becoming outstanding museum leaders.

The second research exercise was questionnaire based. Before attending the focus group, each of the twelve members had been asked to circulate five colleagues at their institution with a questionnaire. Of the 60 distributed, 39 complete questionnaires were returned directly to the author, a return of 65 per cent.

The questionnaire explored just three issues in museum leadership but required quite considerable thought from the person completing it.

The four key questions were:

A. Leaders may have many *functions* in an organization. Please list FIVE, in priority order, which you would expect a good leader of a museum/art gallery to carry out.
B. Leaders may require many *personal qualities*. Please list FIVE in priority order, which you would hope that a good leader of a museum/art gallery should have.

C. Leaders may require *specific qualifications or attributes* to be effective. Please list FIVE in priority order, which you would expect a good leader of a museum/art gallery to have.

D. Of all the functions, qualities and qualification/attributes you have listed, which FIVE in priority order, do you regard as the most important?

Attached to the first three questions were prompt lists of possible answers to help respondents marshal their thoughts.

Since it was known where each questionnaire was returned from it could have been possible to cross-tabulate the replies according to type of institution but the sample was too small to make such an exercise statistically valid.

The free-form nature of the responses – which extended well beyond the prompts offered – meant that there were a large number of different specific responses. Many of these could however quite legitimately be grouped together.

To achieve a balanced picture of respondents' intentions, three different measures of importance were used in analysing the responses to each question. First of all the number of times that a type of response appeared anywhere in the list of five responses was counted up. These 'appearances' were then expressed as a percentage of the total possible. So, in table 5.2 for example, the function 'Produces a clear vision and focuses activities on achieving it' is mentioned by 33 out of the 39 respondents, scoring 85 per cent. Secondly, the numbers of times a type of response was ranked first as top priority is also noted in the 'First Choices' column. So in our example 'Produces a clear vision...' was first choice for 24 of the respondents. Finally, the five responses are attributed a score, 1 for first, 2 for second etc. and the total for each is presented as a Ranked Score, 1.36 in the case of our example.

The findings presented in Table 5.2 show that respondents indicated on all measures that the single most important function of a museum leader is to produce a clear vision and focus activities on achieving it. Two other functions achieved a ranking of less than 3.00 and both of these are clearly closely linked to the most important function: these are establishing policies, goals and strategies and setting clear objectives for individuals of the team. Taken together all three indicate that

TABLE 5.2: Leadership in museums: functions of a leader (n = 39; functions appearing less than 10 times not included)

Function	Appearances	%	First Choices	Ranked Score
Produces a clear vision and focuses activities on achieving it	33	85	24	1.36
Ensures adequate funding	23	59	0	3.22
Unifies team and maintains morale	21	54	1	3.71
Establishes policies, goals and strategies	19	49	8	2.11
Monitors performance	15	38	0	4.27
Sets clear objectives for individuals/team	14	36	0	2.64
Ensures service is understood/respected	13	33	2	3.08
Represents the institution externally	10	27	0	3.90

respondents see the overall function or role of the museum leader as being its strategist.

The other two important functions – ensuring adequate funding and ensuring that the service is understood/respected – relate to the leader's stakeholder manager role. Responsibility for the museum's relationship with key stakeholders – and particularly those relating to funding and governance – is a crucial role and respondents clearly feel that this should be vested in the leader.

Table 5.3 reveals a rather more normal set of results for what museum respondents consider to be the important personal qualities in their leaders. Top ranked here is the ability to communicate. Does this reflect a perception (perhaps based on experience) that museum leaders are not always good commu-

TABLE 5.3: Leadership in museums: personal qualities in leaders (n = 39; qualities appearing less than 10 times not included)

Personal Quality	Appearances	%	First Choices	Ranked Score
Is able to communicate	29	75	9	2.45
Can develop an effective team	22	56	5	2.82
Is able to delegate tasks	18	46	0	3.78
Is able to motivate	14	36	3	2.71
Gains respect and sets example	14	36	5	2.86
Has energy, enthusiasm, activism	13	33	2	2.69
Supports and shows loyalty	12	31	0	4.33
Is both fair and firm	10	27	0	3.30
Has persistence and toughness	10	27	0	3.50

nicators? If that is so then this has to be rather an ironic finding given that a significant function of museums per se is to communicate.

Two qualifications for museum leadership are pre-eminent according to Table 5.4. Supporting what we have already found, respondents stress that the museum leader needs to understand strategic issues. Perhaps this is assumed to include a knowledge of political and legislature issues and an understanding of the sector, accounting for their lower ranking. However, top position goes to the belief that museum leaders must have professional credibility. This does not necessarily mean they are professionally qualified and have had their career in museums but it is safe to assume that this is what many respondents would expect. Regardless of what skills 'outsiders' may bring in – or indeed how valued they may be at some other level in the organization – leadership is

TABLE 5.4: Leadership in museums: qualifications of leaders (n = 39; qualifications appearing less than 10 times not included)

Qualification	Appearances	%	First Choices	Ranked Score
Must have professional credibility	31	79	13	2.42
Understands strategic issues	26	67	8	2.23
Knowledge of political and legislative issues	23	59	0	3.43
Understands sector and opportunities	22	57	0	3.18
Experience in maintaining professional standards	12	31	5	2.58

seen as the domain of someone who must be professionally credible to museum professionals.

Finally Table 5.5 attempts to bring together all the findings and indicate the key factors in museum leadership. The clear first choice is that the museum leader produces a clear vision and focuses activities on achieving it. Two others in the list – 'establishes policies, goals and strategies' and 'understands strategic issues' – are obviously linked to this function. From this it is evident that, referring back to our earlier discussion about types of leadership, *strategic leadership* is what museum professionals want most for their organisations. After that – and allied to it – the leader must be able to secure funding. And what type of person should this leader be? He or she must have professional credibility and be able to communicate.

Taking the two sets of research findings and trying to reconcile them is an interesting exercise. The focus group – made up of individuals whose thoughts might be focusing on how they would operate as leaders in the not too distant future – tended to be a little introspective and concentrated much of their efforts on *what* a leader might do, and, to a lesser extent *how* it might be done.

TABLE 5.5: Leadership in museums: overall leadership characteristics (n = 39; characteristics appearing less than 10 times not included)

Overall Characteristic	Appearance	%	First Choices	Ranked Score
Produces a clear vision and focuses activities on achieving it	29	74	19	1.76
Ensures adequate funding	14	36	0	3.79
Is able to communicate	13	33	4	2.15
Must have professional credibility	12	31	2	3.42
Establishes policies, goals and strategies	11	28	2	2.54
Understands strategic issues	10	27	0	3.50

Their colleagues however were much clearer in their assessment of what was required: strategic leadership. The inference is that this may be lacking in many museums – perhaps because of the uncertainties indicated by the focus group debate or more generally because museum managers may be poor strategic thinkers. To explore this a little further this researcher decided to test the degree of strategic thinking in museums by examining a large number of mission statements, in the expectation that they ought to indicate the strategic position of the museum and encapsulate the broad views of the leader.

MISSION STATEMENTS: THE MANAGEMENT RESEARCH EVIDENCE

As with leadership, there has never been a universally accepted definition of a mission statement. Out of the many definitions on offer this paper has adopted Fred David's 1989 suggestion:

> An enduring statement of purpose that distinguishes one organisation from other similar enterprises ... a declaration of our organisation's

'reason for being' ... reveals the long-term vision of our organisation in terms of what it wants to be and who it wants to service.

Most definitions refer to vision or long term purposes (e.g. Matejka et al, 1993 and Klemm et al, 1991). But there is little in the way of agreed terminology – 'mission statement', 'corporate statement', 'aims and values', 'purpose', 'principles', 'objectives,' 'goals' and 'responsibilities' and 'obligations' all having been used to describe missions (Klemm et al, 1991). Nor can one expect to find much consistency in the form or context of mission statements. They can be as short as a simple sentence or run to many pages. They can be a single statement of a hierarchical series of statements. Sometimes they refer to 'aims', 'objectives', or 'targets' and appear in effect to be statements of business strategy. In others there may be a greater focus on values, beliefs, ethics and philosophy. They may refer to internal or external stakeholders; they may be vague or very specific: they can be unrealistically aspirational or a dull functional definition (Davies and Glaister, 1996).

Some researchers have tried to link mission statements with successful business performers and then to prescribe appropriate frameworks for creating a 'good' mission statement (e.g. McGinnis, 1981; David, 1989). Inevitably these have not been complementary, although they were generally in some way customer orientated and attempted to embody attitudes rather than specific programmes of action. The most innovative approach in recent years has been the creation of the 'Ashbridge mission model' which endeavours to reconcile conflicting views about mission statements in one model.

This model links purpose (why the company exists), strategy (the competitive position and distinctive competence), values (what the company believes in) and behaviour standards (the policies and behaviour patterns then underpin the distinctive competence and the value system). Taken together these can create a sense of mission which gives a meaningful focus to the organization's activities (Campbell and Tawadey, 1990; Campbell and Yeung, 1991). However the universality of this model has been challenged (Piercy and Morgan, 1994), it being suggested that different needs may require different types of mission statements.

If there is not yet complete agreement on what constitutes a good mission statement there is at least broad agreement that they are necessary, or at least useful. The concept of 'mission' being a key element in any organization has been around for over twenty years:

> A business is not defined by its name, statutes or articles of incorporation. It is defined by the business mission. Only a clear definition of the mission and purpose of an organisation makes possible clear and realistic business objectives. (Drucker, 1973)

Most of the reasons for producing and using mission statements fall within one or more of four basic areas: (1) to give a clear definition of the business; (2) to explain the business to external stakeholders; (d) to establish a starting point for the strategy process; and (4) to motivate and inspire employees within the business, including instilling appropriate values among them (Davies and Glaister, 1996).

When transferred from the business sector to the public and not-for-profit sectors, it can be seen that the key importance of the mission statement probably lies in its role of stating quite clearly the purpose of the organization in such a way that that purpose can be clearly communicated to internal and external stakeholders. In a sector where organizations have multiple goals and multiple stakeholders (sometimes conflicting with each other) this can make mission statements an important tool in facilitating consistent decision-making and empowerment of managers.

MISSION STATEMENTS: THE EVIDENCE FROM MUSEUMS AND GALLERIES

A full research study of how museum mission statements are formulated, by whom and why, has not yet been undertaken. Nor has an assessment been made of how they are used and if they have any apparent impact on individual museums or the sector in general. Structured interviews with a pilot sample of fifteen museum managers strongly suggested that the conclusions of such a study would be little different from a recent detailed assessment of mission statements in institutions of higher education. 'Very mixed in context, they appear to be poor on the degree of participation during formulation and weak in their application' (Davies and Glaister, 1996: 291).

Nevertheless, a contents analysis of 270 museum and gallery mission statements has been undertaken to provide an overview of to what extent they reflect the acknowledged leadership role of providing strategic direction for the organization. That the two are always linked cannot be proven, but, as has been suggested, one common criticism of mission statements is that they are too often the result of the leader's view rather than being the outcome of a major consultative exercise with all stakeholders.

In this contents analysis six key questions were asked of each mission statement:

i) Does the statement appear to be 'official' or just made up in response to this study?
ii) Does the statement convey a sense of the museum's values?
iii) Is the statement purely functional or does it convey a sense of the museum's aims?
iv) Does the statement emphasize the museum's collections, visitors or both?
v) Does the statement refer to stakeholders?
vi) Does the statement follow the MA or ICOM definition of a museum?

These are not generally the 'classic' type of analytical questions asked of business mission statements, usually designed to test the existence or absence of pre-determined mission statement features such as strategy, behaviour standards, ethical references and so on (see e.g., David, 1989). However, in this case a preliminary examination of the mission statements suggested that such an approach might be at least premature and possibly even misleading.

OFFICIAL MISSION STATEMENTS

The statements were assessed to gauge whether they have the impression of being 'official' validated documents, carefully conceived and probably formally adopted by the museum. Strong indicators of 'unofficial' statements were those not copied from an official document, grammatically poor or evidently incomplete. As a result no less than 37 per cent of the 270 mission statements were declared 'unofficial' and invalid.

VALUES

The values of the museums were identified using a key word approach. The three main values were concerned with education (in its broadest sense), access and enjoyment. Of the 171 valid questionnaires, 61 referred to education.

> The advancement of the education of the public in the maritime archaeology and heritage of the local areas. (Yarmouth Maritime Heritage Centre, Isle of Wight)

A further 31 made reference to understanding (14), knowledge (6), inform (6), learn (4) and enlighten (1).

> To promote the appreciation and understanding of the men and women who have made and are making British history and culture through the medium of portraits. (National Portrait Gallery)

Access was also an important value, mentioned 26 times.

> Promoting creativity, artistic excellence, and accessibility through a programme of stimulating exhibition, interpretative work and activities. (Wolverhampton Arts and Museum Service)

Even more popular, however, were references to enjoyment, which occur in 35 of the statements.

> To enable and enhance public enjoyment and appreciation of the natural, artistic and cultural heritage of the District of Woodspring. (Woodspring Museum)

Other values referred to were indicated by the word 'interest' (15), 'quality' (11) and 'stimulate' (7).

> To collect, preserve and interpret items which excite curiosity and interest in the history of Tamworth and its people. (Tamworth Castle Museum)

> The museum and heritage service will provide high quality services for the Royal Borough of Kingston. (Kingston-Upon-Thames Museum and Heritage Centre)

> To communicate and stimulate curiosity and fascination in the cultural and industrial heritage of inland waterways. (The Boat Museum, Ellesmere Port)

In total 132 of the 171 valid questionnaires made some reference to values (77 per cent).

STAKEHOLDERS

There were many references to some of the broader stake-holder constituencies associated with museums, public (52), all (15), visitors (12), nation (2) and customers (2) all received mentions.

> The museum exists to promote the public's understanding of the history and contemporary practice of science, medicine, technology, and industry. (The Science Museum)

> To promote the services of Bolton museums and art gallery through the care, interpretation and development of the collections for the enjoyment and education of all. (Bolton Museums and Art Gallery)

In addition to this 41 statements made reference to more specific sets of stakeholders, such as 'residents' or 'community'.

> The museum service aims to provide a high quality service to Newham residents that is educational, accessible, relevant and popular. (Newham Museum Service)

> To provide a museum service to all people living in or visiting Wake-field Metropolitan District. (Wakefield Museums Service)

This type of statement is of course most common among local authority museum services. Specialist museum services such as company or regimental museums, frequently make reference to specialist stakeholder groups.

FUNCTIONAL OR STRATEGIC?

Two-thirds of the mission statements analyzed may be described as functional. Only 33 per cent of them made any reference to aims and none contained any statements which could be inter-preted as being an indication of the museum's strategy. A typical example of a functional mission statement is:

> To collect, document, preserve, exhibit and interpret material evidence and associated information concerning the human and natural history of the Stewartry for the public benefit. (The Stewartry Museum)

The conservative nature of the missions statements is empha-sized by the fact that 66 per cent of them focused on collec-tions and visitors and all of course made reference to collections.

This emphasis on the function of museums is reinforced by the heavy reliance of many statements on the MA or ICOM definition of a museum, although few were quite as blatant as the respondent for Egham Museum who stated that their mission statement was 'as per ICOM definition for the local area of Egham, Eaglefield Green, Virginia Water and Thorpe'. Our analysis found that 70 per cent of statements contained at least three out of the six elements in the MA definition. Some statements almost replicated word for word the MA definition.

> To collect, preserve, document, exhibit and interpret material evidence of Hereford and Worcester's history for the public benefit.

Others simply utilized the keywords or adapted the basic definition to their local needs.

CONCLUSIONS

We have agreed that the literature on leadership and mission statements indicate that there is a very wide range of views about the empirical evidence available to us. The studies (largely carried out in the for-profit business sector) suggest that there is little consensus about the most appropriate approaches to leadership and that even the most recent mission statement models are contentious.

However, our study of what managers expect of a leader in museums gives a much less equivocable picture. The importance attached to the leader engaging in strategic leadership is quite clear. This may well reflect a considerable degree of concern and uncertainty, related to the weak position museums tend to hold in their operating environment. But it is a positive pointer to what leaders need to be doing.

One opportunity available to leaders is to use mission statements to clearly communicate the strategic direction of the museum for the benefit of all stakeholders, but perhaps particularly their operational managers. The basic contents analysis which we have carried out suggests that this opportunity is not yet being fully realized, but the importance of communicating to stakeholders – highlighted by the focus group – is at least recognized.

Mission statements' potential as a leadership tool is probably

not well understood. Most managers (in interviews) indicate that they are sceptical of their value and see them as something which they feel they ought to provide to satisfy an external stakeholder – usually a funding body – as part of the strategic planning process. This negative image of the mission statement is further reflected in the type of statement produced – functional rather than strategic. Certainly a link between mission and leadership is rarely made by museum leaders or managers themselves.

Our findings require further investigation but there is a strong suggestion that the requirements of museum leadership are readily recognizable. Furthermore, while the usual concerns about style and method cannot be set aside, the museum leader could considerably enhance his or her effectiveness by making more strategic use of the mission statement. As a whole this piece of research emphasizes the importance of the leader's role as strategist and stakeholder manager while not denying that other roles may also be significant depending upon the museum's particular circumstances. The museum leader emerges as a strategy, stakeholder and contingency manager.

BIBLIOGRAPHY

Bennis, W. and Nanus, B. (1985) *Leaders: The strategies for taking charge* (New York: Harper and Row).

Campbell, A. and Tawadey, K. (eds) 1990) *Mission and Business Philosophy* (London: Butterworth-Heinemann).

Campbell, A. and Yeung, S. (1991) 'Brief case: Mission, vision and strategic intent', *Long Range Planning* 24 (4): 10–20.

David, F. (1989) 'How Companies Define their Museum', *Long Range Planning* 22 (1): 90–7.

Davies, S.W. and Glaister, K.W. (1996) 'Spurs to Higher Things? Mission Statements of UK universities', *Higher Education Quarterly* 50 (4): 261–94.

Drucker, P.F. (1973) *Management: Tasks, Responsibilities and Practices* (New York: Harper and Row).

Klemm, M., Sanderson, S. and Luffman, G. (1991) 'Mission Statements: Selling Corporate Values to Employees', *Long Range Planning* 24 (3): 73–8.

Kotter, J.P. (1990) *The leadership factor* (London: Collier Macmillan).

McGinnis, V. (1981) 'The Mission Statement: A Key Step in Strategic Planning', *Business* November/December: 39–43.

Matejka, K., Kurke, B. and Gregory, B. (1993) 'Mission Impossible?

Designing a Great Mission Statement to Ignite Your Plans', *Management Decision* 31 (4): 37–47.

Piercy, N.F. and Morgan, N.A. (1994) 'Mission Analysis: An Operational Approach', *Journal of General Management* 19 (3): 1–19.

Shackleton, V. (1995) *Business Leadership* (London: Routledge).

6

Project Management in Practice: The Museum of Liverpool Life

LORAINE KNOWLES

INTRODUCTION

Many aspects of museum work could be described as projects. The term is used to describe any discrete activity which has a distinct beginning and an end, and to which specific and finite financial and human resources are dedicated; in this respect museums are no different to any other organization. The size of the project may vary but the principles of project management remain the same, whether the project consists of a temporary exhibition, the re-organization or move of a collection store or the creation of a new museum, and success will depend on the way in which the project is organized and managed from beginning to end.

The paper starts with an introduction to the author's background and that of her employing institution, National Museums and Galleries on Merseyside (NMGM). A brief discussion of the qualities which make a good project manager and successful project management follows. The main focus of the paper is project management in practice with particular reference to the Museum of Liverpool Life (MLL) from the development of the vision for the museum to evaluation of the finished project – the first phase of the Museum.

AUTHOR'S BACKGROUND

My project management experience is based on practice rather than theory: it began with the organization of small-scale temporary exhibitions as an Assistant Curator at Chichester District Museum. When I moved to Merseyside the size of the projects

increased incrementally and as their scale increased so their time scale decreased: thirteen months to set up the Prescot Museum of Clock and Watchmaking which opened in 1982; six months to set up the Merseyside Museum of Liverpool History (MLH) which opened in 1986 and three months to establish a visitor attraction at St. George's Hall which opened in 1988. The time frame of three years for the creation of the MLL was longer but no less pressured.

BACKGROUND TO NMGM

NMGM is a non-departmental public body, founded in 1986 by an Order in Council, and grant-aided by the Department of National Heritage. It has seven sites open to the public: Liverpool Museum, the Walker Art Gallery, the Lady Lever Art Gallery, Sudley, Merseyside Maritime Museum (including HM Customs and Excise National Museum), the Museum of Liverpool Life and the Conservation Centre. Administratively, the organization is divided into 5 divisions: the Liverpool Museum division, the Maritime Museum division, the Art Galleries division, the Conservation division, and the Central Services division (Figure 6.1).

The creation of the MLL was a direct result of the internal re-organization and re-structuring which resulted from the establishment of NMGM. Prior to 1986 Liverpool's non-maritime history was the responsibility of the Social and Industrial History department within the Liverpool Museum. The MLH was established alongside and separate to this department between September 1985 and March 1986 on the initiative of the Leader of the Merseyside County Council which in 1985 was one of the six Labour-controlled Metropolitan Borough Councils facing abolition by the Conservative government. The MLH had been assigned a building – the former County Sessions House – purchased as an extension to the Walker Art Gallery. Once NMGM came into being the Social and Industrial History department and the MLH were merged to form the Regional History department within the Maritime Museum Division and the Trustees resolved to revert the County Sessions House building to art gallery use. Hence a new site for the museum was required and a new project was born.

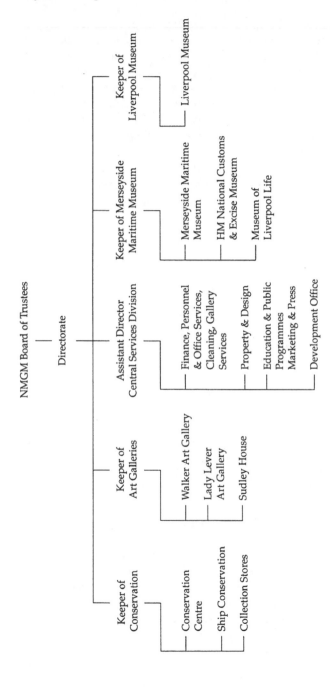

Figure 6.1: Organizational structure of National Museums and Galleries on Merseyside (NMGM)

WHAT MAKES A GOOD PROJECT MANAGER?

To succeed as a project manager you not only need to be a good organizer, and like getting things done, you also need to like working with people and be able to get the best out of them because it is only *through* people that you will achieve your project. Good project managers involve the project team in the planning process and problem solving. They are likely to be the following Belbin team types: shapers, resource investigators, and co-ordinators (Belbin, 1981). They will be on the side of extroversion rather than introversion, able to argue effectively for resources and like/ thrive when working under pressure: deadlines may change slightly as projects develop but it is up to the project manager to ensure that deadlines are achieved.

Project Management Theory

There is an extensive literature on project management theory particularly in the USA of which Baker, 1992, is recommended and I do not intend to address the theory here other than to refer to the basic tool for project management to which most literature refers – networks or critical path analysis. This is a tabular way of displaying the relationships between the various tasks which make up a project.

It allows the project manager to assess the consequences of a delay in one of the tasks; to identify bottlenecks and potential problem areas before they occur and to see where the difficult tasks and the tight deadlines fall. It also gives the project manager the opportunity to explore the effect of alternative courses of action. Critical path analysis can either be done manually, for example, by writing each task on a post-it note and sticking it on a white board and drawing the dependencies between tasks with a marker pen, which makes it easy to re-arrange tasks and explore different options, or by using computer software such as *Microsoft Project*. The method that you use may depend on the complexity of your project or the computer resources you have or indeed whether you feel comfortable using the project software at your disposal. There is a tendency to think that 'computerizing' the project in itself solves the problem. This is not the case – continually monitoring and adjusting the project's tasks is essential. The computer output will only be as good as the information you input. Your relationship needs to be with your project team not with your computer!

Project Management in practice
Before a project manager gets into the detail of critical path analysis he/she will have gone through a number of preliminary stages. The first and most fundamental of these is the development of the vision. Unless you have a vision you won't know where you want to go and you probably won't get there.

With the MLL the vision was quite simple: to ensure the survival of Liverpool history within what was now a national museum service and to unite all the Liverpool history collections on to one site. When the Regional History department was created in 1989 the collections were split across four sites: the MLH, the Large Objects Collection, the Liverpool Museum and a city centre store. The political background to the MLH has been referred to above. This was a key issue, to which the Trustees' response was that a move to a different site would be done on a betterment basis. The other issue was how to unite the MLH and the other 'inherited' collections onto one site. The answer to this was to find the right site.

THE SITE AND BUILDING CONVERSION
Four options were identified and appraised: space within St. George's Hall, a grade 1 listed neo-classical former law court and concert halls building, which NMGM was interested in acquiring for museum use; a gallery within the Liverpool Museum; a gallery within the Maritime Museum and a group of buildings on the Liverpool waterfront at Mann Island where the Maritime Museum had begun in the late 1970s. The option which offered the greatest physical flexibility and allowed the museum to retain a separate identity was Mann Island. It also made sense to have Liverpool's city history alongside its maritime history. There were three buildings on the Mann Island site: the former Liverpool and Glasgow Salvage Association shed (1926) known as the Boat Hall because of its use by the Maritime Museum for a display of small boats; the Shipwright's Shed (1897) originally used as a store by the shipwrights who worked in the graving docks opposite and subsequently used by the Maritime Museum as a schools shop and exhibition area and the Pilotage building, the headquarters of the river pilots until 1978, into which the Maritime Museum had installed a temporary exhibition about Fort Beland on its ground floor (Figure 6.2).

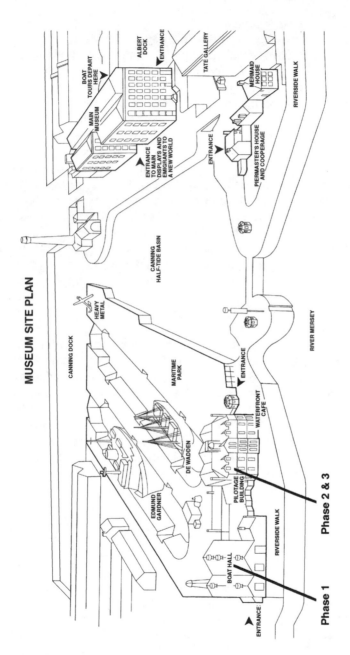

Figure 6.2: Museum site plan

All these buildings faced the river on one side and the city on the other and this seemed appropriate for a museum about the history of a city which owed its growth to the port. They were independently accessed but only from the quayside. Most of the passing visitor trade was on the riverside along a promenade linking the, by now, major visitor attraction of the Albert Dock to the Pier Head. In the past this was the departure and arrivals point for passenger liners. It now serves only as the main terminus for the Mersey Ferries. Across the graving dock was another redundant building – the Great Western Railway transit shed. The challenge was how to unify this motley group of buildings and bestow on them some sort of presence given that physically they were dwarfed by the Liver, Mersey Docks and Harbour Board and Cunard buildings to the north and Jesse Hartley's Albert Dock to the south. An equal challenge was convincing colleagues that all of these buildings should be allocated for MLL purposes which I knew to be necessary if betterment for the department's collection was to be achieved. Until this hurdle was overcome the project could not be defined more precisely.

Adapting buildings for museum life is never easy particularly when the collections one is seeking to house range in size from a trade union badge to a railway locomotive. I knew that without all of these buildings it would be impossible to replace the Museum of Labour History displays and provide space to display at least some of the social and industrial history collections. The latter included the King's Regiment collections to which a gallery had been devoted in the Liverpool Museum since 1972. There were also the land transport collection, part of which had been on display in the Liverpool Museum since 1969. It was clear, however, that none of the Mann Island buildings would provide alternative accommodation for this gallery. However there was the potential of future extension on part of the museum car park. As estate agents say the most important things to bear in mind when buying a house are position, position and position. The same could be said of siting a museum. With the exception of the Pilotage the buildings on offer were not of any great architectural merit and one of them in particular (the Boat Hall) had a limited life. However, their position was outstanding and the key to their usefulness was quite simple: they needed to be physically linked

so that visitors could move from one to the other without getting wet – an important consideration in the Liverpool climate.

After nearly a year of negotiation, from autumn 1989 to autumn 1990, it was finally agreed that the three buildings mentioned above would form the new museum. The Great Western Railway shed, however, was allocated to the recently established Conservation division. As it turned out this was not that great a loss – the building was long and narrow and not really suitable for any of the land transport collections as it was initially thought it might be.

Having secured these buildings the time was right formally to agree the mission of the new museum and to set up the project team which would develop the concept. This was done by inviting education, public programme and marketing staff to join forces with the designers and curators who would be responsible for the detail of the museum design brief. The first task of the project team was to consider who the stakeholders in the museum might be what its market might be, its new title – market research had shown that the Museum of Labour History's title had deterred visitors, especially women – and the needs of disabled visitors prior to considering the concept for the displays.

One of the key marketing issues was the fact that the MLH, like the other museums in William Brown Street, where the MLH had been located, had enjoyed free admission. The Maritime Museum site, within which the new museum was situated, had from its inception charged admission. How could we 'sell' not only the move of the Museum of Labour History to its supporters – to what they in effect regarded as a tourist location – but also the fact that they would now have to pay?

The inspiration for the solution to this problem came from another museum: Tullie House in Carlisle which had recently introduced their 'Tullie card' a special admission deal for local residents. It was therefore proposed to the Director and Trustees of NMGM that this was the only way forward: a special ticket for local residents. They would pay a slightly reduced admission charge once and be given a 'boarding card; which would entitle them to as many repeat visits in the course of a year as they

wished. The Trustees agreed to adopt this scheme and to apply it to the Maritime Museum as well, since the Maritime was experiencing a noticeably small number of repeat visits from local residents. Given that the charge was no more than the price of a packet of cigarettes or fish and chips I felt it was defensible against potential critics.

Without this concession it would indeed have been difficult to convince our supporters, who were invited into the museum to hear about the future pans, of the benefit of the move. Even so, some were sceptical and suspicious of the Trustees' motives. They feared the museum would at least be 'sanitised' or at worst swept away.

Having, on the whole, settled this major potential stumbling block it was now possible to proceed with determining the themes of the new museum. One of the early proposals when considering the move to another site was that the museum might literally be transferred case for case and graphic panel for graphic panel. Although this may have satisfied some of our supporters, and might have been easier and cheaper to achieve, I resisted the idea because the Museum of Labour History's establishment had been so time-pressurized that all of its displays have been based on existing research. This meant that there were certain topics which we would have liked to have included, such as the history of the ethnic communities and local women's suffrage, but couldn't because of lack of research time. Post-1986 a series of research-led temporary exhibitions had been instituted. The transfer to a new site provided an ideal opportunity to incorporate the results of that research into the new museum. The other factor was that the displays had been designed for a very different type of building, an 1880s law court, and a direct transfer would not necessarily have been that straightforward.

None of the MLL curatorial project team, except for me, had worked on the Museum of Labour History displays but two of them had been involved in its temporary exhibition programmes. It was decided to take three of the MLH themes; Employment, Building the Union, and Leisure, but to re-work them using new material wherever possible. Themes were therefore allocated on a subject specialism basis with each curator taking responsibility for a single theme but coming back to the group to discuss ideas and proposals. Whilst this process was underway a problem cropped

up on the buildings front: it was suddenly announced that only the Pilotage building was to be made available. As one of the laws of project management so rightly puts it: when things are going well, something will go wrong; when things can't get any worse, they will and when things appear to be going better, you have overlooked something. Had I overlooked something? I didn't think so. I thought I had won my arguments but it was obvious that I needed to put them again and win them again – but before vacating the Merseyside Museum of Labour History building, my main bargaining point. Conflict and problems are an inevitable feature of projects and coping with them is an essential part of project management but there is a limit to the amount of uncertainty with which one can deal. You can't, for example, plan new museum galleries beyond a certain point until you know where the galleries are going to be accommodated.

The summer of 1991 was thus spent re-making the case and at the same time preparing for the closure of the Merseyside Museum of Labour History scheduled for November 1991. By December 1991 when the staff moved offices to the Maritime Museum it was finally agreed that the first phase of displays would be installed in the Boat Hall with future phases in the Pilotage buildings. Almost at the same time we learned that an application to the Museums and Galleries Improvement Fund had been unsuccessful. Disappointed but undeterred we moved on to the next critical point: the presentation of the architect's scheme of works to the Director and Trustees. I should at this point explain that the conversion of the buildings was a separate project managed by NMGM's Property department, through a consultant architect. The architect's proposal for the entrance to the linked buildings did not meet with the Trustees' approval and this led to delays in starting the building programme. Whilst trying to resolve problems on the building side the exhibition design process was continuing. In February 1992 a conservator joined the team to co-ordinate the different conservation work requirements. At this stage, though, there were still some uncertainties about the number of objects to be included. By June the pressure from Design was building to finalize the object lists and the text and labels. Given that each of the three sections were being written by three separate curators whose style and time available to deliver finished text varied it was decided to bring in

a scriptwriter to speed up the process and homogenize the text. The fact that he happened to have a social history background helped. Had we brought him in earlier he would have fulfilled a true scriptwriting function. As it was he in effect acted only as an editor.

Whilst the detail of the design was proceeding work on the building was gathering pace but it soon became clear that there would be very little time between the completion of the building and the opening date for the installation of the displays. Conservation had requested a three week gap between the two to allow (literally) the dust to settle but this was not achieved. Weekly site meetings with the whole project team began in February 1993 to check progress on the display infrastructure (reconstructions, room sets etc) but the installation of objects didn't begin until April and it continued up until the evening before 3 May (May Day) when the museum was officially opened by the Lord Mayor of Liverpool.

MANAGING UP, DOWN AND ACROSS THE ORGANIZATION

No project manager achieves a project on his or her own. In NMGM's case the expert resources are considerable but that means the number of people who are involved is also considerable apart from the three curators and the project team there were 2-D and 3-D designers, conservators, technical services staff, joiners, gallery services staff, property managers, other curators who were lending material from their collections, the divisional registrar, responsible for tracking and recording the movement of internal and external loans, object handlers, public programme and NMGM Enterprises staff. Each of these staff had their own departmental line managers but also had to report to me, the project manager, on the progress of their particular area of responsibility as far as this project was concerned. I, in turn, had to report to my line manager, the Keeper of the Maritime Museum.

Communication was therefore key not just up and down the organization but across it as well. In this respect the golden rule was/is: *Don't* assume they are communicating or reading your memos or action lists. As they say, 'ass-u-me' makes an ass of you and me so checking and double-checking, in a tactful way of

course, was/is vital. Keeping a written record of all meetings and decisions as proof of agreed processes and actions, in case of dispute, was/is also important. Knowing the project team's strengths and weaknesses is also important.

BUDGETS AND FINANCIAL MANAGEMENT

Achieving a project on time and to budget is often seen as the main criterion of project success. Control is key to both. However, project managers are not always involved in drafting the budgets they have to manage. Fortunately, with the Museum of Liverpool Life, I was. If this is not the case and you have inherited someone else's 'guesstimates' it is important that you check them out before you agree to work to them and that you build in a sum for contingencies which are bound to arise, especially if the project is up against a tight timetable. Services can be bought in to solve a last minute problem but only at a premium. The other thing which you must do is decide whether you are going to be the budget holder/controller for all aspects of the project which would mean signing every order (and with a large project that could mean a considerable amount of paperwork) or whether you are going to delegate financial responsibility for the various areas differentiating, for example, between interior display production, publicity materials and marketing, publications etc. If you do delegate you must be very clear about the budget limits and the fact that they must not be exceeded without prior agreement. This is the system we use at NMGM and which we used for the MLL. Each major project is given a discrete budget code which is then used by anyone preparing orders for expenditure which have to be authorized by the agreed budget holder. Monthly management accounts are then issued for checking to the overall project manager who is ultimately responsible for ensuring that the project is to budget or alerting senior management to any potential over-run.

If the budget which you are working to is of your own preparation you may well have played what has been described as the 'King pawn game', i.e. you asked for more than you knew you needed because you knew it would be cut and that with the cut you would more or less get what you really needed. Unless you really know exactly what you need before the project

becomes live, which in my experience is rarely the case, and certainly wasn't the case with the MLL, you will probably have to rely on square meterage costs for comparable projects as a guideline. If this is the case the inclusion of at least a 10 per cent contingency figure is strongly advisable. Alternatively you can just keep your fingers crossed and rely on instinct but I wouldn't recommend it unless your instinct is founded on experience.

In most museum projects these days sponsorship and increasingly Heritage Lottery funding is a key component of funding. Sponsorship wasn't a significant issue for the MLL in that this first phase of the museum wasn't sponsor-dependent. (The subsequent phases are and they are yet to be installed.) However, it is interesting to note, with hindsight, that the two most popular features with young visitors turned out to be those which were sponsored: the children's play area in the museum courtyard, sponsored by the Friends of the Merseyside Maritime Museum, and the interactive Brookside exhibit, sponsored by Mersey Television. Managing the cashflow of a project which is dependent on the receipt of grants and sponsorship is another matter which this case study cannot address.

CONSERVATION – PROCESSES AND PRACTICALITIES

One issue which was significant for the project was conservation. The systems which NMGM's new Conservation division had established required the curators to submit for examination all objects which they were considering using in the displays. The specialist conservator would then submit a report on the condition of the object with a recommendation as to its suitability for display and proposals for its treatment together with an estimate of the time required. Prior to 1989 NMGM had had a very small and over-stretched conservation staff and relied on the curator's judgement as to whether an object needed to be submitted for conservation treatment prior to display. It simply wasn't feasible for every object to be examined as a matter of course. The same applied to loans-in and new acquisitions but each of these activities was now to be subject to conservation condition reports. Whilst the upgrading of conservation resources to an almost ideal level, which made these processes possible, was to be welcomed it would be untruthful to claim that the transition to the new

system was smooth. Apart from the extra administration caused by, quite rightly, having to fill out a conservation work request form for every object which was to be examined, curators did not like having their judgement questioned as to which objects were suitable for display, how and where. The designers also did not like no longer being involved in the actual installation of the objects. What had previously been a designer/curator function now became a conservator/curator function. This new, more professional way of working, caused some tensions in the project team initially until we got used to working with our new conservator colleagues. Several years on it has become a natural and effective way of working.

MARKETING AND PRESS

As mentioned above one of the first issues which the MLL project team addressed was the market which the new museum was likely to attract. Given the museum's location adjacent to the Albert Dock we knew from the qualitative and quantative market research conducted at the Maritime Museum in 1990 that the audience was likely to be primarily a family audience. In planning the displays we had therefore heeded the advice from the marketing department that there should be something for all the family. The building adaptations had taken cognisance of the fact that an 'all weather' facility was important and this had been achieved – with the exception of the play area which was in the open air. We provided several memorable experiences in each gallery (large items, touch displays, reconstructions, demonstrations etc.) and we tried to ensure that all ages and abilities would be catered for. These were the factors which it was considered would make the museum marketable.

However, there is a difference between being marketable and being marketed. Marketing needs financial resources as well as human resources – at least 9 per cent of the cost of the project. Without an adequate marketing budget one is reliant on media coverage which is by its very nature ephemeral and unpredictable. It very much depends what else is news on the day as to whether or not you achieve news coverage. For a variety of reasons – principally conflicting internal demands – the MLL neither had an adequate marketing budget nor did our press department have

adequate time to devote to publicising the project. In effect it lost out, understandably perhaps, to more internationally significant projects such as *Jason* and the new *Battle of the Atlantic* gallery in the Maritime Museum which was to be opened by HM The Queen at the end of the same month. Despite the absence of a concerted campaign we did succeed in attracting local press coverage thanks to a press call which featured the cast of *Brookside*. Our position on the waterfront and good threshold marketing resulted in many visitors who just 'happened' upon the museum and by the end of the first year we had achieved attendance figures of 127,263.

EVALUATION AND LESSONS LEARNED

A team de-brief is essential at the end of any project. It should be separate from the celebration which marks the project's completion and is best arranged once everyone's energy levels have been restored but before their memories of events have faded. All a de-brief need consist of is an informal round table discussion of what went well with the project and what could have gone better. The discussion should be minuted (but without attributions) and circulated for future reference.

The following are some of the strengths which the MLL de-brief noted: it all got done on time despite the timetabling difficulties; the initial public reaction was favourable; staff, consultants and contractors were all loyal to the project even in difficult situations and they all took pride in their work; the working atmosphere was good and there was no sense of panic (!); everyone found the project team meetings at the beginning of the process, the conservation/design/curatorial progress meetings and the site meetings at the end useful, and the experience of the new conservation system was beneficial.

The main weakness was seen as lack of time and the other competing programme demands in NMGM; the Trustee involvement in the entrance foyer design was seen as a negative by some as was the quality of the Boat Hall building itself. The lack of a marketing campaign was also regarded as a project weakness.

The latter was something which visitors often picked up on themselves; certain remarks in the visitors' book – a valuable and very cheap way of gaining insight into visitor reactions – expres-

sed indignation at the fact that this excellent museum had only been discovered by chance. Not surprisingly in the first year the high percentage of first time visitors (75 per cent) who 'just happened to be passing' was confirmed in the visitor surveys which were conducted on a seasonal basis. The only specific exhibit evaluation which we undertook was on the *Brookside* display. This highlighted some areas for improvements which have now been addressed as part of a generally updating of the set to reflect changes which have occurred in the Dixon household on the screen.

CONCLUSION

Although this first phase of the project was successfully completed and has been up and running now for nearly four years, the rest of the project is incomplete. The Pilotage building has been refurbished and the concept for phases 2 and 3 has been agreed. A planning footprint for phase 4 – the new building – has also been established. We are ready to roll again as soon as funding is in place.

BIBLIOGRAPHY

Baker, Sunny and Kim (1992) *On Time – On Budget: A Step by Step Guide for Managing any Project* (New York: Prentice Hall).
Belbin, R. (1981) *Management Teams* (London: Butterworth-Heinemann).

7

'When they are good, they are very, very good, but....' The Challenge of Managing Retired Volunteers in Small Museums

KATE OSBORNE

INTRODUCTION

'"I'm sorry, but we're not ready for you yet"'. Voice from a window in an all-volunteer museum to approaching visitor during advertised opening hours, 1993.

Much has been written recently on volunteer motivation and management techniques seeking to develop and sustain volunteer motivation and involvement. Publications have covered organization theory and motivation (Handy, 1988); the motivation of volunteers in general (Hatch, 1988; Thomas and Finch, 1990; Mattingly, 1984; Croner's, 1993); retired people as volunteers (Hadley and Scott, 1980); the management of volunteers (Wilson, 1976; Willis, 1992 and undated; Brown, Fletcher, 1997) and the management of volunteers in museums (Tanner, undated; Millar, 1991). However, there is a gap in the literature about managing the specific combination of retired volunteers (i.e. retired people who are now volunteers) in museums, and in particular small, independent museums. It is that gap which this contribution aims to explore, not only because retired volunteers are already an integral part of many museums, but also because this involvement is likely to increase. Since the research for this paper was undertaken, the Department of National Heritage (DNH) report *Treasures in Trust* has stated that 'The Department attaches great importance to the role volunteers ... play in museums' (DNH, 1997: 24). This study explores the differing attitudes, perceptions and needs of retired volunteers and professional curators in small

149

independent museums (hereafter SIMS). It then suggests adaptations to managerial practice that might assist curators in SIMS to reconcile the difference and have a greater chance of achieving the museums' goals – including survival.

The south-west of England (here meaning Cornwall, Devon, Somerset, Avon, Gloucester, Wiltshire and Dorset) was chosen for this study as it has a remarkable number of independent museums: 105 with their collections in the public domain out of a total of around 300 Area Museums Council for the South West (AMCSW) member museums. They range in size from those which attract over 100,000 visitors to those which attract less then 200, and from those in purpose built premises to those in small, converted historic houses. The region has been described as

> predominantly rural in nature and services are focused on small/ medium sized towns (...) tourism is an important element in the regional economy ... there is a close sense of identity within local communities ... the size of the region and large number of small museums within it pose particular problems. The professional infrastructure is not strong compared to other regions and provision of support services for museums ... is therefore important in order to maintain and develop standards. (AMCSW, 1993a: 4)

It also has a large retired population (Millar, 1991: 70). It is well known that many south-west museums heavily involve or are entirely run by volunteers (Willis, 1992). Because of the nature of the area and the population, all 105 independent museums were sent a questionnaire asking for information about the extent and nature of retired volunteer involvement in their operations (Osborne, 1993: Appendix One). Ninety replies were received of whom eighty-one involved retired volunteers. Of those eighty-one museums, thirty-five had paid curatorial staff. Of these thirty-five, twenty-seven had only one or two such staff and it is this measure which is used to define 'small' (the paid staff: retired volunteer ratio being more relevant to successful personnel management than the size of the building or visitor numbers). For many of these small, independent museums with one or two paid staff, there are several extremely high retired volunteer: staff ratios, for example one or two curators to between forty and one hundred volunteers.

It is assumed that payment means some obligation on the post holder to attempt to achieve professional standards at their

museum. In the future it will not only be paid, *in situ* curators who will have this responsibility but also 'a growing network of museum development officer posts ... the creation of new posts has ... been accorded a high priority in recent years' (AMCSW, 1993a: 8). They will be working with the forty-six all-volunteers museums, bringing the potential SIMS total to seventy-three. It is with these seventy-three museums that this contribution is concerned.

Ever increasing demands are being made of SIMS, as they are of all museums. Three recent publications illustrate this point. In *Rain or Shine – a Tourism and Museums Strategy*, which highlights the particular importance to south-western museums of being in a tourism area, one general policy statement is 'to support initiatives to enhance the quality and appeal of museums including creative interpretation and improved visitor facilities'. It states

> museums which are already successful in attracting visitors, when there is so much else to choose from, know that they have to provide a satisfying experience and value for money, if they charge ... it will not be long before museums will be asked to meet 'Customer Care Standards' now being piloted by the Museums and Galleries Commission. Many museums already subscribe to the 'National Code of Practice for Visitor Attractions' ... the introduction of the British Standards Quality Systems may also be on the agenda for the next decade. (AMCSW and West Country Tourist Board (WTB), 1993: 5, 6 and 8)

Victor Middleton's report *New Visions for Independent Museums* confirms this, stating that

> most small independent museums with less than 5,000 visitors per annum, mainly operated by volunteers, appear best able to survive without significant change in the next decade. *Although many are under considerable pressure to sustain their numbers and revenue and enhance their displays and visitor facilities.* [my italics] (1991: 73)

There are at least thirty such museums in the south-west. Moreover,

> Museums under greatest threat in the next few years are those attracting 10,000 to 100,000 visitors per annum. This category includes the majority of active independent museums. They are all very small businesses ... most such museums cannot generate the funds needed for essential long term maintenance of their buildings, to undertake

necessary curatorial services, and to bring their displays and facilities up to modern standards. (Middleton, 1991: 73)

There are at least twenty-two museums of this type in the south-west. Some SIMS are staffed by curators technically seconded form local authorities. For museums with such local authority support, data for the Audit Commission's Performance Indicators (PIs) are now being collected based on those PIs listed in *The Road To Wigan Pier?* (Audit Commission, 1991). This represents another source of pressure on SIMS, this time to demonstrate that they provide value for money, and are therefore worthy of continual local authority support.

It is therefore quite clear that SIMS in the south-west are now service delivery organizations and have as much pressure on them to change and improve their curatorial and visitor services, as larger institutions with greater numbers of professional staff. The above reports appear to demonstrate that either they change to survive, or they do not and remain marginal (if lucky). The point is that SIMS largely rely on retired volunteers to carry out the changes and to deliver the service. At the very least, 78 per cent of SIMS rely on retired volunteers to be able to open to the public, but local competition for volunteers is stiff and under twenty per cent of SIMS 'always have enough retired volunteers' (Osborne, 1993: diagram 4). With small staff to large volunteer ratios, volunteers inevitably undertake a whole range of work, being most frequently involved front-of-house, dealing directly with visitors and contributing greatly to their experience of museums. In the light of the above reports, this can be considered a legitimate core task alongside behind-the-scenes work.

In order to examine more closely the contribution retired volunteers are making to the SIMS' goal of survival through change, the challenge set by Hatch in *Volunteers: Patterns, Meanings and Motives*, has been taken up. He states that

> the performance of organisations whose work is done (or largely done) by volunteers cannot be understood in isolation from the motivation of those volunteers ... in seeking to explain the strengths and limitations of voluntary actions, the relationship between the motivation of volunteers and the goals of voluntary organisations, and the way voluntary organisations seek to develop and sustain the motivation of the participants, seem particularly to deserve exploration. (1988: 7)

The exploration began by first interviewing forty-two retired volunteers at a case study SIM. As some responses were of a personal nature, anonymity has been preserved throughout this study. Volunteers were interviewed in groups of 8–10 and asked to complete a questionnaire anonymously (Osborne, 1993: Appendices 2 and 3). The aim was to gather information on their motivations for, attitudes to, and feelings about volunteering, both in principle and in reality, based on their experiences in the museum itself. Their responses were analyzed using three established theories of motivation, as discussed below.

Secondly, five professional curators in SIMS were interviewed in addition to completing the general questionnaire, to find out what sort of contribution they felt retired volunteers were making to their museums' survival and what limitations to this contribution were being experienced. These five SIMS are typical of the south-west. All are in small, country towns with a surrounding large retirement population. The towns themselves have populations of between 6,500 and 10,000 and are attractive to tourists either intrinsically or because of surrounding features like National Parks. There is plenty of volunteering competition and all five are in listed historical buildings of limited physical size.

Finally, the likely success in SIMS of the volunteer management techniques set out by Millar (1991) were assessed in the light of this research, practical experience at one of the museums, and in the context of Charles Handy's theories on the management of voluntary organizations. Handy's work was chosen for analysis because 'any wholesale rejection of the ideas of management must be naive. None the less, the instinctual desire to put management in its place and make it subservient to the cause and the people has to be right', and because those people 'are free citizens with minds and values and rights of their own' (Handy, 1988: 19, 21). It is hoped that this study will be of benefit to any professional curatorial staff finding themselves in charge of retired volunteers.

THE MOTIVATION OF RETIRED VOLUNTEERS

An interest in museums and their work may be part of the motivation for individuals but is never the whole picture and museum staff employing volunteers ignore this at their peril. (Willis, undated: 7)

The questionnaire sent to 105 independent museums in the south-west requested statistics specifically on retired volunteers. Retired was defined as aged sixty or over and retired from formal employment, aged fifty to fifty-nine and early retired from formal employment, or retired from being effectively the central figure of the family – being 'a granny figure' as one volunteer said.

For SIMS in the south-west, the average age of retired volunteers was most frequently estimated to be sixty-five, but at the case study museum, where actual figures are available from volunteer Registration Forms, the average age was sixty-nine, with fifty-four per cent of this workforce aged seventy or over and thirteen per cent aged eighty or over. Over eighty-five per cent of SIMS found retired people to be the main type of person to offer their services and curators are probably working with substantial numbers of older and quite elderly people. The information in the completed Registration Forms at the case study museum provided more detail. Inevitably with an older work-force, there are some health problems associated with 'old age', but most retired volunteers claimed to be fit and well. There is a plethora of previous careers pursued and current interests and hobbies which reveal a profoundly middle class (A, B, C1) volunteering body (Osborne, 1993: diagram 8; Rose, 1993).

The responses of the forty-two volunteers who completed a questionnaire at the case study museum were analyzed through the application of three established motivation theories. The first is Abraham Maslow's Hierarchy of Needs: 'His conclusion was that each of us have various levels of need and as we satisfy one need level, we move up to the next', ranging from physiological needs to self-actualization (Wilson, 1976: 43). Maslow also thought that a met need was no longer a motivator but that if a need was not satisfied, everything above it became unimportant.

Herzberg's 'Motivation-Hygiene' theory categorizes factors to do with a person's working environment as being 'hygiene factors'. They include policies, administration, supervision, working conditions, interpersonal relations, status, security, and money. These, Herzberg argues, do not actually motivate people, but their absence demotivates them. What does motivate people are 'motivators', factors which involve positive feelings that a person can experience in a job that offers challenge and scope. They include achievement, recognition for accomplishment, chal-

lenging work, increased responsibility, growth and development. These two theories overlap (Wilson, 1976: 45, and Osborne, 1993). A third theoretical approach of value is McClelland and Atkinson's work on whether the need for achievement, the need for power or the need for affiliation affects an individual's work-related behaviour (Wilson, 1976: 46).

The anonymous questionnaire was partly designed to apply these theories directly to the retired volunteers to see what more they could reveal about their motivation. Before proceeding to their responses, however, it is important to understand the case study museum's recent history because it affected some of the responses received and because it is all about change for survival – the crucial issue. Twenty-two of the interviewees became involved in the museum between 1962, when it originally opened as an all-volunteer museum, and 1990, when the first salaried team of Curator and Assistant Curator were appointed, and who immediately led a major redevelopment of the museum. Both professional posts were created at the instigation of the all-volunteer Museum Management Committee who had acknowledged, in the light of an AMCSW report, the need for professional support if the museum was to develop its potential into the next decade.

Their decision to invite such support and the District Council's willingness to fund the salaries, meant that those 22 volunteers saw the museum change almost beyond recognition. The vastly increased public profile of the museum during and directly after the redevelopment, together with appeals for more volunteers to steward the enlarged museum, meant that 20 of the interviewees began volunteering at the museum with the new regime in place. Three volunteers also have experience of working in other museums. The curatorial staff had at their disposal, therefore, a body of volunteers with quite similar backgrounds, with differing experiences of the museum and varied interests like any other workforce. What is it then, age and health apart, that differentiates them from other workforces – and consequently affects their motivation?

Retirement is the key differential to consider. As Hadley and Scott put it, 'how does the retired person face the demanding task of being a person rather than doing a job?' (1980: 5). The interviews revealed clearly the relevance of this distinction between the greater importance to an individual of their personal needs, in

comparison to the needs of any organization in which they might become involved in retirement.

Two contrasting meanings were attached to retirement: freedom and disorientation. Regarding the first, and most commonly expressed meaning, volunteers exclaimed 'oh, its wonderful! I recommend it ... I can do exactly what I like ... I was tied for so long'. Sixty per cent of volunteers retired from their careers when they wanted to or later. Freedom was firmly linked with the feeling 'you're more in control of your life, aren't you?'. Such control was felt just as strongly by those volunteers who had been tied to their home as those retired from professional careers. Not only is it freedom from doing things that were disliked or from demanding personal circumstances, it is also freedom from responsibility: 'one thing I enjoy more than anything is not having the responsibilities anymore. I really appreciate that ... after having had responsibilities, this lovely feeling of relaxing into life'. It is also freedom from time constraints:

> You don't want to commit yourself to anything too far in advance – this is the big problem. ... Like 4 or 5 weeks' time ... I might have upped sticks and gone somewhere ... we all expect a little freedom in retirement to go away when we want to or to entertain our relatives. You must accept that we are retired people and that's the area of freedom that you feel you would like.

The other meaning of retirement is disorientation and loss for those who found retirement difficult to accept and just over seven per cent of volunteers retired earlier than they wanted to:

> I found it very difficult to come to terms with retirement ... I went for my first pension and it was pushed out as if I was completely unintelligent ... there was this feeling of being rather unwanted ... I don't like it ... I would much rather be back at work.

Turning to, and starting at the bottom levels of the motivation theories, it was assumed that the retired volunteers' basic physiological needs were met. Next, the questionnaire responses showed that, freed or disoriented, most were not troubled by personal finances or security of home, and although health gave more cause for concern, the Registration Forms discussed above showed most claimed to be fit and well. So it seems that most were beyond Maslow's safety/Herzberg's security need level, putting them in a secure enough position to volunteer. They were

also secure about the need for them to continue volunteering, 'without us, the museum would be in trouble!', as one said.

However, Hadley and Scott point out that 'others may be active in their retirement but prefer to devote their energies to interests other than volunteering' (1980: 13). Although some volunteers had had their arms twisted, 'I came to see a Christmas exhibition and somebody found I was interested, and ... before I knew it I was enrolled to help for next year!', many came as the results of appeals. But why did they take up an invitation to volunteer at all? Getting out of the house and getting reinvolved was important for those who disliked retirement, but so also was a tradition of volunteering, an average of twenty-one years' volunteering emerging from the forty-two interviewees, either instilled, it was felt, through a 'church upbringing' or as a result of the spirit of volunteering in the Second World War.

A further motivation was seeing the need and saying thank you for good fortune: 'without sounding too pious you feel it's something you do because you live here in a nice place like this and therefore you are going to make some efforts to do something that needs to be done'. Another was to do with one's own beliefs about today's quality of life: 'there is too much value put on money and keeping up with the Jones's and all that sort of thing. ... I think (volunteering) gives you a different feel to life'. Both those who enjoyed retirement, but especially those who found it difficult to adjust, said that meeting people was an important motivating factor in their decision to volunteer. It was felt that in small towns predominantly populated by retired people, 'the way to meet people is to volunteer'. It also provides a reason why they decided to volunteer at the museum in particular. It was partly to do with the type of people, both visitors and colleagues they met: 'most of the people who come here are so nice! ... they share one's interest'.

This was confirmed by trying to find out what type of people in McClelland's terms the volunteers were. A ranked response to whether they thought they were primarily achievers (achievement motivated), changers and runners of things (power motivated), or people who liked making friends, helping and meeting people (affiliators) shows an overwhelming majority were primarily affiliators who 'concentrate on relationships rather than the task' (Handy, 1988: 28), making Herzberg's achievement motivators

relatively unimportant. The questionnaire responses showed that most felt the museum had a warm welcome for retired volunteers and that there were friendly social groups, confirming that the Maslow social/Herzberg interpersonal relations level was being met at the museum.

However, just under half felt there were cliques amongst volunteers. Perhaps a connection can be drawn with several of the long-standing and curatorially 'inherited' volunteers who originally became involved in the museum because of the legendary charisma of the late original owner and founder. Importantly, she remains for a few the primary reason to continue being involved after the museum had undergone enormous change.

> She truly is the reason why I am still here ... she was a delightful person ... she was always there, always very friendly, you know. I knew her right until the end of her life and it was a promise I made to myself and to her that I'd stay with the museum, so therefore I still am.

Moving on to Maslow's self-esteem/Hertzberg's status hygiene factor and recognition motivator, most felt valued by both curators and the public, and no one felt unvalued, a majority felt that volunteers were given sufficient recognition and everyone felt they were trusted to do a good job. In terms of Herzberg's working conditions, administration and supervision hygiene factors, the questionnaire revealed that working conditions front-of-house at the museum could be more comfortable for some. The policies hygiene factor was not discussed as there was, then, no volunteer policy.

Therefore there are some problems with affiliation and a few missing hygiene factors, both of which could be demotivating retired volunteers. However, there is an interesting dilemma for those managing them. It seems that if one were to attend to these factors, it might not increase the prospect of many retired volunteers progressing to higher levels of motivation and motivators. Questionnaire responses indicated that forty-one out of forty-two retired volunteers at the museum felt that they already got enough out of volunteering at the museum. This could be said to be the volunteering equivalent of being paid enough (Herzberg's money factor). It also takes into account Handy's motivation concept of the psychological contract whereby the energy con-

tributed by an individual and the expectations met are balanced (1988, 27). Most felt the demands made of volunteers were about right, and wanted no change in the degree of responsibility they had regarding front-of-house work.

The most revealing answers came in response to the question about the development of volunteers' skills, which equates most closely with Maslow's self-actualization level and Herzberg's challenging work, responsibility, growth and development motivators. Most answered negatively, the most memorable comments being 'already developed. That's why I'm retired' and 'none. I already put in as much time as I can give'. Therefore, whilst the generosity of the retired workforce at the case study museum is considerable (a total of at least 484 hours per month), it needs recognizing that they volunteer at the museum very much on their own terms. The 'free acceptance by individuals of voluntary obligations to the community of which they are members' (Millar, 1991: 5) does not come without strings attached. It would seem that the freedom retirement brings for most means freedom to pursue what they want, as far as they want, when they want.

Why should this matter? Because self-actualization (meaning 'a person will not be ultimately happy unless he is doing what he is fitted for' [Wilson, 1976: 43]) and higher motivators seem most likely to result in professional-quality output that is needed by service-delivery SIMS (Handy, 1988: 14). They seem to be the only levels which are not concerned entirely with volunteers' inner needs; motivators, for example, 'relate to the job itself' (Wilson, 1976: 44).

There is hope that self-actualization might be possible, however, related to what the museum in particular can offer. First, two volunteers expressed a strong desire to be more involved with things and less involved with people, as it is 'less demanding on a personal level'. Second, several (in particular incomers) expressed an interest in knowing more about the history of the locality as a way of establishing a link with their unfamiliar surroundings. The case study museum is, like many south-west museums, a museum of the town and surrounding area (AMCSW and WTB, 1993). Third:

> obviously we choose the things that are going to be interesting to us, unless we are going to be very saintly ... and choosing something

which isn't going to bore you too much as you go to it all the time...,
yes, you're doing it for your own pleasure ... you wouldn't do it if
you didn't like it.

These three points all point to the self-actualization-motivation
level.

Ostensibly, then, some retired volunteers' motivation will at
least be sustained as long as there is an opportunity for social
contact with suitable people, to live out their own beliefs about
the quality of life, and to be loyal to the past. For them this is
enough. For others however, progression to self-actualization
seems desirable where they wish to pursue their historical inter-
ests, improve their knowledge and thus make links with the area.

This motivation background sets the scene for the next section
where, as Hadley and Scott (1980) suggested, the relationship
between curatorial/organizational goals and volunteers' motiva-
tions are explored.

THE CURATORIAL AND ORGANIZATIONAL NEEDS

Not surprisingly, professional curatorial staff have mixed feelings
about a workforce that volunteers largely on its own terms, is
motivated largely by inner need (not bad per se, most of us are)
but which only sometimes seems to be motivated by challenge,
responsibility and self-development. Five professional curators in
SIMS (Curators A-E) were asked about retired volunteers' con-
tributions to their museums. One encapsulated the polarity of
feelings which reflects the strengths and limitations of this con-
tribution: 'frustrated by them, irritated by them, impatient with
them but very fond of them and full of the knowledge that we
just couldn't do without them' (Curator D). One great strength is
their availability during working hours (opening hours) on a
regular basis, without consuming family or job searching commit-
ments that accompany non-retired volunteers. Without their phy-
sical presence, many SIMS would simply close or be staffed front-
of-house by professional curatorial staff (Curator B already
covers the front desk at lunch times when volunteers cannot be
found).

Politically and ideologically their involvement is a strength
because of the element of community involvement they bring
(Millar, 1991; Major, 1992). Curator A felt that they made the

museum more democratic and much less of a personal project, and there is no denying that they are a great source of support for staff where there is genuine respect for professional input (Curator C). Where the latter occurs, all five curators expressed respect and fondness in return.

Another strength is their enormous contribution to creating a warm welcome, presenting 'a very good face to the visitors, chatty and welcoming' (Curator D). Front-of-house work also involves providing a less intimidating security role than would uniformed attendants. The most frequently mentioned expectation of working at the museum and also enjoyment experienced there was meeting and chatting to visitors, and getting involved in this way can sustain the motivation of those who want no great demands made of them.

However, if the goal of survival through the provision of improved visitor experiences and curatorial services is to be achieved, SIMS need more than a physical presence and a chatty manner. Millar defines professionalism in the context of volunteering as 'skill and competence; reliability and accountability and an ability to achieve goals' (1991: 17). Curator E adds the following in his description of an ideal volunteer:

> an awareness of visitor needs, a flexible attitude to the tasks needing to be done, procedural efficiency and reliability, an ability to learn and cope with change, to offer constructive criticism, loyalty and respect, and most importantly, some genuine enthusiasm for, and interest in the museum and local history.

It is true that 'a professional staff demands professional volunteers' (Millar, 1991: 17).

Already a contrast between professional, organization needs and the retired volunteers' apparently less goal- and more self-oriented motivations can be seen. Yet SIMS must survive by being geared both to the retired volunteers' motivations and to achieving organizational performance standards as defined by the outside world. In this contrast, it seems, lie the limitations of the retired volunteers' contribution. To take this analysis further, it is revealing to look at organizational cultures and structures and the role of individuals within them as outlined by Handy (1988). Briefly, Handy outlines organizational *culture* as the 'taste and flavour' of an organization, and describes four main types: club

or power culture, likened to a spider's web, with the key person at the centre surrounded by 'ever-widening circles of intimates and influence'; the role culture, which 'looks like a pyramid of boxes ... the box continues even after the individual (filling it) departs'; the task culture, where 'a team of talents and resources are applied to a project; and the person culture, where 'individual talent is all important' (Handy, 1988: 86–93). Handy describes organizational *structure* as an organization's skeleton (1988: 103). The skeleton is held together in three main ways: 'hierarchy of command', 'rules and procedures', and 'co-ordinating groups' (1988: 108). Organizational *systems* (communication, number and participation systems) act as the 'nerves' (1988: 121). Organizational *shape* is concerned with balancing the size and feel of the organization with its aspirations. Handy suggests two shape models: federalism (rather like a donut), and the shamrock (comprising three sections) (1988: 113).

First, the museum's cultural history needs consideration. The case study museum started very much as a 'club culture' with the museum's founder as a central controlling spider, surrounded by a web of around 20 directly involved volunteer friends. By 1990 it was still a club culture, but with a very different professional curator spider in the web. Club cultures can respond immediately to opportunities (necessary for survival) but they also 'abound with almost mythical stories and folklore from the past and can be very exciting places to work, if you belong to the club and share the values and beliefs of the spider' (Handy, 1988: 87). Curator A, for example, is fast becoming mythical and it is significant that he and the museum started out together: 'we're all very friendly, ... I've got a kind of personal following because I've been involved for a long time at the museum ... there's some loyalty to myself. All the other curators 'inherited' their core of volunteers however, and in this situation not everyone necessarily shares the values of, feels loyalty to, or shows respect for the spider. At the case study museum, one of the long standing volunteers who expressed loyalty to the past felt that before the 1990 redevelopment:

> It was more intimate because it was Miss C's museum ... there were
> no demarcation lines, we all did what was necessary ... and when
> we'd finished we came up and sat up here drinking tea with her and

discussing the day ... I must admit, I preferred the old one [and not] this, forgive the word, gimmicky modern museum that brings in the crowds.

The motivation of loyalty to the past rather disproves Handy's statement that 'no one can voluntarily stay in a group and dis-approve of its ultimate aims and values. As a result, there is much less criticism of the organization from within than you might find in other places' (1988: 35).

In fact, loyalty to the past (understandable when you helped create it) coupled with an inability to cope with change, results in the wearing and negative contribution of non-constructive criti-cism like that above. In addition, inheriting a club culture can be a painful experience, especially for younger staff (all curators interviewed were aged between 20 and 40 on appointment). Curator B, for example, found himself up against a 'don't tell us what to do sonny because you're new to this' attitude. Even with his particularly supportive committee, Curator C wryly remarked that 'some of them think they could run the museum better than me!'.

One could interpret these as merely expression of preference, but Curator D found that the inheritance of a private retirement club atmosphere resulted in problems which were detrimental to visitors' needs and therefore contrary to organizational goals:

we had one particular volunteer whom I am quite convinced must have put people off and had great difficulty in actually letting someone in the door ... that's to do with links to the Natural History and Archaeological Society. We heard her saying to someone that they couldn't use the library as they were not a member ... which is absolute baloney!

Even 'new' retired volunteers who are not members of a long-standing club have been known to start creating one. One volun-teer 'forgot' to inform staff that the gallery video was switched off so he 'could do my crossword in peace'!

However, as a result of redevelopment, the case study museum grew in size, visitor and volunteer numbers, and the development of a role culture became an organizational necessity to carry out day-to-day tasks, including front-of-house tasks. With a bigger organization, there is a greater organizational need for procedures to get things done and 'people are, in one sense, a less critical

factor. They can be trained to fit the role. Indeed, role cultures do not want too much independence or initiative' (Handy, 1988: 90).

The personal need for independence (freedom) is, however, exactly what retired volunteers want if they are concerned with being people and not doing jobs or filling roles. This can manifest itself in strong feelings about what roles an individual will or ought to do, regardless of organizational need: 'I *don't* work in the tea room', as one firmly said, leaving the Curator to provide this service that visitors have come to expect, the other volunteers being too frail that day.

Freedom to do what you like can also manifest itself as well-meant use of initiative which ultimately works contrary to the organizational role culture need for procedural efficiency, reliability and professionalism. Curator E can find himself with inadequate front-of-house coverage because volunteers have taken it upon themselves to decide that there is sufficient coverage, bypass established absence procedures and not turn up. They also turn up late because 'I have to dog-sit', 'the cat died yesterday' and 'oh, I forgot'. Curator C stated:

> I'm there to encourage them to do the job they think they want to do in the museum and making sure that when they do it they do it properly ... they can't always see the logic of that ... there are fairly strict parameters which I have to reinforce every now and again. If you don't reinforce, people do go off, they do think that maybe there is a better way of doing it.

Significantly, some of the most reliable and efficient volunteers at the case study museum are those who dislike retirement. As one of them said 'I like knowing that every Monday I have a little job to do' – role culture personified.

The role culture's distancing effect can also alienate retired volunteers. As one said, 'I think perhaps when it was small ... we felt in a sense, more involved than we are now'. Handy outlines the problem: 'Organisations have always wanted to be big enough to cope with a range of activities (because that makes them more effective and gives them more clout) but also to be small enough to have a common identity' (1988: 113).

Experiments with organizational shape, part of organizational structure, have been tried in an attempt to reconcile the conflict between cosy-clubness and organizational growth. One of two

suggestions which Handy feels should be taken seriously by large
[or growing] organizations' is the federal model. This is where the
organization's professional core (curators) does the things which
the other parts cannot or do not want to do, and where the
'energy and initiative come from the parts not from the centre'
(1988: 115). With a workforce which largely does not want addi-
tional responsibility, or demands made upon it, and whose moti-
vations sometimes clash with organizational needs, this sounds
like a recipe for disaster in SIMS. The alternative shape is the
shamrock which has three categories of workers and sounds alto-
gether very familiar. One category is the professional core (cura-
tors) doing the key jobs, with the organization demanding 'their
commitment, their flexibility, and their willingness to go any-
where, do anything, be available almost any time' (Handy, 1988:
117). This is reflected in SIMS and seems closely connected with
trying to maintain a club feel:

> You have an open door policy. It does mean you get an awful lot of
> interruptions and it's difficult to get down to any work you should be
> doing, which can be a problem, particularly with retired volunteers
> because they do relish the social contact and if it's quiet in the
> museum they want to have a chat – it's only natural and I'm certainly
> not going to shove them out the door and say 'I'm sorry I'm just too
> busy to talk right now (Curator A.)

With SIMS staff:volunteer ratios of up to 1:100 this can
become very disruptive and might explain why curators in SIMS
across the south-west mentioned 'time' as the most frequently
needed resource for managing retired volunteers (Osborne, 1993:
diagram 30). Connected with universal availability is the will-
ingness to do anything, which includes SIMS becoming 'a branch
of the social services really ... listening to problems' (Curator C).
These problems quite often relate to volunteers' life stage. Speak-
ing of a recently widowed volunteer Curator A commented that 'I
think it [volunteering] is helping her, it's a kind of therapy, but
you've got to know what you're doing, that's the problem and
I've got no formal training in that kind of thing ... it's quite dif-
ficult ... you're treading on eggs sometimes'.

In terms of flexibility, small numbers of curators are dealing
with all the idiosyncrasies of a huge variety of individual person-
alities – an immensely demanding task when the latter want to be

in control and can themselves be inflexible enough to say 'no one
can be unpleasant to you, otherwise you leave ... if you turn up
five minutes late, there's no point in anyone being beastly I
mean'. This attitude, resulting from personal need for freedom
and control, is exhausting to deal with on a daily basis. Both
Curators D and E have a policy of always taking the blame for
mistakes regardless, Curator B tries being 'everybody's friend'
whilst Curator D stated:

> you've got to be very careful. You can't just open your mouth and
> speak. You've got to think about what you're saying all the time ...
> and trying to phrase orders to them that don't appear as orders but
> as requests keep you on your toes verbally ... I would prefer to say
> 'would you do this for me please?' and come back and know that it
> would be done. But you can't really do it like that, its 'would you
> mind, I'm really sorry about this, but do you think you could...?

Anyone managing a workforce thinks about appropriate ways to
phrase things, but not with the risk of them walking out if mis-
takes are made. It is arguable that SIMS curators have to cope
with this, but there is a danger in refusing to, especially if the
curatorial post is financed by the museum Trust, meaning that
the post-holder can effectively be seen as a servant. In Millar's
key work (Millar, 1991), there are two sections on 'Attitudes of
Paid Staff to Volunteers' (1991: 62–3), but a glaring omission of
a section entitled 'Attitude of Volunteers to Paid Staff'! No
wonder such a wide range of personal skills, including 'patience',
'tolerance', 'tact', 'communication skills', and 'an ability to get on
with people', is felt necessary by curators in SIMS, if they form
the shamrock's core workforce (Osborne, 1993: diagram 32). The
other two elements of the shamrock organization are addressed
below.

Returning to different organizational cultures, the task culture
is able, like the club culture, to respond speedily to change.
However, it usually consists of 'young, energetic people develop-
ing and testing talents' (Handy, 1988: 91) which does not sound
much like the main body of volunteers as they presented them-
selves earlier. Handy's fourth culture, the person culture,
however, does seem to fit the retired volunteers situation more
comfortably. People affiliated to this 'value their freedom highly,
the right to make their own decisions, to work in their own way

and to express their own identities; they like to think of no one as their boss' (Handy, 1988: 101). Handy states that person cultures are 'very difficult to run in any ordinary way ... (workers) can be persuaded but not commanded; influenced, cajoled or bargained with, but not managed' (Handy, 1988: 92). Whereas club, role and task cultures all put the organization's purposes first and harness individuals appropriately, the person culture puts the individual first and makes the organization simply a resource for their talents. It does not, therefore, sound ideal for SIMS unless those talents are used ultimately to benefit the museum.

Sometimes they are. At the case study museum, one volunteer works on the costume collection and has made authentic reproduction costumes for figures in period room settings because:

> It's my great interest ... I can now further my knowledge in sewing techniques [by] being able to study at close quarters how things were made and then hopefully my own knowledge will be of use to the museum and I will be able to make things myself, which I have already done for the museum'.

This particular sort of involvement, i.e. behind-the-scenes, as opposed to front-of-house, is ideal for those with a genuine interest in the museum and its subject matter: a task/person culture-based partnership of volunteer self-actualization, but, of critical importance, with a professional-standard output which can contribute greatly to the museum's goal of improved interpretation.

Unfortunately it is not always possible to have that many such partnerships in SIMS. Firstly, retired volunteers do not always wish to use their professional skills in a voluntary capacity (Millar, 1991: 36). Secondly, behind-the-scenes volunteers need careful supervision and 'you can't shirk that part of it ... it backfires on the curatorial staff because it's not done right and it has to be done again' (Curator D). Also with small staff volunteer ratios it simply cannot be done properly, except on a small scale. Even if there were enough supervisory personnel, a third problem experienced by all five curators, is the sheer lack of physical space available in SIMS behind the scenes. At one museum, it is not possible to use the attic stores as work-space because of fire regulations, nor would it be advisable to have 70-year-olds going up and down steep and uneven staircases. What available space there is is at saturation point. Fourthly, and most importantly, not

everyone has the professional attitude needed to work on collec-
tions. Curator B found it 'a quite difficult task to match the right
personality, character (and health type) with the work that we
think is relevant to the museum'. Inevitably, therefore, some
retired volunteers who want more than to meet people, who
declare themselves interested in the museum and local history but
who cannot be catered for behind-the-scenes 'end up' doing front-
of-house work. This seems hardly calculated to sustain their
motivation, and when there are fewer visitors to meet, boredom
soon sets in for everyone – it is by far the most frequently noted
dislike (Osborne, 1993: diagram 31).

Referring to job shape, another element of organizational
structure, Handy states that 'voluntary organizations ought to ...
practise subsidiarity ... in other words, give people as much
responsibility as they can handle' (1988: 105). For some volun-
teers interested in history, would this not be an opportunity to
take advantage of having access to museum resources and to take
on the responsibility of enlarging their historical knowledge for
the benefit of visitors? Could not the person culture enable them
to make the museum a resource for their own interests at the
same time? Unfortunately, it is not quite so straightforward. One
volunteer, was evidently dissatisfied:

> As an ordinary volunteer [i.e. front-of-house] you see, really, we are
> not highly involved and if one is very interested in history or archae-
> ology, one really has to go on courses or something to be involved in
> that. Being a volunteer at the museum doesn't really give you that ...
> you're here, you're interested, but you are really communicating with
> the public on a very ordinary level aren't you?

However, on no occasion, to the best of the curator's knowledge,
has the above volunteer ever shown an interest in the museum
library or information files to which she has access. One curator
from another museum wrote (entirely unprompted) to express her
frustration on this point:

> About five out of twenty-eight stewards will take a file off the shelves
> and try to improve their knowledge. The rest seem content to sit
> talking and drinking tea for three hours! Any suggestions I make as
> to how they can usefully fill the time are either resented or ignored, so
> I have given up. I have spoken to other museum curators with volun-
> teer staff who have the same problem.

So although there is the opportunity to make the museum a resource for their historical interests, it seems this interest is not strong enough to motivate them to find out more *for themselves.* Millar asks if a job is 'humane, interesting ... providing satisfaction, a sense of belonging and a chance to learn' (1991: 36). It certainly could be if volunteers were self-motivated enough to take the opportunities available. Perhaps it is significant that although boredom was the most frequently mentioned dislike, the least frequently mentioned dislike was not having the right answer to visitors' queries. Managerially this is the most frustrating limitation because this ought to be an area where 'interest' motivation and organizational need overlap to outstanding mutual benefit.

The interest is there, but needs to be spoon-fed, as Curator E found when a volunteers' day-school on the history of the museum building was quickly fully booked. Spoon-feeding is fine if it benefits the museum; i.e. the individual's talents and abilities and willingness to use acquired historical information to aid interpretation for visitors are actually put to this use in the museum. However, evaluating whether this is so presents its own difficulties, discussed later in this contribution.

The shamrock concept partly explains this self-motivation problem. The other two workforce elements of this tripartite organizational model are the contractual fringe (e.g. individual experts, small commercial enterprises and consultants) and the flexible labour force (volunteers). Of the flexible labour force Handy says 'you cannot assume the same loyalty and commitment ... as you can from the professional core; [it] does not expect the work to be intrinsically rewarding or motivating' (1988: 118–19). No wonder 'patience/tolerance' was mentioned most frequently as a skill needed in supervising retired volunteers. As for organizational shape, the shamrock seems to be a recipe for curatorial burn-out!

This section has tried to explain the strengths and limitations of retired volunteers' contribution to SIMS by exploring the relationship between their motivations and organizational needs. The strengths are where motivations coincide with organizational needs, the limitations where they work contrary to them. Brutally put, the limitations seem to outweigh the strengths, but happily this has not stopped the publication of practical ideas to help

improve matters – important as the retired population is due to continue rising into the twenty first century and volunteering with it. The next section takes up Hatch's challenge to explore 'the ways voluntary organizations seek to develop and sustain the motivation of participants' by examining the aspects of organizational theory that encompass practical techniques and analyzing why some techniques have worked and others are unlikely to, at one museum reliant on retired volunteers.

TECHNIQUES PUT TO THE TEST

> All too frequently when we fail to achieve the results we want, we look for the causes everywhere but the right place. Frequently it is our inappropriate managerial methods. It is much easier to blame others, such as ... the 'unreliable volunteers'. (Wilson, 1976: 27)

Earlier sections have shown that although retired volunteers' motivations sometimes coincide with organizational needs, often they do not. How, then, are curators to try and sustain motivations that do coincide, and, given the resistance to self-actualisation, try and develop them further to help volunteers enhance their contribution towards organizational goals, which is what the museum needs? Which methods are, to put it bluntly, the most cost-effective use of curatorial time in museums aiming for improved service-delivery?

First, it would seem most cost-effective, and certainly kind, to attend to the remaining missing and demotivating hygiene factors. The issues of comfortable seats, refreshments and warmth can be addressed, bearing in mind the sometimes extreme difficulties of positioning furniture in relation to fire exit routes in small, converted listed buildings, of affordable warmth for museums in draughty historic houses and that recently one volunteer was found fast asleep in an armchair in front of the open fire in a period room! Personality clashes between volunteers can be left for themselves to sort out unless it is detrimental to visitors' needs at which point managerial intervention is called for.

Curators in SIMS need to find out what other managerial techniques are available to them. Handy is in favour of excluding the term 'management' altogether in the voluntary sector because of the overtones it has, especially for volunteers. However, the most significant publication to date in this field is concerned with

volunteer *management*, and indeed includes the word in its title (Millar, 1991). Handy's organizational structure and systems which encompass practical management techniques, and the findings of earlier sections are used in this section to explore why some techniques seem to have worked well in terms of retired volunteers *and* organizational needs and why others have not.

In order to survive through change in response to demands from the outside world an organization needs to change too (Handy, 1988: 107). A role culture has already been noted as a necessity and of three 'main ways of holding an organization together' which Handy describes (1988: 110), having 'rules and procedures' seems the most appropriate, as it complements the role culture's need for procedure. There are two alternatives, the first being 'hierarchy of command', which would rely on volunteers being left to their own devices. This is 'fine if they are responsible people you can trust' (1988: 110) and difficult if they are not motivated by responsibility and/or need spoon-feeding. The second is 'co-ordinating groups' of autonomous groups with power and resources to control their destiny. Again, this would be difficult with volunteers who, by their own admission, are not task oriented, power seekers or changers of things, when change is needed to survive and power needs wielding with acumen. Both alternatives seem inappropriate in SIMS. The 'rules and procedures' method works on the theory that if parameters and ways of doing things are known, things will fall into place. Rules, procedures and consequently policies, would also seem to sort out the problem of the missing hygiene factors of communication, administration, policies and supervision.

In the case study museum over the past few years, volunteering has become more codified and procedural in an attempt to hold together the increasing number of volunteers in this swiftly growing and changing museum. Most of the ideas have been taken from Millar (1991) but have been modified to suit the circumstances, as she herself recommended. In all areas, the gentle touch has been important because for affiliation-motivated people 'a manager who is all business both frightens and alienates this type of person. They are sensitive and easily hurt, so the climate must be accepting, supportive and genuinely friendly' (Wilson, 1976: 53). There has always been a volunteer organizing the front-of-house rota; a difficult job at the best of times. The

current post-holder who, importantly, volunteered and was not cajoled into it, helps not only drawing up the rota but also by providing the direct, personal touch and in sharing the curators' roles as social workers. She spends about five hours a week juggling, persuading and listening which would otherwise have been done by curatorial staff. She is, as Millar points out, 'an immense advantage' and contributes greatly to preventing curatorial burnout.

As a direct result of Millar's work, a Registration Form was drawn up together with a welcome letter given to potential volunteers at point of interest. They act as useful filters, because although their tone reflects the need for a gentle approach and information requested is essential, not all forms given out come back. If they do, references are taken up and once received, the Rota Organizer undertakes an informal interview whilst showing the new recruit around the museum to meet other volunteers and staff.

The Registration Form was introduced retrospectively and it was with some relief that only one volunteer took exception to the idea and promptly left the museum as a direct result and only one other refused to fill it in. Most retired volunteers appreciated this as a sensible, professional move and did not mind entering personal information such as their date of birth, once it was understood that it was kept in absolute confidence and that it was also necessary to know for insurance reasons. No one has resisted the request for references. Millar suggests that a formal job description, one that requests specific skills, and lines of accountability, should help in attracting suitable volunteers. This seems likely to be too strident for potential recruits because of the freedom and friends factor. However, the job in hand does need to be made clear and the introduction letter is a more informal adaptation. The production of a pocket-sized front-of-house helpers' 'handbook' has been much appreciated. Designed to help volunteers feel more secure in carrying out everyday procedures as smoothly and as professionally as possible, its approach again, is a firm but gentle adaptation of Millar's advice – she suggests including information about insurance, dismissal, codes of practice and volunteer agreements, but these were omitted.

Effectively, the above all act both as administrative and super-

visory hygiene factors, as well as self-esteem motivators. The self-esteem level also includes appreciation, training and rewards. Many museums have end-of-season and Christmas 'thank you' parties alongside daily appreciation. A quarterly front-of-house newsletter has been much appreciated and AGM's and press-releases are also good for public applause.

Appreciation of a different kind is also sought which equates to one of Handy's organizational systems, the number system concerned with what sort of numbers make different people tick (1988: 132). One volunteer, talking about the National Trust, pointedly remarked

> you notice the appreciation – you notice they were told how much money they saved (the National Trust) ... you picked that up. Now that's, in my experience, absolutely typical ... volunteers are kept totally informed about everything and thanked.

The museum responded to this by starting to tabulate and inform volunteers about the number of complements paid to staff in the visitors' comments book, the money saved by their voluntary efforts and the amounts taken in the till.

Training, both in visitor needs and the museum's subject matter, is also an essential part of volunteer self-esteem as well as being a security factor in the case study museum. Refresher days are held just before the start of the season to remind people of basic and emergency procedures, changes thereto and visitors' likely needs. They are also informed of any changes to displays and given an explanatory talk and tour. There are mid-season updating sessions and information folders on the permanent displays are being developed together with collections-based training days.

Intimately connected with both procedures and training is communication, a hygiene factor and another of Handy's organizational systems. He points out that at the best of times usually only fifty per cent of what is said or written is ever received (1988: 122). He advocates direct communication (usually the only way in SIMS) which casts doubt on the effectiveness of the cascade training idea (Millar, 1991: 44). However, one of the most frustrating aspects of training retired volunteers is that 'you are dealing with a particular age group, and, this is an awful generalization, you do tend to find yourself explaining things time

and time again to the same people' (Curator C). Curator D stated
that she found

> a refusal to read notices and so on, which means that they're ignorant
> of what's going on and that can cause endless problems and it looks
> extremely inefficient. [I've] tried standing up at coffee mornings and
> saying, 'please, please ...!

Partly this is to do with the pattern of volunteering within small
towns by retired volunteers. All five museums had volunteers
working on a weekly or fortnightly basis. Curator D points out
'maybe, once or twice a year they will have to use the entry form
system ... you cannot expect them to be a professional and as
slick as someone doing that 4 or 5 times a week'. At one museum
the curatorial staff deal with enquiries on the spot for this very
reason. Another problem is health related – deafness and poor
sight for example make training much harder (Curator C).

Self-esteem about undertaking voluntary work may explain
why, when asked if they thought there should be concrete
rewards, a unanimous 'no' was the response. Curators across the
south-west noted that where travelling expenses were offered, they
were seldom claimed. Refreshments are obviously appreciated (as
hygiene factors), but experience at one museum suggests that if
tea is occasionally served to volunteers by a member of curatorial
staff, so much the better! Self-esteem is a need worth satisfying if
it takes volunteers on to self actualisation and the above techni-
ques have been found largely to contribute to more effective
service-delivery through confidence being built, procedures being
followed properly, and perhaps some spoon-feeding returning to
the visitor. However, rules and procedures do not solve every-
thing.

Millar's suggestion of recording and evaluating volunteers'
work (1991: 42) is perhaps appropriate if there are a few volun-
teers only, and for the self-actualising volunteers, but the scale of
volunteering at SIMS and the staff:volunteer ratios would make it
prohibitively time consuming. One also wonders what purpose it
would serve where most of the volunteers, by their own admis-
sion, are not interested in a volunteering career or personal devel-
opment, but helping out and meeting people. They are not in it to
be evaluated; as one of them said 'we all do our best and if they
don't like it they can...!', making it difficult to evaluate how

much training *is* actually cost-effective in terms of improved visitor services.

Furthermore, extreme formalization works contrary to the gentle touch. Although Millar states that 'volunteers are more aware of their rights: they are developing high expectations' (1991: 27), this claim does not stand up to much scrutiny. For example, the volunteers at one museum were asked what rights they thought volunteers had. There was a long pause on each occasion and they gave the strong impression that they had never given any thought to it before now. However, the general reply (eventually) was the right 'to walk out! ... I can say no ... I'll do this for you, but not the other ... I am offering you something and I have the right to withdraw it'. One said that rights 'doesn't come into it really – you are not forced into it!'. This is why the idea of a Volunteer Agreement was not implemented at the case study museum. A legally binding document (Millar, 1991: 41), it is designed to give two way accountability. When retired volunteers were asked for their reaction to the agreement as an idea, it was one almost of revulsion:

> you had enough of that in your working lives and we have no obliga-
> tion to volunteer for anything ... it's stopping all the kind of trust
> between people ... you would get most of the people leaving, you
> would definitely ... it destroys the sense of freedom doesn't it? ... this
> is something that should be fought tooth and nail.

Freedom is a key word here, and so is trust. The introduction of such an agreement would destroy both utterly for many volunteers and as Millar herself says 'trust is essential to co-operation' (1991: 44). Moreover, they do not need to sign an agreement which would give them the opportunity to 'file a complaint' or follow a grievance procedure (Millar, 1991: 48). Actions speak louder than words and they could simply walk away.

Rules and procedures cannot counteract this basic fact, explaining why often disciplinary procedures need the kid-gloves touch. If one 'acts promptly on day-to-day discipline' (Millar, 1991: 47) it needs going gently: after all, how beastly is beastly? The gentle alternative to discipline, persuasion, does not always work in small towns. Often a particular day in a museum is over-subscribed with volunteers whilst another is difficult to fill because of other activities in the town, making changing a volun-

teer's schedule difficult. Here the relative value of volunteering at
the museum needs consideration. One volunteer pointed out that
in their town there exists a definite hierarchy of volunteering. Top
came the Minster, then the local National Trust stately home,
and then the museum, so the good and the great come first. But
it might explain why persuading retired volunteers to change their
duty days may not always succeed and if the late person is late
on an understaffed day, there is precious little to be gained in
moving them away from it. Other work (i.e. behind-the-scenes) is
difficult to find, as already discussed, and dismissal is a final
resort, but has been used in one museum. It does, however,
sometimes leave a nasty taste behind, especially with friends and
acquaintances of the dismissed.

Nor can rules and procedures counteract the tendency towards
amateurism. Under the heading 'the perils of voluntarism', Handy
describes 'strategic delinquency': 'to stand for something is
perhaps more important that to achieve' (1988: 6). Millar states
optimistically: 'the realisation by paid professional staff in
museums that volunteers ... are not a 'necessary nuisance' has
created the climate whereby voluntary activity is no longer
equated with amateurism' (1991: 3), but has not met one volun-
teer who, forgetting how to work the shop till, was referred to his
individual handbook with till instructions in it. His reply was 'I
prefer to muddle around and find my own way' with absolutely
no appreciation of the need to get the till right. he did not take
up the offer of a till training session, demonstrating how very dif-
ficult it sometimes is to communicate why training is needed. As
Curator D pointed out, how do you convey the need 'without
making them feel that they're doing it wrong anyway and why
should they bother?' Likewise, some volunteers still impart inac-
curate or misleading information to visitors despite the spoken
and written procedures and availability of the curatorial staff.
Perhaps their confidence is taking longer to build up than antici-
pated. Volunteers were asked if they would like to become trained
tour guides and a few responded positively to this, although
many more were not enthusiastic. A less kind analysis is to feel
that this is related instead to not wanting a great deal of respon-
sibility, certainly not the responsibility of 'doing it properly'. So,
although it has been said that as volunteer managers 'our need
has a tendency to create filters which hinder us from hearing the

volunteers' needs and interests' (Wilson, 1976: 43), is it not just as valid to say that volunteers also create filters which hinder them from hearing the museum's/curatorial needs and interests as well as their own?

Finally, recruitment of volunteers other than retired people at one museum was, until recently, virtually impossible because the Management Committee felt that recruitment should only take place by word of mouth – another manifestation of the club culture. Now admitting that the museum needs to recruit younger people as the original club members and their friends get fewer, curatorial staff put forward for all volunteers' consideration and vote an alternative timetabling proposal that might make volunteering easier for, for example, mothers with school age children; a genuine attempt at community involvement. The resounding response was that timetabling should stay the same.

This is a good example of the third of Handy's organizational systems at work: the participation system, concerned with accountability and democracy. In this case, it was what Handy describes as democracy by consent (1988: 138). Here the group (volunteers) has power of veto on any decision, but it is the leaders' (curators') job to put a decision to the group. A veto on different timetabling means it looks like retired volunteers will continue to be the mainstay for some time to come, even though it might be contrary to organizational requirements.

A brief analysis of all the above techniques shows that in maintaining and developing retired volunteers' interests, and in trying to help them augment their contribution towards the museum's need for improved service-delivery, much work falls on the shoulders of the curatorial/supervisory staff with everything from Registration Forms to handbooks and training days. With training days for example, 'If you can get there and back in a day they're fine. They don't want to stay overnight – those courses are a disaster – they can't afford it and we can't afford to pay them' (Curator C), and in-house training can mean that 'attaching a volunteer [or forty] to an overloaded curator/manager can hinder work in progress rather than offering training opportunities' (Millar, 1991: 44).

So is it all cost effective? The curatorial hours spent devising and producing these methods at the case study museum have totalled 584 per annum (Osborne, 1993: Appendix 14). With a

ball-park salary of £15,000 gross to the curator's employer, the salary is £8.20 per hour or a minimum of £4,730 per annum spent managing volunteers. The following argument is academic since this museum cannot afford to employ paid attendants if it did not have volunteers, but with volunteers contributing a minimum of 484 hours per month, for 8 months of the year, this totals 3,872 hours per annum. Charged at an attendant's rate of perhaps £5.00 per hour totals £19,360. In theory volunteers do therefore seem to earn their keep. Is it qualitatively effective as well as quantitatively? On the whole it would appear so, with notable exceptions, as in volunteers who, because of their own motivations can be unreliable, despite the adoption of approved management techniques, as the opening quote to this paper demonstrates. The way forward from here, Millar argues, is to plan volunteer policy. The concluding section of this paper will examine the opportunities and threats to Millar's suggested action plan.

CONCLUSION – THE CURATOR, THE MUSEUM, ITS VOLUNTEERS
AND THEIR MOTIVATIONS

The involvement of retired volunteers in the core-tasks of curatorial and visitor service delivery is vital for SIMS' survival. It seems they are motivated primarily by the need for freedom, social contact and a tradition of helping out as well as loyalty to the past. They are thus excellent at providing a friendly welcome to visitors. They are motivated by recognition ('we thrive on appreciation' as one said) but largely seem content not to have a challenging, self developmental role. Those that do feel they are under-utilized largely do not have the self-motivation, confidence or perhaps the desire to improve matters for themselves. This means their contribution to a changing organization's goals is very much appreciated, but in reality limited. However, the need for SIMS to have professional quality input is no less than for any other museum. This difference in needs results from cultural mismatch and leads to the creation of the organizational shamrock shape, both of which take their toll directly on service-delivery effectiveness and curatorial staff.

The strengths and limitations of their contribution can be ameliorated by the judicious choice of management techniques, but

on a wider, policy-based outlook. What further opportunities can be grasped to improve matters and what threats are there to having an effective and efficient museum service? It is pertinent to answer this by running through the elements (italicized) of Millar's 'Summary for Action – Policy – Planning for Volunteers' (1991: 70).

A *tailor-made* policy should 'meet the requirements of a particular museum and be organized around the potential pool of volunteers in the region. The large number of retired professional people in ... south west England ... makes careful selection both desirable and a viable option' (Millar, 1991: 70). Everyone should know the boundaries in which they are operating, including volunteers. However, the limitation of such policies in SIMS need to be recognized: there are not enough volunteers, it is difficult to attract other types of volunteer, and those that come are at least aware of their right to walk out if they do not like it. A policy in these circumstances does not have many teeth – and retired volunteers may not feel inclined to read it however good for them it might be.

The opportunity to select only ideally suited volunteers is truly tempting. The museums investigated, however, rarely turn away a volunteer for front-of house duties. SIMS cannot be too choosy because many are necessary to provide sufficient coverage (one museum needs at least 8 a day to provide minimum security for open displays). There are seldom enough on duty at any one time because forgetfulness, 'upping sticks', and sadly, illness and death are not infrequent occurrences. In the sheer scale of volunteer operations in SIMS, however, lies the threat. Handy says 'small groups are easier to run in a participative way ... small groups breed commitment and energy ... it is best to keep any group as small as you dare' (1988, 54: 58).

Developing the *Attractive Package* is one way of dealing with the problem depending on the criteria chosen; a package to attract enough retired volunteers might tie in with the motivations mentioned earlier, a package to attract reliable retired volunteers might emphasize the roles available. One might even try reversing the following statement: 'we must rethink the jobs we are offering ... to be sure they are generously laced with motivators and not overly encumbered with hygiene factors' (Wilson, 1976: 51). One could follow Handy's advice and bear in

mind that 'people like targets'. Part of the problem of front-of-house work, can be its ongoing and rather loose, untargetted nature. If, however retired volunteers are not task, but relationship oriented, targets seem inappropriate.

Perhaps the best hope is to persuade volunteers on the self-esteem level of the importance of front-of-house work and to keep up the spoon-feeding. For example, if *core functions* should be identified in museums where professional and volunteer staff work together, front-of-house work should be made known to volunteers as being of core importance. Significantly, the number and speed of acceptances to the invitation to be interviewed for this dissertation on which this paper is based was startling – there is nothing like being asked and made to feel important!

The threat is that with these approaches alone, unbalanced by any statement of the museum's need, there is a danger of creating a person culture that exists only to further its own interests and which cannot be enforced to do otherwise. Another is that self-esteem does not alleviate the boredom of the function during quiet periods or necessarily encourage volunteers to make use of the time in a way which might alleviate boredom and contribute towards the museum's goals. It would be ideal if 'volunteers' needs, expectations and skills (were) in step with organizational requirements' (Millar, 1991: 35), but divergence seems inevitable.

There may be two levels of *reciprocity* operating. One is volunteers volunteering to help a local need in order to say thank you themselves for good fortune, especially for living in a nice place of their choice. This is an opportunity for true community involvement. However, having satisfied this level of reciprocity, there is, perhaps, a threat to organizational goal achievement from a second level, whereby they expect to be thanked for volunteering, regardless of the degree of commitment, well aware that they could take their services elsewhere in the area, if it was not forthcoming, and still satisfy their own need to say thank you for good fortune. This could also help explain the problem with reliability and commitment, for if volunteers volunteer in more than one place to satisfy their need, occasional unreliability in any one venue, especially if it is not perceived as that valuable, does not compromise this need. However, if many volunteers do this just once in a while, in total it does compromise organizational needs. It is interesting that perhaps those who dislike

retirement do not feel quite so thankful to the locality, but thankful to the museum for providing structure and roles.

Supervision, in the form of a rota organizer, if one can attract a good one who really wants to do it, is a necessity. The opportunity then arises to reduce greatly the time spent by curators supervising and being social workers and organizing anything up to 100 retired people whilst increasing the amount of time that is spent appreciating them. The threat is not getting the right person for the job. This is one job where being selective is vital.

How one approaches *communications* is just as important as what is communicated. As well as the written and spoken word, perhaps curatorial staff should branch out into training videos on displays and visitor care, much as the National Trust has for volunteers undertaking preventive conservation on their collections. The threat to all communication is, again, the sheer scale and diurnal fluctuations of retired people's volunteering in SIMS and the fact that one cannot have a chat with a video tape.

The opportunity for *consultation*, at the case study museum, happened on a large scale back in 1990 when the decision to employ professional staff was made by the volunteer Management Committee. Questionnaire responses showed that no volunteer confessed to disagreeing with their employment. Appointed because of their expertise, the curators have to use persuasion and reason as a means of influence (Handy, 1988: 68). However, the threat to constructive consultation is the club culture resistance to reason because of loyalty to the past and cultural mismatch. Democracy too sometimes poses a threat to achieving organizational goals. But even persuasion and reason 'will not work unless your power is backed by some access to resource power, in other words if people feel that you can actually sack them, cut their pay or their budget or increase their allowance' (Handy, 1988: 69).

Even with resource power, it would seem wise, as regards motivation, to use available financial and material *resources* available for volunteer management on hygiene factors in the first instance, if Maslow and Herzberg are right. It needs realizing however, that such expenditure might contribute to organizational goals by encouraging volunteers to remain, rather than by inspiring them to greater things.

Under greatest threat is the resource of curatorial sanity. As

Curator C said (not entirely in jest) 'you kind of walk out and bash your head against a brick wall and then see one of your colleagues and swap stories'. Handy believes 'the danger lies in the shamrock' (1988: 160) but for the volunteers, rather than the curators, feeling the former to be both under-used as the flexible workforce and potential candidates for the contractual fringe: 'the self-managed group, increasingly well trained and well qualified, giving of themselves professionally for part of their time. The pay which they would receive, in this version of the psychological contract, would be the training and experience that would allow them to feel, and to be, professional' (Handy, 1988: 161). One feels strongly that this would apply to only a few retired volunteers and so the danger lies just as much in the endlessly demanding position of SIMS core, curatorial staff. If there is one reason alone for writing a volunteer policy it should be that without one 'the complexity of managing them [goes] unrecognised' (Millar, 1991: 27). Curator A, contemplating possible cost-cutting redundancy and replacement by a 'cheaper alternative' sums it up:

> it would be difficult to attract people of the right calibre. They'd have to learn pretty damn quickly to fit in with this kind of organisation. I'm not saying that I'm indispensable but ... it's not quite as simple as ... coming to work for the local museum, it's much more personal than that, really [it's about] being attracted by the nature of the museum and the people who work here.

Curator C has the last word, which must surely apply to curatorial staff working with retired volunteers in any museum: 'it's not a job for everybody'.

ACKNOWLEDGEMENTS

I would like to acknowledge the following:

The Area Museum Council for the South West and East Dorset District Council for jointly funding my attendance on the Museum Studies Masters Degree course at the Department of Museum Studies, University of Leicester, and additionally to the Carnegie Fund UK for part funding a place on the Museum Training Institute's 'Supervising and Supporting Volunteers' course; to Dr Michael Nix and Ms Lisa Conway the course leaders; the five anonymous curators in small, independent

museums in the south-west who supplied me with their frank opinions; Clare Conybeare for her help with compiling the questionnaires and group questions – any faults in them are mine entirely; Dr Stuart Davies for his help ascertaining the statistical validity of the questionnaire responses; Mr Kevin Moore for his encouragement and constructive comments; Dr William J Philpott, Mr James Rattue and Mr Stephen Price for their extreme patience both as friends and colleagues; the voluntary organizations who supplied me with information about their volunteering situation and, of course, the retired volunteers without whom I could not have written this contribution.

BIBLIOGRAPHY

AMCSW (1993a) *Forward Plan* (AMCSW).

AMCSW (1993b) *Annual Report for 1992* (AMCSW).

AMCSW and WTB (1993) *Rain or Shine: a tourism and museums strategy* (AMCSW).

Audit Commission (1991) *The Road to Wigan Pier?* (London: HMSO).

Brown Fletcher, K. (1987) *The 9 Keys to Successful Volunteer Programs* (Rockville, USA: Volunteer Management Associates).

Croner's (1993) *Management of Voluntary Organisations* (London: Croner Publications).

Department of National Heritage (DNH) (1996) *Treasures in Trust. A Review of Museum's Policy* (DNH).

Hadley, R. and Scott, M. (1980) *Time to Give? Retired people as Volunteers* (Volunteer Centre UK).

Handy, C. (1988) *Understanding Voluntary Organisations* (London: Penguin).

Hatch, S. (ed.) (1988) *Volunteers: Patterns, Meanings and Motives* (The Volunteer Centre UK).

Major, J. (1992) *The Individual and the Community: the role of the voluntary sector* (London: HMSO).

Mattingly, J. (1984) *Volunteers in Museums and Galleries* (The Volunteer Centre UK).

Middleton, V.T.C. (1991) *New Visions for Independent Museums in the UK* (Association of Independent Museums).

Millar, S (1991) *Volunteers in Museums and Heritage Organisations: policy, planning and management* (London: HMSO).

Osbourne, K. (1993) 'When they are good, they are very, very good. ... Motivation versus management: the management of volunteers in small independent museums in the south-west' (unpublished MA dissertation, University of Leicester).

Price, S. (1991) 'Priest's House Museum', *Museum Development* May 1991.

Rose, P. (ed.) (1993) *Social Trends 23*. Central Statistical Office (London: HMSO).

Tanner, K. (undated) *Museum Projects: A Handbook for Volunteers*, Work Experience and Temporary Staff (AMCSW).

Thomas, A. and Finch, H. (1990) *On Volunteering: A Qualitative Research Study of Images Motivations and Experiences* (The Volunteer Centre UK).

Willis, E. (1992) Speech given by Elaine Willis to the South West AMC Council AGM November 1992.

Willis, E. (undated) *Managing Volunteers: the Strategic and Policy Implications* (The Volunteer Centre UK).

Wilson, M. (1976) *The Effective Management of Volunteer Programs* (Colorado, USA: Volunteer Management Associates).

8

Why Are There Not More Women Museum Directors?

MAGGIE BLAKE

This paper is based on the research carried out for an MA at Leicester University in 1993. As little primary research has been carried out in this museological field, the majority of the findings are based on personal interviews with twelve carefully selected women on a non-attributable basis. In addition, research material was also gathered from seven senior male managers (the majority of whom were directors) by means of a questionnaire.

INTRODUCTION

> I always thought that museums were equal opportunity employers. And I know that when you start off there as many, if not more, women then men. There's got to be something wrong if by the time you get to the top the women are weeded out for some reason. (Manager)

Women make up 51.2 per cent of the population but they do not hold a broadly similar number of top posts in the workforce as a whole, or in museums in particular. As Souhami highlights, 'women still do all the low-paid, low status work and are grossly under-represented in Parliament, the law and other positions of power' (Souhami, 1986). A similar trend exists in appointing directors. According to a 1992 report from the Policy Studies Institute, fewer than 5 per cent of directors are women even though the pool of talented and experienced women available for such appointments continues to expand (Equal Opportunities Review [EOR], 1992: 5). This report also argued that outdated views about women's capabilities and ambitions lead board chairs and executive directors to rely on the old boy network for their non-executive director appointments (ibid: 6).

185

According to Legget's (1984) and Prince's (1988) research in the museum context, the percentage of directors who are women is reasonably good in comparison with other areas of work. Unfortunately, there has not been a recent update on these figures. As a result, any current estimate has to be based on a personal insight into the profession. This gives the clear impression that there is still a marked disparity in the percentage of directors and senior managers who are women, compared to the number of women in museums as a whole.

THE ROLE OF WOMEN IN THE MUSEUM WORLD

'It looks as if the position of women in museums is broadly similar to the position of working women in Britain as a whole' (Prince, 1988: 60). According to a 1993 survey, there appears to be an equal balance between men and women in the museum profession (Museum Training Institute, 1993: 3). This conclusion is at odds with the data held on the Museums Database which found that, 'museums (irrespective of type) employ men to a degree that far outweighs any statistical observations of chance' (Higgins-McLaughlin and Prince, 1987: 91). However, it may be that a broader definition than usual of the word 'museum' was used.

Unfortunately, the Museum Training Institute survey did not aim to discover the number of women directors that have been appointed. Therefore reliance has to be placed on figures which are almost certainly out of date. Legget (1984) found that 26 per cent of directors were women whilst Prince (1988) highlighted that, 'over 90 per cent of the directors of national museums are men, with approximately 80 per cent of the other two main categories of museums [local authority and independent] also having male directors' (Legget, 1984: 24 and Prince, 1988: 58–9). However, the percentage of women directors in other countries is little, if at all better. Direct comparisons though, are difficult as the various studies have been carried out at different points over a number of years. The United States has the most legislation to support the career progression of women. However, a 1978 survey by the American Association of Museums showed that only 16.7 per cent of directors were women (Friedman, 1985: 15). A 1982 survey by the Association of Science Technology Centres came up with similar results. It found that more than 80 per cent

of all science/technology centre-directors were men (Hicks, 1985: 19). Perhaps most surprising of all, though, is that even in 1991 only 15 per cent of art museum directors were women (Glaser, 1991).

In this country at least, art galleries as a whole seem to be more positive in their attitude towards women. As a keeper of art highlighted, 'one thing I find is that the museum world is filled with all the prejudices which have come up through the higher education system'. Such 'prejudices' result in more women fine art curators than there are women curators of technology. This tends to mean that there is a greater likelihood of a woman being a director of an art gallery than of a science museum.

The development of a more positive attitude towards women in the British museum profession (at least in local authority museums) in recent years is borne out by the comments gathered during the interviews. Interviewee 'C' said that she had not been able to start her museum career properly until relatively late in her life as, 'all those years ago (approximately twenty) they were prejudiced against married women'. Another woman ('D') highlighted that in the late 1970s, 'people felt good because they'd got a young woman on their committee: whether they listened to her was another matter.' In the early 1980s, 'E' experienced resistance when she wanted to return full-time after the birth of her first child. As she explained, 'the trend then was very much towards part-time employment when the children were tiny. And I did encounter quite a lot of opposition to coming back'.

All of the women who had been working in the museum profession for some years stated that the number of women directors had increased during their career. In addition, there are many more women in senior management in British museums than there were ten years ago. Yet although the overall position of women in museums maybe improving, there is no room for complacency considering the number of women in the work force as a whole.

WHAT PREVENTS MORE WOMEN FROM BECOMING MUSEUM DIRECTORS?

> I think there are a set of barriers along the way and I think that there is more chance of women falling at these barriers than men. (Assistant Director)

Most people would nowadays agree that there are no intrinsic reasons why women cannot become directors, including directors of museums. It is argued (see below) that it is only a matter of time before there will be many more women directors than there are at present. This 'logarithmic progression' may have a role to play in increasing the number of women museum directors. However, the difficulties for women aiming for the top which are outlined below are always likely to hold many women back unless changes are made.

THE DIFFICULT OF COMBINING CARING FOR CHILDREN AND A
CAREER IN MUSEUMS

> I very rarely talk about my son at work. It's like if you're continually ill, people just don't want to know. (Curator)

Since there is enormous competition for jobs in museums, employers can afford to expect applicants to have high academic qualifications. The 1993 Museum Training Institute survey showed that over 85 per cent of curators and managers have degrees or higher degrees (Museum Training Institute, 1993: 1). This can mean that a person does not get their first paid work in museums until they are in their mid twenties. Most women who aim to combine a museum career with having children want to first of all establish themselves in their chosen field. Unfortunately for women who are aiming for a management position, the time when they are likely to be starting a family is the point when their male colleagues are beginning to filter through into senior management. In addition, there are many practical difficulties inherent in trying to combine a career with caring for children, not only in museums but in the work force as a whole. As a result, many older professional women have made a conscious decision not to have children.

Women that do decide to have children obviously need good, reliable child care support. Dix in her book *Working Mothers* found that most of the women she interviewed were only able to work full-time because they could 'afford full-time child care either in their own home or provided by a day nursery or child-minder. They consider themselves privileged that they earn well and can afford to subsidise their child or children's care' (Dix, 1989: 175). A 1993 government study found that working women

spend 'as much as a quarter of their earnings on child care' (Bassett, 1993: 2). Perhaps because museum work is less well paid in comparison with other professions, some of the London women interviewed were spending between a third and a half of their own wage on child care. Unfortunately, museums for the most part are unable to provide financial assistance or offer childcare facilities. Therefore, mothers in museums have to rely on a supportive partner. However, this presumes a supportive partner exists who has a reasonably paid job himself.

Clearly, many women find it a struggle to organize and pay for reliable child care. It is perhaps not surprising that male director 'G' felt that the problem of combining caring responsibilities and career was the underlying reason for the lack of women at the very highest levels in museums. Most of the mothers interviewed also found it difficult to convince their managers and colleagues that they were no less committed than before they had children. In museums at all levels, being 'fully committed' involves working late in the evenings and going in at weekends. As one mother explained, 'in the past, as many people do, I've been through periods of my life where I've been totally committed to the museum and worked tremendously long hours and its been my whole life. But that kind and level of commitment to the museum just is not possible now'. Museums are clearly only managing to function because everyone, even mothers with young children, are prepared to work far more than their contractual hours. However, if museums hope to attract more women into senior management the necessity to work late regularly or attend long meetings out of normal office hours will have to be modified. In addition, more emphasis needs to be given to objectives achieved rather than simply hours worked.

Many of the mothers interviewed felt very strongly that in order to appear professional they had to completely divorce their home life from their work. Child care arrangements were seen as their personal responsibility and they did not expect any help from their museum in arranging it. However, some museums do make use of the facilities provided by the parent body such as a local authority. In addition, the attitudes of managers can be vital and a flexible supportive approach can be as important as any tangible benefits organized by the museum.

Even if women find the strain of combining a young family and

a career too much, it is difficult to leave the profession and return a few years later. Museums for the most part cannot afford to offer career breaks as with constant cut backs they cannot guarantee that there will be a job to which to return. Evidently, some women when they leave to have a child, must depart from the profession for ever, taking their skills and valuable experience with them.

Although combining caring for children and a museum career is a major organizational feat for most mothers, it is not, according to 'D', the reason why more women are not in senior positions. She argues that, 'it's the reason why some women don't put themselves forward. But there are many women who don't have child care responsibilities ... who are not succeeding in getting into senior positions in organisations – museums in particular – but its the same elsewhere'. This analysis ties in with a conclusion from Coe's survey on the attitude to women in management amongst the membership of the Institute of Management. This found that, 'there is little correlation between the management level reached by women and their family circumstances. The women with children in this sample are just as likely – or equally unlikely – to reach the top' (Coe, 1992: 6). As 'D' concluded, 'child care is one of a number of issues'.

THE ATTITUDES OF WOMEN

> Are the last barriers to our success subtly internalised ones? That it is not the attitudes of others, but our own? (Taylor, 1984: 32)

There are obviously historical and cultural reasons why women have been reluctant to assert themselves. For example Kevan Moss, Executive Director of the Gallery Association, New York State, believes that the indecision of younger women on her staff is, 'an inhibition that originates in a need to be approved or seen as always right' (ibid, 31). It is also argued that women fear failure more than men. Women often feel that a poor performance in a senior position reflects badly on all women, not just themselves. Lisa Taylor felt that she could not make one mistake when she was the first woman appointed to direct a Smithsonian museum. She believed that if she was unsuccessful, 'it might be another 150 years before they hired another woman director!' (Craig, 1985: 23). Women also underestimate their own ability

and are often plagued by self doubt. Cooper and Davidson argue that, 'women's lack of confidence in themselves is found time and time again in research studies as the biggest inhibiting factor in women's career development' (Cooper and Davidson, 1984: 12). Hubert Landais, President of the International Council of Museums (ICOM) from 1977–83 supports this view. He maintains that women 'do not consider themselves capable of doing certain things and they have difficulty in overcoming their own psychological blocks. That may be why they do not hold the responsible positions they deserve' (Des Portes and Raffin, 1991: 130). This lack of self confidence often manifests itself when women apply for jobs. As Caroline Langridge, Head of the National Health Service's Women's Unit points out, 'women may look at a top job and think they can do 90 per cent of it but worry about the other 10 per cent and decide not to apply for the job. Men think "I can do 50 per cent so I'll whack in an application"' (Benn, 1993: 99). This lack of confidence in their own ability is noticeable when volunteers are required for high profile projects. 'E' has found that, 'if it is a meeting which includes men and women and they're looking for people to do a job, you tend to find that a male is more likely to say, 'I'll do it'' even if he is less competent to do it than others around the table'.

Women's attitudes to each other are also very important. 'F' in particular felt that there was a tendency amongst the older, childless women in the profession to be unsupportive of younger mothers like herself. Women without children cannot fully understand the organizational difficulties that arise from balancing caring for a child and a career. As she explained, 'they're not always sympathetic to other women coming up who are trying to juggle both areas of their lives ... they can do more harm than good for women in general. You quite often find that a man who has a wife that works will be more sympathetic'. If more women such as 'E' (who has a young family) were to reach senior positions, then perhaps other mothers would feel there was greater understanding as they try to combine career and caring responsibilities.

It is clear that women's attitudes towards each other may, in some cases, need to become more positive. However, women's views of their own capabilities is of more general concern. Yet according to 'D', women's negative attitudes about themselves are

a reaction to, 'organisational values and inherent sexism. As a result of that, women sometimes hold themselves back. It's a response to external pressures largely'. Clearly it is necessary to look at the culture of the workplace.

MUSEUMS – ARE THEY CONSERVATIVE ORGANISATIONS?
 They would say here that they weren't sexist and everything is equal.
 ... But putting it into practice is a different matter. (Manager)

The research carried out shows that there are conflicting views as to whether or not museum hierarchies have changed their underlying assumptions regarding the role women should play in the organization. A male director wrote in reply to the questionnaire that 'there is still a bias against women in business. This bias is not as evident in the performing arts and museums'. This view of museums was supported by 'C'. She felt that there was no prejudice against women in her museum, 'but if you go down to the Council House and deal with the other departments – planning, legal, whatever – you'll still find some of the 'old guard' there who are quite surprised to get all these professional women to deal with'. Two successful women in the profession who were interviewed ('J' and 'K') felt that discrimination only affects women if they expect to be discriminated against.

However, others in the museum profession argue that museums are conservative organizations, 'when compared to other sectors of society such as the media, despite being part of supposedly progressive structures like local authorities' (Roberts, 1992: 433). This analysis is supported by 'D' who found it very difficult to persuade her museum's senior managers to allow her to take six months unpaid maternity leave. In other council departments within the same authority it was normal practice to offer such an option. She argued, 'it was basically about sexism and senior managers finding it very hard to think through why this was a reasonable thing to do'.

However, local authority museums appear to be more receptive to women in senior positions than the national, university and independent museums. Presumably the prejudices against women are strongest in university museums since on average in their parent bodies, only 3 per cent of professors and principal lecturers are women (Employment Department Group, 1993). From

a recent perusal of the university museum entries in the Museum Association Yearbook, it is clear that there is an almost total male hierarchy. However, as Kavanagh highlights, national and independent museums are little better (Kavanagh, 1991: 52).

One of the major organizational reasons for this lack of women at senior levels in museums is that governing bodies are almost wholly dominated by men. As the Equal Opportunities Review (EOR) journal highlights, 'the temptation is ever to recruit and promote staff in one's own image. It takes effort to look at skills and achievements objectively, following the needs of the organization rather than one's own prejudices' (EOR, 1993a: 23). Ullberg and Wos support this view. They cite a male search committee member who admits that male trustees of large American museums are 'still carrying some baggage' in their views about the role of women (Ullberg and Wos, 1985: 36).

The governing bodies of non-profit making organizations in the United States 'are beginning to realise that a sexually balanced board is beneficial to their public image and community influence' (Taylor, 1984: 36). Governing boards in this country do not seem to be moving in a similar direction in any noticeable fashion. Many local authority leisure services committees or their equivalent are still populated with an overwhelming predominance of men. Unfortunately, many 'old guard' councillors still exist who Legget argues are, 'influenced, possibly unconsciously, by traditional ideas of women's role and capabilities' (Legget, 1984: 5). Boards of Trustees and local government committees do sometimes still question, 'whether a woman director can be as effective as a man at getting the necessary respect from business leaders ... and other influence people in the community' (Taylor, 1985: 21). In addition, the further one climbs up the museum hierarchy, the greater the involvement there is in political manoeuvrings and business deals. Many older male councillors and trustees can doubt whether women have the temperament to thrive in such a male oriented culture. It is a culture which is unlikely to change in the near future as any alterations have to be sanctioned by those already in office.

The fact that the highest levels of museums are dominated by men has led many to believe that a 'men's club' exists which works to the detriment of women. The women in Coe's survey came to a similar conclusion with regards the workforce as a

whole. They 'perceived the existence of the men's club network as the greatest barrier to women' (Coe, 1992: 3). Most of the women I interviewed also felt an informal 'men's club' did exist. Interviewee 'H' commented on instances where such a network has come into play concerning senior appointments. In addition, the museum profession is relatively small and presumably this has also helped perpetuate the 'system', even if its influence is slowly decreasing.

The declining influence of these 'club land style cliques' (as male director 'L' described the network) coincides with the need for museums to become more business orientated. With the decline in public funding, museums need to attract more visitors. Therefore the 'I went to Eton/Harrow and I know so and so and I'm dabbling in it' style of curator (as 'A' described them) are fast disappearing. In their place, curator-managers are appearing who have a subject specialism, together with financial acumen and project management skills. Yet even in this work culture which is more attuned to enterprise and initiative, women still feel they cannot divulge their career aspirations of wanting to become a museum director. 'B' reflected, 'it's not really considered the attitude to have in museums, especially if you're a woman'.

It is clear that museums as a whole have some way to go before women are as likely as men to reach the level of director. Some employers in the workforce as a whole have been trying to help women climb up the managerial ladder with the help of equal opportunities policies. This is mainly because they have been concerned about the skills shortage and a shrinking pool of school leavers (Handy, 1989: 28–30). However, museums have never suffered from a lack of people wanting to work in them. As 'J' confirmed, 'there are always more people that want to work in museums than there are jobs. That's likely to be true always'. Therefore, are equal opportunities 'a luxury that museums must do without?' (Porter, 1990: 25).

EQUAL OPPORTUNITIES INITIATIVES ON THE BACK BURNER

Just as equal opportunities were beginning to bite, we get into a situation where frankly lip-service has been paid to equal opportunities both in redundancies and in the redeployment shuffling that has gone on (Curator).

Finding employment in museums is never easy but the situation has not been helped by the emphasis on tight public financial management and the increasing number of courses offering museum/heritage qualifications. When cuts have to be made in a museum's budget, equal opportunities initiatives (such as special training) can seem a non-essential item for the running of the museum. 'K' explained why she felt equal opportunities were becoming less important:

> As times get harder for local authorities in particular, you have to save money where you can. If you really believe in it [equal opportunities] as I think many councils do, then you might be prepared to carry it. But I can't see how you could justify carrying it if you're having to make people redundant in order to be able to offer it. And the public service is important at the end of the day. I think equal opportunities initiatives might be at the end of your list of priorities, which is a shame.

'D' highlighted how cut backs have affected flexible working arrangements which have been an integral part of helping women juggle family commitments and a career. 'With cutbacks in local government all these, in a sense, very flexible, very progressive terms and conditions of service are becoming harder and harder to maintain'.

It would therefore seem that the argument for equal opportunities in museums (which obviously affects women) rests on whether it is believed a less homogenous workforce will improve the institution. However, in a period of tight fiscal controls, even this argument must carry less weight when survival is of paramount concern. Evidently, it is difficult to hold back exceptional women from achieving their full potential. Yet it is interesting to note that three very capable childless women of childbearing age expressed concern as to whether more conservative minded museum services would be prepared to employ them, fearing the added cost and disruption of maternity leave. Dyckhoff (quoted by Warren) argues, 'women are judged not too much on their abilities and achievements, but on assumptions about their family life, responsibilities and future intentions. Only the top one per cent of women triumph over these attitudes' (Warren, 1993: 15).

DO WOMEN WANT TO BECOME MUSEUM MANAGERS?

The underlying assumption thus far has been that most women want to be senior managers and eventually directors. Yet this follows the traditional 'macho' definition of success which believes that the only important goal is reaching the top. Women perhaps prefer to have a balance of life interests, a stance increasingly being taken by younger men (Summers, 1991a: 14):

> I think it is very difficult in museums because at a certain level, which is not very high, you leave the collections based work and become a manager. There's a kind of black hole where there's nowhere to go if you want to work with collections and objects unless you become some kind of researcher or lecturer. If you did that you'd be moving out of museums. So you see why people want to stay at assistant keeper level (Curator).

Ambition is obviously a vital factor in whether women become directors. Many of those I interviewed at the lower end of the professional scale highlighted that they had specifically entered museums because they loved objects and they did not want to leave handling them on a day to day basis. They felt that a move into management would mean supervising projects and budgets instead of caring for collections.

Research in social services departments has also highlighted that, 'the long hours required assume the postholders have minimal family responsibilities. The time demands also prohibit a balance of life interests' (Allan, Bhavani and French, 1992: 3).

K's experience seems to bear this out. 'You've always got evening meetings, particularly in local government. Councillors expect you to be there when you're needed and if you've got young children at home, it must be very difficult'.

Another difficult which faces all career minded museum people is that the profession is relatively small. As a result, there is no clear job progression (Museum Training Institute, 1993: 3). The problem is becoming more acute as services 'rationalize' their staff structure. Therefore, in order to reach the top both men and women have to be prepared to move around the country to a greater extent than in some other professions. If a museum woman professional has a partner, a decision will normally have to be made on the grounds of her job satisfaction, rather than on the man's earning power. Obviously this dilemma applies to men

in the profession. However, it is probably less likely for a woman outside museums to be earning more than a male museum professional than vice versa.

SOLUTIONS: A 'LOGARITHMIC PROGRESSION' OR A CHANGE IN ATTITUDES?

> In a museum where most of the professional staff spend most of their career, occupancy of the top positions tends to be achieved at around forty to forty five, after fifteen to twenty years service, and this reflects the workplace culture of fifteen to twenty years ago (Assistant Director).

Interviewee 'J' argues that at the present time it is unrealistic to expect there to be many more women directors than have actually been appointed. As the 1993 Museum Training Institute (MTI) Survey concluded, staff turnover is generally low and therefore, 'J' maintains, it will take several years for women to filter through to director level (MTI, 1993: 3). This 'logarithmic progression' which she feels will come into play, relies on a 'snowballing effect'. As she explained, 'you start off with two or three and then you get thirteen and then you get thirty and then you get sixty. And so we're going to hit the thirty to forty mark somewhere around the year 2000'. The reflections of male director 'I' support this view:

> A quick glance at the membership of the Museums Association indicates that there may be anything from a 60:40 to 70:30 split. Given that proportion, it is inevitable that over the next decade there will be more women directors than men. There is, I admit, a clear imbalance in the London based and national museums. In the regions and in the academic world, however, the situation has changed and is still changing.

Male director 'I' also questioned the validity in the present day of asking about the underlying reasons behind the lack of women at senior levels in museums. To support his argument he included a list (which he said could easily be extended) of twenty-four successful women in the profession. In addition, it has to be remembered that when most of the women who have enough experience to be considered for the post of director entered museums, the prevailing ethos was very different from that which exists today. Such women may not be interested in managerial concerns but

prefer to devote as much time as possible to the collections, which were the reasons they chose the profession in the first place. Maybe younger women in the profession today will be more interested in taking on a leadership role as they will have been introduced to the role that management now plays in museums early in their careers, if not at pre-entry training.

However, most of the women interviewed were more pessimistic about a large increase in the number of women museum directors happening under its own momentum. They felt it would be unwise not to take any positive steps to eradicate the practical difficulties that women face. These would always hold back a large number of women, even if a 'logarithmic progression' does occur. In addition, they argued that a marked shift in society's general attitudes towards not only women themselves but also the nature of management needed to take place before there would be a noticeable increase in the number of women museum directors. As Prince maintains, the reasons underpinning the relative performance and position of women in museums

> must be sought from the sources far beyond any considerations of the management structures and occupational characteristics of museums themselves and into deeply held and in many senses, entrenched social values and political attitudes towards the role of women in society as a whole (Prince, 1988: 55).

The need to have a fairer allocation of caring responsibilities (not only for children but also for elderly dependent relatives) was raised several times by those interviewed. As 'D' highlighted, 'the bottom line is that society places very different expectations on men and fathers than it does on women and mothers'. Several of the women interviewed also emphasised the need for paternity leave and more public child care support.

The concept of management also needs to be examined afresh. As noted previously, management at present requires full-time commitment with no career breaks. One male manager in Coe's survey believed that, 'successful management requires commitment with no outside worries – for women to succeed they must therefore be single or have adult children' (Coe, 1992: 16). Coe argues that a change of emphasis is required. She refers to a female manager who maintained, 'it is time that the British working culture changed to recognise performance in terms of

achieved targets rather than compliance with the company culture (ibid: 23). In addition, Coe highlights that

> all managers effectively work part-time on any one project, yet companies still seem unable to make the mental leap of imagination that would allow them to change the structure of their management jobs. Until they do so, they may get less than optimum performance from both men and women managers who are increasingly combining dual roles (ibid: 23).

Evidently a 'logarithmic progression' and a change in society's entrenched attitudes are at best long term situations. If museums do not want to waste the talents of the present generation of women, what 'positive strategies' could be taken immediately?

THE EXTENSION OF FLEXIBLE WORKING ARRANGEMENTS

> Job-sharing and part-time working may be one solution [to help women combine caring responsibilities and careers] but they do not further careers (Skojth, 1991: 124).

Many mothers in particular felt that the way to encourage more women into senior museum management was to encourage more freedom in the exact number and times contractual hours were worked. Most museums seem to operate a flexitime system (albeit sometimes informally) which the mothers interviewed found very helpful in organizing their child care. Other systems in operation include a four day working week and extra unpaid leave during the school summer vacation. Job sharing was quite widely available at the lower levels of the profession but it seemed to be considered unsuitable at managerial level. It is clear that, 'employers which may allow or even encourage part-time work or job-sharing for lower grade employees operate a ban on anything other than very full-time employment for managers' (Summers, 1991b: 14).

It appears that flexible working arrangements help women to combine careers and caring for children, but they do not seem to help women reach senior management. A survey at senior and managerial levels by 'New Ways to Work' found that 37 per cent of the respondents felt that 'working on a flexible basis had negatively affected their opportunities for promotion. In some cases offers of promotion depended on a return to full-time work' (Equal Opportunities Review, 1993b: 7). Whilst management is

seen to require total dedication, the key to increasing the number of women in senior management does not seem to lie in this approach.

TRAINING

> I think I came to management without realising it as I think a lot of people do. Yes, I have had management training but not in advance of needing it. And I've learnt a lot of things the hard way by making mistakes and getting egg on my face. ... That is the hardest way to learn not only for you but for your institution because they're having to bear the cost of your mistakes. There isn't enough training to prepare people for management before they actually need it. (Director)

Training has a vital role in helping to improve museum standards in general. 'British museums and galleries spend an average of £91 per year per employee on formal training for their staff. This averages out at just over 1 per cent of their total personnel budget, although more is spent by the nationals' (Museum Training Institute, 1993: 3). Training is a particularly important way to help increase the number of women at senior levels in the workforce as a whole and in museums in particular. Taylor argues that women do not yet understand that 'leaders are not born, but made' (Taylor, 1984: 36). Women (as well as men) need the skills and knowledge to help them carry out the duties of senior managers. Many of the older women in the profession that I interviewed learnt almost everything in post. For example, 'H' has been in her present position for several years. However, until 1993 when she attended a five day course at a private business school, she felt she had not received any quality training which had direct relevance to her position as director. There is now increasingly the recognition that training beforehand can help prevent expensive mistakes. The Hale report for example, suggested that management training at junior and senior levels should be available to curatorial and non-curatorial disciplines (Museums and Galleries Commission, 1987: 8). Although systematic training is important for the women (and men) who aspire to senior management, it is also needed by the people who appoint them. For example, personnel officers need courses to teach them how to draw up job descriptions which do not exclude good candidates.

Equal opportunities awareness needs to be part of mainstream courses and not just specialist training programmes. 'N' for example felt that men needed training so that they did not unconsciously exclude women from a particular project normally associated with 'men's work'. It is clear that unless the necessary steps are taken equal opportunities policies can all too easily become regarded as only of relevance to a small number of people. For the most part, people rely on others to provide training. Therefore, support systems that women develop for themselves can be important in giving them self confidence and also providing them with contacts to approach for help and advice.

SUPPORT SYSTEMS – ROLE MODELS, MONITORING, NETWORKING AND CAREER PLANNING

> I think with regards to getting women into senior positions its about encouraging women to think that they do have the skills which are needed. (Curator)

It is generally accepted that if women could see other women in senior positions, then they would become more confident that they too could reach a similar level. 'D' suggested that work-shadowing can be a very empowering tool for young women. As she pointed out 'its only when you see someone doing the job that you think, "I can do that"'. There is now also a greater variety of potential role models from which to learn. As 'D' added, 'when I started the only women in senior positions were very much women who had taken on a male managerial style and a male model. Now at least there are being modelled for younger women a variety of styles that a woman can adapt within a professional life'.

Mentoring is also regarded by many as being very beneficial for young women who aspire to reach senior management. Taylor argues that the average women museum professional lacks political acumen, 'and the only way to gain it is from those who have it'. You need to find individuals in the field who excel in shrewd thinking and have a political grasp of museum affairs and establish a mentor relationship with them. Do this as early as you can, and learn whatever they are willing to teach you' (Taylor, 1984: 37). Many of the senior women in the profession informally mentor other women and all the women whom I interviewed

regarded mentoring as beneficial. Interviewee 'D' when asked what, if anything, she would have done differently in her career if she was starting out again, said that she would have acquired a mentor, 'somebody to whom I could refer on various career points'. 'A' suggested that the support of a woman well known within the profession would be very useful at a time of hoping to gain promotion via a move to another museum. She argued that it was still largely a matter of who you knew in museums and not what you know which counts. Women, she felt, had to play by these already defined 'rules', at least in the more conservative institutions.

Networking is also seen, especially in the United States, as a useful approach to helping women in their careers. Women are unlikely to be part of an 'old boy network' and therefore, Taylor argues, it makes sense to form their own networks (Taylor, 1984: 37). Curator O commented regarding a group of which she was a member, 'a lot of issues came out of that group and people hadn't realised that there were common issues that could actually be worked through, and something quite positive could come out of it rather than struggling away on your own'.

Clearly, networking in a profession where people are often geo-graphically isolated is very important. Although many specialist groups exist (including Women, Heritage and Museums, which campaigns 'for equal employment in museums and related fields'), a group for women senior managers has not been formed. This may be because women are fearful of revealing their ambitions. In addition, many women I interviewed were also concerned that such a group might become marginalised and its members dis-credited if they did not have a common purpose over and above being a group for women managers in museums. However, some women have formed networks with women from other depart-ments after attending a management course. In addition, 'B' has joined a professional women's group outside the museum com-munity which she feels will give her a wider range of contacts.

Finally, career planning, particularly in the United States, is seen as an important mechanism to help women reach the top of the museum profession (Taylor, 1984: 20). Some of the women interviewed (especially those who are aiming to be directors) had planned their careers although the majority seem to have taken the opportunities as and when they have appeared. Evidently it is

difficult to plan a career in a small profession where many posts are threatened. As 'D' remarked, 'someone who had a career plan fifteen years ago and was working in local government would be finding it very difficult to hold on to that career plan at the moment'. It is possible, though, to decide on one's ultimate objective and then attempt to gain the variety of experience required. As 'B' explained, 'I have an idea of what I want to be and I've always had the idea at the back of my mind, which is why I've moved around quite a bit.' Achieving career objectives may involve a personal investment of time and money if the museum is unsupportive. Women also need to be prominent within their own organisations (which can be achieved through offering to chair meetings and participating in working parties) and in the profession at large.

Many of those interested in reaching senior museum management commented on the need to attend conferences and specialist group meetings. The value lies not only in learning new skills and being kept up to date with current concerns in the museum world, but in the opportunity to make new and renew old contacts. In addition, as 'H' has found, involvement in museum committees outside of the workplace can give the chance to meet people at national level and become acquainted with the people who have the major powers of appointment.

However, it has been argued that since women are at a disadvantage in the workforce as a whole, they should be given extra assistance to let them achieve an equal footing with men. The Equal Opportunities Review believes that targeting 'is encouraging women with ability to advance their potential' (EOR, 1993a: 4). Is positive action then a suitable means to increasing the numbers of women in senior museum management?

POSITIVE ACTION – THE WAY FORWARD FOR MUSEUMS?

I am one of these women who feels that positive discrimination, if that means allocating certain jobs to women as such, isn't a good idea because I think all that happens is that the women and their jobs are regarded as second rate. The whole thing becomes labelled as 'the woman's bit' with consequent devaluation. And both the women and the jobs, and by inference, therefore, all women, find themselves more or less back where they started. (Lecturer)

Positive action seems to have a few adherents in the museum world. Male director 'L' would only consider using such a step, 'in certain entrenched contexts' whilst most of the women interviewed wanted to be promoted on their merit rather than simply because of their gender. These women felt that positive action puts pressure on women to succeed. Male director 'I' argued that, 'this form of discrimination, far from being positive is actually another form of negativism, doing more harm than good it purports to be promoting'.

For most museums as for businesses as a whole, positive action in the form of informal targets is regarded as being dangerously close to discrimination in favour of women. 'D' told me that her museum does have informal targets for the employment of women in order to help balance out the workforce and the director is expected to deliver this target as part of his contract. However, most of the people interviewed seemed to be more in favour of providing training so that all could compete on an equal basis, rather than reserving jobs for women, a view supported by the respondents to Coe's survey.

CONCLUSIONS

I think things are going to improve greatly because there were a lot of very intelligent, very determined women on that course who knew what they wanted. From their personalities, I don't think they're going to be messed about. (Museum Studies Student)

This paper has aimed to dispassionately discuss the main reasons for the lack of women museum directors and suggest solutions as to how this number could be increased. It is clearly not simply a feminist issue but also a managerial one as well. Museums face an uncertain future and they require leaders with as much skill and expertise as possible. Museums cannot deny that this pivotal role could be filled by women.

However, as noted earlier, little statistical or qualitative data is available regarding the women museum directors who have already been appointed. As Legget has argued, 'we need a clear picture of the status and problems of women in museums before we can move effectively to improve the situation' (Legget, 1984: 17). Bonnie Van Dorn, Director of the Association of Science Technology Centres in the United States has carried out a

survey over a number of years, tracing the demographics of personnel in her museum sector (Dubberby, 1993: personal communication). A useful piece of research would be to contact students who have trained at Leicester University Museum Studies Department and see how far they have progressed, though as the departmental database only has information covering the students from recent years, it will take some years to see if women are reaching the senior positions in greater numbers than they are at present. In the meantime, a statistical survey needs to be undertaken to discover the number of women museum directors who have actually been appointed. In addition, a comparison between the position of women in local authority, national, independent and university museums would make interesting reading.

It sometimes seems that because people can highlight a few exceptional women who have become museum directors, they feel that there is no cause for concern. It is noticeable that many of the women at the very highest levels in museums have been unhampered by bringing up children. Brenda Dean, former general secretary of the print union SOGAT argues, 'If Brenda Dean had been married at twenty and had produced a couple of children and still became general secretary of the union, then we would be motoring, but until then we aren't' (Parkin, 1993: 32). I think a similar case can be argued in museums. It is of interest to note that the women now climbing up the museum hierarchy ladder and aiming for the top feel that they *can* combine having children with a senior museum position. If they are very determined they will probably succeed. It is up to individual museums, or preferably the museum community as a whole, to help ensure changes are made so that *all* women (and men as well) fulfil their potential.

The value of a balanced senior management team which reflects the community it represents and the museum workforce needs to be recognised. Obviously, finance is a major issue with regards, for example, childcare support. However, often what is more important is a change of attitude (*Museums Journal*, 1990: 7).

Therefore, I look forward with hope to the day when the appointment of a woman director is not seen as exceptional, but simply as making full use of an underused pool of talent.

BIBLIOGRAPHY

Allan, M., Bhavnani, R. and French, K. (1992) *Promoting Women in Management, Development and Training for Women in Social Services Department* (London: HMSO).

Basset, P. (1993) 'Working mothers spend 25 per cent of their pay on child care', *The Times*, 5 July 1993: 2.

Benn, M. (1993) 'Top of the Civil list', *Cosmopolitan* August (1993): 99–101.

Coe, T. (1992) *The Key to the Men's Club: Opening the Doors to Women in Management*, Institute of Management Foundation (Corby, Northants).

Cooper, C. and Davidson, M. (1984) *Women in Management* (London: William Heinemann Ltd).

Craig, T. (1985) 'Risking it – women as museum leaders – profiles', *Museum News* 63: 23–32.

Des Portes, E. and Raffin, A. (1991) 'Women in ICOM', *Museum* 171: 129–32.

Dix, C. (1984) *Working Mothers – You: Your Career: Your Child* (London: Unwin Hyman Ltd).

Equal Opportunities Review (EOR) (1992) 'Few women in the board-room', *EOR* 41: 5–6.

—— (1939a) 'The effects of the recession on equal opportunities', *EOR* 50: 4–23.

—— (1993b) 'Promotion barriers to flexible working', *EOR* 48: 7.

Friedman, R. (1982) 'Museum people: the special problems of personnel management in museums and historical agencies', *History News* 37: 14–18.

Glaser, J. (1991) 'The impact of women on museums – an American seminar', *Museum* 171: 180–2.

Handy, C. (1989) *The Age of Unreason* (London: Business Books).

Hicks, E. (1985) 'Introduction', *Museum News* 63: 19.

Higgins-McLoughlin, B.A. and Prince, D.R. (1987) *Museum UK – The Findings of the Museums Data-Base Project* (London: Museums Association).

Kavanagh, G. (ed.) (1991) *The Museum Profession – Internal and External Relations* (Leicester: Leicester University Press).

Legget, J. (1984) 'Women in museums – past, present and future' *Women, Heritage and Museums Conference Proceedings* (Social History Curators Group).

Museums and Galleries Commission (1987) *Museum Professional Training and Structure: Report by a Working Party* (London: HMSO).

Museums Journal (1990) 'Editorial', *Museums Journal* 90: 7.

Museums Training Institute (1993) *Museums/Heritage Sector Workforce Survey – Executive Summary* (Bradford: Museum Training Institute).

Parkin, J. (1993) 'Glenys and the bright new future', *Daily Express* 17 September 1993: 32–3.

Porter, G. (1990) 'Are you sitting comfortably?' *Museums Journal* 90: 25–7.

Prince, D.R. (1988) 'Women in museums', *Museums Journal* 88: 55–60.

Roberts, A. (1991) 'Employment, equal opportunities for women in the United Kingdom museum profession', *Museum Management and Curatorship* 11: 432–6.

Skjoth, L. (1991) 'This is a first: introduction by the co-ordinator of this issue', *Museum* 171: 124–5.

Souhami, D. (1986) *Woman's Place: The Changing Picture of Women in Britain* (Harmondsworth: Penguin Books Ltd).

Summers, D. (1991a) 'Mums not the word in the corridors of power', *Financial Times* 3 July 1991: 14.

—— (1991b) 'No room for new faces at the top', *Financial Times* 7 May 1991: 18.

Taylor, K. (ed.) (1984) 'Room at the top', *Museum News* 84: 31–7.

Ullberg, P. and Wos, J.H. (1985) 'The right preparation and the right attitude, *Museum News* 63: 3–6.

Warren, J. (1993) 'Can women really make it to the top?, *Daily Express* 4 March 1993: 15.

9

Organizational Cultures in a Museum and Art Gallery

ALF HATTON

This chapter describes a study of organizational culture in an English city museum and art gallery (MAG) during the early 1990s. It is an example of one approach to analysis and interpretation of the dynamics of museums and art galleries (MAGs) as institutions, and between them and their operating environments: like all other organizations, MAGs have organizational culture(s). Secondly, since the observations took place at the beginning of a reformulation of strategy and delivery of a formally approved agenda for change, *and can be seen more or less to have assisted that process*, this represents one part of one approach to managing change.

BACKGROUND TO THE STUDY

The MAG was part of a leisure department, amalgamated as recently as 1992 into a single cultural services division with libraries, arts, archives, and a youth arts and media studio. This service mix was further complicated by the MAG's name being used throughout leisure as shorthand for a diverse service consisting of the MAG itself, the remains of a medieval priory at that time serving as an archaeological museum, exhibition centre, and home to the city's excavation unit, an excavation site set up as an experimental archaeological reconstruction and visitor centre, a guiding service sharing another medieval building with civic catering, and an exhibition space available for rent in the civic centre.

Over the preceding five years, three internal audit reviews had been carried out (1987, 1989, and 1990), and there was

wide concern, amongst MAG staff, leisure and other officers and members of the city council, that little change had been effected.

The 1987 reviews' principal observations were straightforward enough, noting the lack of:

- any formal comprehensive consideration of the direction of developments, i.e. that there is no systematic approach to the preparation of a strategic plan
- any method for preparing detailed action plans for individual sections
- a system of performance measurement, performance monitoring
- a planned, regular review of its activities
- a regular, quantified information system for performance that would allow informed decision-making

The 1989 review commented that:

- the plan to present aims and objectives derived from the statement of purpose and interpretations of the role of the museum derived from the Code had itself drifted somewhat, and had now been partially superseded by a new arts policy
- the framework for planning had not been implemented

More strikingly, it stated:

No serious attempt has yet been made to identify the purpose of the museum – either its aims or objectives – and in consequence, there is no framework within which, even if there was the will, it would be possible to produce a strategic plan of the direction of future development for the guidance of those with operational responsibility.

Significantly in terms of this study, it also stated: 'The Senior Keepers have not changed the way in which they plan for the long term. They are still free to set their own objectives, if any, or they try to fit in with external factors, e.g. education with other sections in the MAG.'

The senior keepers on the existing staff structure were identified early in this study as a power block that would need to be addressed, if change was ever to begin. *Their very methodology of negotiated settlements of boundary and resource disputes, had in effect cohered them intermittently as a team with its own agenda,*

i.e. to preserve that methodology, since it gave greatest freedom to them. Factors requiring MAG-wide resourcing were left to be sorted out above their level.

As the second review indicated:

> Because of the organizational structure of the MAG with Keepers being responsible for their own particular area, some of the issues which cross these boundaries are not taken up by specific members of staff, e.g. catering, promotional activities, retailing. Some of these issues have been given to sub-committees of the management team to tackle, e.g. the trading group, while others have been given to specific members of staff, e.g. the foyer area. Management team has not considered the way the remaining issues should be handled.

Given the impending strategic review and agenda for change, the hypothesis was that simply tackling the formalities, re-stating missions, re-listing objectives, remodeling the existing staff structure, and identifying resource shifts and/or deficiencies at the MAG, *was no more likely to engender the desired changes than the three previous reviews.* Indeed, if anything, a further solely rationalistic review would be likely to fail quicker, since the MAG staff were already inured to this kind of review. Disbelief in their efficacy was at a high.

It was essential therefore to enrich and inform whatever formal changes were identified within the rational aspects of the new review, by an analysis of the more subtle, soft data potentially available through an investigation of the cultures, subcultures, and counter-cultures that existed at the MAG. The extent to which previous MAG management was unable to implement basic management systems due to aspects of organizational culture can only be guessed at.

Mintzberg noted in a study of the media managers actually use, that: 'a great deal of the manager's inputs are soft and speculative – impressions and feelings about other people, hearsay, gossip, and so on.' (1976: 54) He suggested that managers synthesize this information, rather than analyse it, as they might with reports, documents and other *hard data* they receive.

What was interesting about the previous reviews, apart from the woeful lack of response they catalogued, was their adherence to a formal, rational, bureaucratic, strategic planning model,

although this might not seem unexpected from a central department auditing a service department.

Far more significant, however, they neither addressed themselves to issues of organizational culture which may have been the cause of inertia, nor to any other causes which may have been apparent from their studies. In other words, they seemed to be implying, rather baldly, that the imposition of *new systems alone* would resolve the problems. Most management of change literature accepts that this is not the case.

RESEARCH OBJECTIVES AND METHODOLOGY

The research was conducted through a series of structured interviews with half the staff representing administrative, professional and technical grades, with complete confidentiality guaranteed. The other half, the security, front-line staff were represented through their two team leaders and the head of security.

Though this represented a convenient cut-off for the research, it would not be unreasonable to suppose that interviews with all the security staff would have further enriched the data. Given the need to inform a strategic review, time was important, and it seemed administrative, professional and technical grades might be (a) more affected directly, and (b) more used to having influence over policy/strategy, and thus needed to be engaged directly.

This kind of qualitative research seeks data that can be analyzed and interpreted *inductively* to further enhance understanding of the phenomenon under study. As such, it falls broadly into the ethnographic method (Gill and Johnson, 1991: 92 et seq), and is more usual within management and social sciences research than the true experiments of the scientific method.

The semi-structured interview can be, and frequently is, used as a planned intervention within an action research project (Gill and Johnson, 1991: 60 et seq). In this case, promoting dialogue (the semi-structured interviews) began to *unfreeze* existing notions of acceptable behaviour, acting as one means of unblocking resistance to change, by preparing the way for discussion of new forms of behaviour.

ORGANIZATIONAL CULTURE AND MANAGEMENT OF CHANGE
As Johnson and Scholes so aptly state:

> *Managing strategic change is, in the end, to do with achieving a change in the culture of the organisation*: that is, a change in the recipe and the aspects of the cultural web that preserve and reinforce that recipe. It is unrealistic to suppose that strategic change can be implemented if the current beliefs and assumptions and ways of doing things remain the same. (1989: 307) (my italics).

TABLE 9.1 Johnson and Scholes' process of change (1989: 307–12)

Johnson and Scholes' change process	Triggers for change
• the unfreezing process	• maybe triggered by external threat • challenge and exposure of the existing recipe, formally in planning processes, informally in meetings questioning ways of operating • reconfiguration of power structures, e.g. legitimizing those who dissent from the current recipe (*this needs powerful advocacy from management*) • often accompanied by outsider, e.g. new chief executive or consultant
• the adoption of a new recipe	• a new view of strategy is not of itself a guarantee of acceptance • nor will the unfreezing process of itself lead to acceptance – it may even be seen as destructive • concrete performance, physical evidence of change is more likely to succeed than analytical arguments about the need for change • partly dependent on the extent to which status is enhanced or diminished • partial implementation, e.g. through the use of project teams or taskforces • symbolic activity signaling change, e.g. irreversible personnel changes

● symbolic action	● changes in organizational rituals
	● changing formal control mechanisms
	● organizational myths subverted or new ones put in place
	● symbols of change, e.g. relocation of offices, changes in furnishings or decor, changes in logo or house style
	● style changes in the clothes people wear

There are of course formal structural changes that can also be symbolic: amalgamation of or splitting into smaller parts of existing subdivisions; removal of staff at the top. In addition to their formal effects, they are also symbols of 'the expectations of those making those changes' (Johnson and Scholes, 1989: 312).

Waterman, Peters and Phillips offer the '7-S Framework' analytical model, enlarging the boundaries of management of change:

> Our assertion is that productive organization change is not simply a matter of structure, although structure is important. It is not as simple as the interaction between strategy and structure, although strategy is critical too. Our claim is that effective organisational change is really the relationship between structure, strategy, systems, style, skills, staff, and something we call superordinate goals. (1991: 308)

The previous reviews only made reference to MAG structure and systems (Table 9.2).

TABLE 9.2 The 7-S Framework of Waterman, Peters and Phillips

	1987 Review	1989 Review	1990 Review
● structure	yes	yes	yes
● strategy	no	no	no
● systems	yes	yes	yes
● style	no	no	no
● skills	no	no	no
● staff	no	no	no
● superordinate goals	no	no	no

Whilst the sophistication of a McKinsey-style consultancy was perhaps not to be expected, and hence omission of reference to style and superordinate goals is understandable, the lack of attention to strategy, skills and staff was a serious matter. Given an agenda for change, including the design, building and launch of a tightly time-constrained new gallery, a critical strategic issue was whether or not the MAG actually had sufficient staff and the right skill-bases with which to deliver.

Handy recommends embracing continuous change and argues that major organizations follow a predictable pattern (1991: 8–9) (Table 9.3).

Authors such as Harrison (1972), Handy (1985, 1988, 1989) and Pheysey (1993: 23) variously describe organizational culture as the glue that holds the organization together, the symbols, values, rituals, politics, heroes and myths of organizations. In short, it is the unwritten structures, lines of informal communication and power groups, which both proscribe and describe the activities of organizations, but which cannot be derived from organizational structure charts, balance sheets, etc..

Anthony points out a singularly important distinction between *corporate* and *organizational culture* (1994: 3), corporate culture being the organization's view of itself, what it says in recruitment literature, policy documents, *a sort of ideals wish-list* for how things should be. Usually this is top management's view:

- top managers' beliefs about how to manage themselves, other employees, and how to conduct business, often invisible, but having a major impact on the thoughts and actions of others (Lorsch, 1986: 95)

Organizational culture is much more about shared systems and constructs of identity:

- Values, heroes, the rites and rituals (Deal and Kennedy, 1982: 14–15)
- the rites, customs and values of organizations (Trice and Beyer, 1984: 653–69)
- the pattern of basic assumptions that a given group has invented, discovered or developed in learning to cope with its problems of external adaptation and internal integration (Schein, 1985: 25)

TABLE 9.3 Handy's pattern of organizational change

Handy's Predictable Pattern of Organizational Change	Notable Features	Features Present at MAG
• Fright	• the possibility of takeover, collapse or bankruptcy	• there was an implicit threat of swingeing cuts by the city council as it wrestled with cuts in its resources
• New Faces	• new people are brought in at the top	• there was a new manager in post
• New Questions	• questions, study groups, investigations into old ways and new options	• the postholder had started asking questions and investigating 'old ways and new options' (although there was cynicism among the staff since this has happened before with no visible results)
• New Structures	• the existing pattern is broken up and rearranged to give new talent scope and break up old clubs	• the existing staff structure had already been targeted by the new manager as needing to be changed rapidly since it would not assist change, and indeed, may well have been resistant to change
• New Goals and Standards	• the new organization sets itself new aims and 'targets'	• new aims and standards were clearly on the table for discussion, more a result of the city's lack of satisfaction with performance, than from any internally generated view, although everyone agreed things were not right

- the cultural web – rituals and myths, symbols, power struc-
 tures, organizational structures, control systems, routines
 (Johnson, 1989: 46)
- appropriate behaviour which bonds and motivates individuals,
 and asserts solutions where there is ambiguity (Hampden-
 Turner, 1990: 11), a rewarder of excellence, a set of affirma-
 tions (ibid: 12–13), giving continuity and identity to the group
 (ibid: 21)

Not all the literature makes Anthony's (op cit) important dis-
tinction and there is some debate within the field as to whether
cultures are something organizations *have*, in the sense that they
can be managed and modified, or whether in fact cultures are
something organizations *are*, in which case management strategies
and actions have to fit the culture in order to succeed. The differ-
ence seems to be a question of whether or not members of orga-
nizations are aware *meta-cognitively* of their culture(s). Either
way, the literature agrees that cultures can and do change.

A fundamental aspect of organizations is that: 'In all organisa-
tions, there are individuals and groups competing for influence or
resources, there are differences of opinion and of values, conflicts
of priorities and goals. There are pressure groups and lobbies,
cliques and cabals, rivalries and contests, clashes of personality
and bonds of alliance' (Handy, 1985: 222).

Within themselves, the very diverse services of the MAG pre-
sented different perspectives on potential missions and objectives,
but also on ways of operating. For instance, the archaeological
unit commonly used seasonal labour, much of it low paid, stu-
dents and graduates gaining field experience on excavations. Their
culture was highly unlikely to be the same as that of permanent
paid staff at the MAG. Similarly, both the staff at the excavation
site/visitor centre and the guiding staff were seasonal, whereas
staff at the medieval priory were permanent but part-time.

Handy lists the factors (history and ownership, size, technology
or workflow, environment, and people – 1985: 197–201; 1988:
94–5) which will influence the mix of cultures, and the overall
culture will vary with the relative affects of these. Several cul-
tures, subcultures and counter-cultures may coexist, more or less
satisfactorily in the same organization.

Some greater awareness of this cultural mix on the part of

management in large organizations, for instance local authorities, might go some way to lessening the otherwise perfectly understandable tensions caused by perfectly reasonable differences in goals, priorities and operating systems. Leisure in many ways embodied this awareness and was prepared to live with very different cultures arising from very different services.

Organizations often start off as power cultures, and when the founder moves on or maturity sets in, progress towards a role culture. When a role culture is confronted with the need for greater flexibility (e.g. due to market changes), the *organization needs a culture change* (Handy, 1985: 206).

He recommends carrying out a check on the primary characteristic activity of the organization: is it in a 'steady state', 'innovation', 'crisis' (or 'breakdown'), or 'policy' mode (1985: 206)? The organization will be more effective if the culture matches the dominant state of activity (Handy, 1985: 208) (Table 9.4).

He also states that causes of organizational conflict are twofold: objectives and ideologies, and territory (1985: 236). Differences in beliefs, standards, values, organizational goals versus societal ones, short-run versus long-run goals: all these are the basis of organizational culture clash. 'The values of the curator are often a mystery to the security officer and the clerical assistant and, when lack of understanding is added to impatience on either side, trouble often ensues' (Diamond, 1992: 166).

Ownership of territory is conferred variously by deeds such as organizational charts, job descriptions, partly by precedent, squatting or staking a claim (Handy, 1985: 241). Boundaries are set in various ways: *physically* by screens, offices, separate buildings; *procedurally*, by committee memberships, circulation lists; *socially*, by dining groups, informal groupings, carpets and other

TABLE 9.4 Handy's dominant state organizational culture check

Dominant State of Activity	Preferred Culture
• Steady State	• Role
• Innovation	• Task
• Crisis (Breakdown)	• Power
• Policy	• Power

status symbols. Territorial jealousy follows similar lines: overt signs of status, information jealousy and the *in-group* phenomenon.

There may simply be overcrowding (Handy, 1985: 241), i.e. too many people doing too few jobs. This is frequent after restructuring as boundaries are explored, and may even result from a new manager's appointment in taking away from subordinates, rather than enlarging the sphere for the organization.

Managerial strategies are either to turn conflict into fruitful competition, or to control the conflict. Fruitful competition is only likely to occur if: 'There is a clear and shared purpose for the group or organisation. Without a common goal individuals are, in effect, licensed to do the best for themselves within the rules' (Handy, 1985: 246).

This is a most significant observation for the MAG: there was no shared *implicit* mission, let alone an explicit one. Control of conflict is at best a short-term solution. It involves arbitration, rules and procedures, coordinating devices, confrontation (Handy, 1985: 254), separation, even neglect, though this is not desirable. The MAG had experienced all of these, i.e. attempts have been made to control conflict, but not to deal with its origins.

RESEARCH FINDINGS

The semi-structured interviews covered the following topics:

- History and lineage, length of service
- MAG successes and failures, MAG people, 'heroes' and 'heroines', do people matter at the MAG?
- The MAG as a place of work
- Those most likely to succeed and those most likely to fail
- Decision-making at the MAG, who makes MAG decisions, non-decisions, people who get ignored in decision-making
- General directions and priorities for the MAG

Obviously, as a matter of research ethics, the data from respondents have been distilled, and as far as possible *anonymised*. This is partly to protect identity, and partly also, because the methodology is disinterested in the actual responses and interested in a reflective digest of them: *it is not so much what was*

actually said, as what it all means when summarized and interpreted. There is, therefore, some weakness in the methodology from a scientific stance, since it relies on the researcher's (participant-observer) interpretive skills. This kind of hermeneutic understanding, however, is not dependent on causal explanation (Lichtheim, 1970: 15), and hence is consistent with social scientific and humanities approaches.

Varying responses were elicited on the history of the MAG, partly split along length of service, and partly also by distinction between *professional* and *other staff.* Its history and origins endured in informants' minds, although only two were actually old enough to remember its founding – and even they as children. Others personally remembered the 'old MAG over the road'. Their responses all, however, proved the strength and endurance of folk memory in organizational culture.

The quality of collections by comparison with other city MAGs, and its consequent affect on determining market positioning strategies also figured highly:

> ... because of the short life of the MAG, we don't have the riches of other municipal museums. ... In a curatorial sense, it's very young. The flipside is we have no identity. It was created from scratch, not set up to house a collection – we have relatively recent collections – and it shows. It hasn't got that solidness that c. 1830 museums have. That's where it loses its *museum feel,* has to work in a slightly different way. It's partly the building, partly the collection.

Low morale could be traced from an alleged decline of the MAG from the 1980s, voiced in terms of the lack of opportunity for research: 'There is an impression that we are moving away from research: exhibition generation is becoming harder; collection maintenance is becoming harder; we are becoming more accountable to council who want a whole range of goods and services; they don't fully understand our functions.'

A strategic perspective was offered, one informant bemoaning the lack of an industrial museum despite the city's very broad industrial history. A recurring theme was the loss of the car collection to form the now independent transport museum. Interestingly, this was seen as *their loss,* but no-one wanted to reverse the decision, since the transport museum was universally hailed as successful.

Possibly the sharpest distinctions were to be found between recent and long-serving staff, and between 'professionals' and 'assistants'. Even with this small sample of thirteen (out of a total of thirty-one), eight had less than fifteen years service (excluding prior contract service less than ten). The remaining five had in excess of sixteen years' service each.

> They tend to move and get ahead that way, e.g. professional staff. Most of the people *on our side* [assistants] tend to stay. It's the climate – when I first started here, it used to be called 'The Elephant's Graveyard', e.g. bus drivers etc. coming up to retirement.

Of course, the distance between the 'professionals' and the 'assistants', highlighted so sharply, may be a general feature of all museum security staffing. It is usually after a considerable career in some other field, that individuals undertake the attendant or warding role. Their routine duties and general lack of involvement in strategic decision-making reinforces a sort of *officer and other ranks* attitude, which does not encourage security and support roles in themselves as a *career*, or enlargement of that role into others, e.g. interpretation.

The newer staff may be identified by their sharper appreciation of the alleged decline of the MAG: 'I hope I'll never lose that "first shock" of how appalling the place was! I can't believe it! Also I was sold a very positive line by the city. I was sold a vision, but then there wasn't one in place when I arrived.'

The MAG was perceived to have had a run of a few successes contrasted by quite a lot of failures, although a recent change in this pattern, whereby now three or four successes had occurred consecutively, was strongly felt, so much so that: 'It has changed quite a bit for the better; it was so antiquated when I started! Everyone was set in their little ways "because it's always been done that way". There's still room for a lot of improvement – publicity-wise it's now on the map. Exhibition-wise it's improved a lot. There never used to be variation in exhibitions.'

Exhibitions with a local content were seen as successes, thus one section claimed to generate all the visitor figures. Conversely, certain exhibitions were not seen as successes, 'failure' being due to both lack of quality and topic, and the city's socioeconomic composition: 'a number of so-called contemporary exhibitions

were not of high calibre; there was lack of publicity, lack of quality; lack of an audience in the city...'.

The dysfunction in museum purpose, or the lack of a clear mission, also came out clearly: 'The city has traditionally been a "workday" town, full of what is mistakenly called "ordinary people": so the museum has always looked to two audiences – local and national/international.'

Responses covering people who worked at the MAG, not unnaturally, were very revealing, indicating quite clearly some of the subcultures and counter-cultures:

> The assistants are not museum people; they are mainly from industrial backgrounds; they are used to working as a team, they see this place as a refuge even – they come in when they are on their holidays for a cup of tea! The feeling is comfortable. There is a fair team spirit amongst the support staff. There is a slight difference with the other staff because their *disciplines* are different, e.g. they are academics. ... But it still feels good teamwork; but there are still two teams.

There was perceived to be a friendly, people-oriented environment at the MAG, with a wide range of backgrounds: 'It really is a mixed bag – we range from the most set in their ways factory type ... to those who read Foucault before breakfast.'

The MAG was seen as a 'good' place to work, with satisfaction linked to achievement, flexibility and freedom: 'It's a great place to work. I never heard anyone say "this is a bloody awful museum to work in"' and: 'Basically, it's a good place to work. My reaction to it was tinged by what I had before, e.g. crude things like there isn't someone jangling keys at me at 5.15 saying "go home" – that relaxed atmosphere. I don't feel there are people I can't talk fairly freely to here!'

But there were drawbacks, e.g. dissatisfaction with quality and neglect of the building: 'I tend to find the building is getting old, e.g. re-wiring, the lift; the building needs money spent on it, the structure, we are trying to make a silk purse out of a sow's ear.'

However, the contrasting viewpoints of two informants underline the existence of different subcultures: 'the only way to get things done was to operate as a guerrilla unit from a transit. MAG is a very effective place ... at low level. We don't have the

ability to do large strategic things.' and 'There isn't any comparison – I still remember what it's like working on a car track! There is a big difference! They don't realise what it's like. This type of work is far more rewarding exhibition-wise etc. – there's an achievement...'.

Decision-making at the MAG obviously has to be a focus of the research given its timing. Individual perceptions of how it worked or how it did not, were extremely informative: 'Badly. Whether good decisions or bad, they're all made badly. But the full implications are not thought through, except in exhibitions. We never weigh up other ideas against priorities or the full implications.' Implementation also seemed something of a problem: 'It's the talking that's important, not the doing, six months talking; three months ordering; six weeks to put up; then it's in the wrong place!'

From the evidence, it seems fairly incontrovertible that decision-making was undertaken by individuals, not by management or any form of collective process. Indeed, the MAG's management committee, management team, or management group (it was referred to by all three names), clearly failed as a decision-making body: 'The climate of the museum encourages autonomous decision-making.'

The lack of an overall direction, purpose, and strategy was also problematic: 'Yeah, a number of things – the O & M, corporate plans. There's a lot of talk, yet we never saw to it we had a decision. Big decisions about where MAG was going, the shop front. It's partly a financial consideration.' The MAG *not* having facilities by then considered *normal* in MAGs was also raised: 'Major decisions to change the physical structure of the building, e.g. the cafe, new offices, don't get made.'

Clearly, one group of staff who might be expected to believe they were being ignored, would be the assistants, and this was confirmed by the evidence: 'Yes. The assistants – they are the same in numbers as the Keepers, but only have one voice (me) ... here we have to learn to admit mistakes – some won't make decisions on pain of failure or making a mistake.'

Opinions on general directions and priorities for MAG understandably varied enormously. That opinions were proferred, however, does underpin the main hypothesis *that formalized planning may not reveal the whole picture*, as a number of directions

argued for would clearly be beneficial to the MAG's general future. For instance, the need for a corporate view of the diversity of the whole service was clearly pointed out:

> The new gallery is one thing. The salvation of the museum service is not the new gallery: it may be a catalyst. I take an expansionist view, the image of the museum has to change. I am not 'MAG-bound', I work on all sites ... we should extend our custodial role. There's untapped income, kudos for the council and the city. A big mistake with the MAG, is it has no 'front'; it is very uninviting, the 'wrong message' is given by the architecture of the entrance, e.g. fill in the walkway.

There was also an awareness of the need to attack financial difficulties firmly: 'Money control – we're not successful here; we don't have a shared purpose or goal; we are almost competing, especially for budgets...' and:

> One thing I would like to see ... is other sections finding ways to raise money by simply doing their job, e.g. taking in conservation for payment, e.g. ecology doing work for planning – at the moment, we don't charge – plenty of places do.

A clear picture of the wider social roles of museums also emerged:

> The role of the MAG is to be part of the glue which holds together the diverse cultural background of this city. I'm very concerned about art as a tool (not didactic) but also enjoyment; I want to broaden people's horizons, 'open cultural windows'. The multicultural thing is very important, and shouldn't be ignored. But it also shouldn't be isolated.
>
> We have to maximize our relevance to as many people as possible ... the likes of Jorvik etc., that style of thing where the public are involved, not just juggling in medieval costume, e.g. handling of collections, of animals, interaction....

On strategy: 'The thing about strategy is that we have one! A vision! The only thing – the sooner we get a vision, the better; the vision at the moment is "implicit"; we need to get it "explicit".'

Not unnaturally, there was a variety of viewpoints expressed about the main priority. The city council had agreed to inject

capital into the new gallery project, though a number of strategic issues had not by then been addressed:

- what was the MAG's main purpose and market?
- what would happen whilst the existing gallery closed to allow construction of the new one?
- how would the MAG operate when the new gallery was complete, and what would be its new goals?
- should the MAG charge admission for the new gallery or for the whole MAG?
- would there be any re-training, e.g. for interactives planned for the new gallery, or for a more customer-oriented approach?
- would ancillaries, e.g. a shop and cafe accompany the new gallery as new sources of revenue potential?
- did the MAG have the infrastructure to cope with a major capital project?

The informants were therefore allowed to ignore the fact of the new gallery as an existing, declared priority. They were presented with some possible options and it was explained that this was not an exhaustive list. The new gallery evidently was seen as some sort of panacea to the MAG's ills, with eight out of thirteen respondents seeing it as top priority. Four of those saw it as linked either to a new entrance, cafe and or shop, or all three. Only three saw it as lower than top priority. That degree of commitment was, however, coloured by some of the comments, which may reflect more on the way the decision was arrived at, than the scheme itself, and in view of what was said about decision-making in general, this was hardly surprising.

> When we first all came out in favour, the money wasn't just for the new gallery – it included the whole of the ground floor, it included the cafe and shop etc. When you talk about consultation! Even now, we are doing well in that space ... there are things we could have done first. It won't be a great tourist puller! We still need cups of tea.

The excavation site/visitor centre was a much lower priority, which may be explained by the fact that at that time virtually none of the staff had anything to do with it, as it was being run entirely separately as branch of the archaeology section. Nevertheless, this was surprising, since of all the MAG's sites, it was then the one with the most significant income generation. One

might have expected more empathy, and perhaps, a suggestion that it serve as a model worthy of emulation elsewhere.

CONCLUSION

Any conclusions drawn from this study can only be tentative. Firstly, the interviews covered the *upper layer* of staff, the 'professionals', thoroughly, whilst the other half, the 'assistants' were represented by the head of security and two team leaders. This omission represents the entire front-line staff, and in any further studies of this kind, my strong recommendation would be that they must be included as fully as any other staff category. The study also did not address groups such as assistants at the medieval priory, the excavation site/visitor centre, the guides, seasonal excavation staff, or the large numbers of regular volunteers and students on placements, upon which some sections of the MAG relied for much core work.

Secondly, to verify the efficacy of the organizational culture audit *as an intervention*, i.e. the independent variable, the findings would have had to be fed back to the respondents themselves, i.e. the *double loop* of action research.

In the sense that the new agenda (new gallery, re-launch of the MAG, shop and cafe) were produced on time and on budget, to some acclaim from city, citizens and the museum movement, the intervention can be seen to have been effective:

> The ultimate criterion is the perceived likelihood of chosen actions to produce desirable consequences for the organization. Action research is a kind of science with a different epistemology which produces a different kind of knowledge of use to the particular organization, *in the course of which its members are developed to solve their future problems* (Gill and Johnson, 1991: 73) (my italics)

What cannot be stated absolutely is that the organizational culture audit alone brought this about, independently of other management of change initiatives, such as staff re-structuring, considerable re-working of mission and objectives, the appointment of a young and energetic project team to complete the new gallery, and considerable re-training *in situ* for the whole MAG staff. These other factors represent rational strategic planning and management of change strategies accompanied by considerable quantitative data collection and analysis such as market

research. This type of research, however, requires such quasi-sci-
entific proof.

One concern, then and now, is that the main MAG quantita-
tive data – visitor figures – were still collected by hand, and *not
analyzed* for seasonality, trends, socioeconomic composition, fre-
quency of visit, tourist categories, etc. Reliance on these raw data
to justify continued revenue and capital expenditure seems to me
an *unprofessional, though regrettably, common practice.*

Tentative conclusions can be reached. Firstly, the sub-hypoth-
esis that the earlier reviews' very reliance on a rational, systems
and structures approach may well have been what produced
inertia, seems more than reasonable. In not suggesting methods
of achieving the desired results, and as prescriptive, deterministic
approaches, they ignored *the need to create awareness of the need
for such change* (Quinn, 1989: 21) *or the need to create commit-
ment to implement change* (ibid: 29). Certainly, the main hypoth-
esis that any new strategy needed to be informed by *soft data*,
gathered via a qualitative, interactionist, phenomenological
approach, stands virtually proven.

Handy's four main organizational cultures (1985: 188, 190, 193,
195, and 1988: 86), were used as models to interpret findings on
organizational culture(s). Handy uses diagrammatic forms sugges-
tive of *formal and informal* organizational structures (Table 9.5).

TABLE 9.5 Handy's organizational culture types

Structure	All Organizations Culture	Voluntary Organizations Culture	Structure
• *spider's web*	**Power**	**Club**	• *spider's web*
• *classical Greek temple (the traffic symbol for museums!)*	**Role**	**Role**	• *pyramid of boxes*
• *net*	**Task**	**Task**	• *net*
• *cluster*	**Person**	**Person**	• *star cluster or constellation*

Part proof of the hypothesis was that there was culture clash between the MAG and Leisure, which managed the MAG remotely, mainly through its personnel and finance sections. Though Leisure management seemed to understand such differences *instinctively*, these sections often appeared rule-driven and inflexible, deriving authority from *position power*, i.e. tending towards a Role Culture.

If work is sequential, or interdependent, then the organization will need regulations and procedures, and hence shift toward a role culture (Handy, 1988: 94). Clearly, MAG work was very definitely not sequential, much more resembling small unit production, each exhibition and event a one-off. Hence there was little need for procedural rules and regulations to formalize it. The divergence with the Leisure's Role-type approach could not have been more marked.

The *professionals* at MAG tended towards a Person Culture (1985: 195), deriving authority from *expertise power* (in museum work). Certain members were seen as *stars*, projected themselves as such, and were dedicated to career goals. They shared influence, worked from an *expert knowledge* power base, and accepted control only by mutual consent – all Person Culture characteristics. In an interesting comment on the Club Culture, the voluntary sector equivalent of the Person Culture, Handy notes: 'If there are memoranda, they go from Gill to Joe, or more often from set of initials to set of initials, rather than from job title to job title' (1988: 87).

The MAG's mail was distributed via twenty-one trays, all labeled with the initials of the post, rather than the names of the postholders, or even the names of the sections to which mail is being addressed. The implications were that communication was very much to and from positions of status within a hierarchy, rather than from functional teams to other functional teams.

There were clear signs also of a distinction between the two major staff groupings: the assistants and the professionals. Handy states that, amongst others, those with a low tolerance for ambiguity, will prefer a Role Culture (1985: 204), and those needing to establish their identity through work will better fit a Power or Task Culture, being seen as disruptive in a Role Culture.

It could be that the professionals were seen as *agents of change*,

establishing their professional identity at work, whereas the assistants and some of the longer-serving professionals were perhaps more interested in the security of the Role Culture.

Without further data, it would be impossible to represent the other major staff group as a specific culture type, though given their *modus operandi*, individual backgrounds, suggesting routine, regular work flows, and prescriptive job content, it would not have been unreasonable to expect a Role Culture.

One of the main findings of the study was the clear absence of any *structure or culture* which would have been capable of delivering the new gallery on time and on budget. It was not readily apparent that Leisure understood the critical nature of this gap. It needed, without doubt, something of a shift towards a Task or Power Culture to achieve that critical momentum.

Other findings were some of the potential causes behind prior underachievement and evident organizational conflict. The following Figures (9.1, 9.2 and 9.3) attempt to portray graphically the boundaries evident in terms of subcultural groupings at that time, physical separation, and relationships through function.

Figure 9.1 shows the clear split then between professionals and

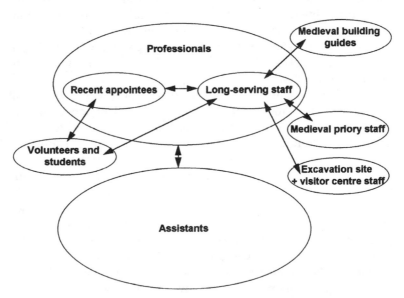

Figure 9.1: Main relationships of MAG groups and subgroups

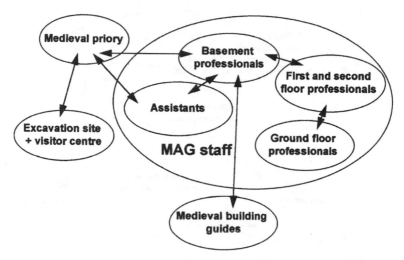

Figure 9.2: Spatial separation and main communication channels of MAG groups and subgroups

assistants, within an additional split among the professionals between long-servers and recent appointees. There were also satellite groups: volunteers and students on placement whose main interface was with professionals of both subgroups; guides whose main interface was with the head of security; and two groups of front-line staff at the medieval priory and the excavation site/visitor centre whose main interfaces were with the heads of archaeology and security, both long-servers.

There were also physical boundaries (Figure 9.2) which mitigated against cohesion: one group of professionals had offices in the basement, where the head of security had an office and the assistants had a jealously guarded mess room, but others were separated on two other floors and at the other end of the building.

Finally, Figure 9.3 shows assistants clearly interfaced with the head of security, their direct supervisor, but that the head of archaeology also had a direct relationship with front-line staff at the priory and excavation site/visitor centre.

The potency of these physical and psychological boundaries should not be underestimated, and was such that a move to integrate the separate professional staff tea room with the basement mess room (assistants only, with some professionals as guests)

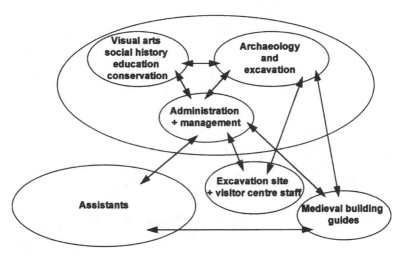

Figure 9.3: Functional relationships at MAG

was fought off with the threat of union action – the assistants at
that time simply did not want full integration.

Other office reshuffles moved a long-server in from an out-
station to share an office with two recent appointees, joining the
ground floor group. The breaking of boundaries in this way at
the very least created opportunities for the regular, informal com-
munication which often underpins formal relationships. 'Indivi-
duals do and it shows – we're not always rowing in the same
direction. There's a willingness to communicate. It's partly the
shape of the building – people feel disenfranchised if they're away
from the hub. Those in the basement feel they are one group.
Those upstairs are another group.'

Another boundary area operating against cohesion is that the
professionals may well have been working to *social definitions of
work and leisure which are radically different* from that of the
other main group, the assistants. Given their respective back-
grounds, this would be reasonable. They are, at its simplest,
approaching their jobs from significantly different angles, with
significantly different motivations and personal goals, and hence
results.

In the absence of some consideration of the cultures and the
implementation problems at the MAG, even incremental change
would have been difficult. Thus, despite using techniques such as

needs-sensing, developing informal networks to gain acceptance and derive objective information, even partial, tactical moves towards satisfactory results, i.e. *satisficing* (rather than failing to achieve optimally desired results – Guth and Macmillan, 1989: 316), would have been unlikely to succeed in achieving very much.

Thus, it seems fairly conclusive that, whilst the effects of other strategic planning and management of change initiatives cannot be isolated, the organizational culture audit was an effective intervention, *if only in its unfreezing effect*. It assisted the process of strategy reformulation and paved the way for the agenda for change to succeed.

The subtext of this study was: *does formalized corporate planning work?* The answer is: *not on its own.*

BIBLIOGRAPHY

Anthony, P. (1994) *Managing Culture* (Buckingham: Open University Press).

Deal, T. and Kennedy, A. (1982) *Corporate Cultures, The Rites and Rituals of Corporate Life* (Harmondsworth: Penguin Books).

Diamond, M. (1992) 'Personnel management', in J.M.A. Thompson (ed.) *Manual of Curatorship, A guide to museum practice*, 2nd edn (Oxford: Butterworth-Heinemann Ltd) pp. 156–66.

Gill, J. and Johnson, P. (1991) *Research Methods for Managers* (London: Paul Chapman Publishing).

Guth, W.D. and MacMillan, I.C. (1989) 'Strategy Implementation versus Middle Management Self-Interest', in D. Asch and C. Bowman (eds) *Readings in Strategic Management* (Basingstoke: Macmillan Educational Ltd) pp. 307–21.

Hampden-Turner, C. (1990) *Corporate Culture: from vicious to virtuous circles* (London: Hutchinson).

Handy, C. (1985) *Understanding Organisations* (Harmondsworth: Penguin).

——— (1988) *Understanding Voluntary Organisations* (Harmondsworth: Penguin).

——— (1991) *The Age of Unreason* (London: Random Century Ltd).

Harrison, R. (1972) 'Understanding your organisation's character, *Harvard Business Review* 50(3): 119–28.

Johnson, G. (1989) 'Rethinking Incrementalism', in D. Asch and C. Bowman (eds) *Readings in Strategic Management* (London: Macmillan Educational Ltd) pp. 37–56.

Johnson, G. and Scholes, K. (1989) *Exploring Corporate Strategy, Text and Cases* (London: Prentice Hall).

Lichtheim, G. (1970) *Lucász* (London: Fontana).

Lorsch, J. (1986) 'Managing Culture: the Invisible barrier to change', *California Management Review* 28(2): 95–109.

Mintzberg, H. (1976) 'Planning on the left side and managing on the right', *Harvard Business Review* 54 (July–August 1976): 49–58.

Pheysey, D.C. (1993) *Organizational Cultures, Types and Transformations* (London: Routledge).

Quinn, J.B. (1989) 'Managing Strategic Change', in D. Asch and C. Bowman (eds) *Readings in Strategic Management* (Basingstoke: Macmillan Educational Ltd) pp. 20–36.

Schein, E. (1983) 'The Role of the Founder in Creating Organizational Cultures', *Organizational Dynamics* 12: 3–29.

Trice, H. and Beyer, J. (1984) 'Studying Organizational Cultures Through Rites and Ceremonials', *Academy of Management Review* 9 (4): 653–69.

Waterman, R.H., Peters, T.J. and Phillips, J.R. (1991) 'The 7-S Framework', in H. Mintzberg and J.B. Quinn (eds) *The Strategy Process: concepts, contexts and cases*, 2nd edn (London: Prentice Hall) pp. 308–14.

10

Total Quality Management in Museums: An Investigation into the Adaptive Relevance of TQM in the Museums Sector

CAROL BOWSHER

INTRODUCTION

Quality is one of the watch-words of the 1990s and is believed by many management gurus (Deming, 1988; Juran, 1988; Feigenbaum, 1983; Peters, 1987) to provide the key to organizational growth and success. 'Total Quality Management' (TQM) is a long term management approach founded on the belief that quality should permeate every aspect of an organization's culture and operation. Its origins emerged in the engineering industry. Its key features are customer orientation, empowerment through employee involvement and an emphasis on efficiency, working to the principle of 'getting things right first time'. TQM has been in practice in the private sector for over forty years, where significant improvements in quality, productivity and costs have been evident. Its application in the public sector is now becoming increasingly widespread.

Back in 1990 Middleton (Middleton, 1990: 32–3) stressed the importance of product quality, customer orientation and the applicability of management principles for museums to operate successfully in an increasingly competitive and constantly changing environment. However, although improvements have been made in the areas of financial accountability, performance measurement and customer responsiveness, post *Wigan Pier* (Audit Commission, 1991), advances have generally been piecemeal and management of the museum's key resource, its people, has largely been neglected. Moore suggests progress has been hindered by a

reactive stance and a continued cultural aversion and distrust of
management and management theory (Moore, 1994: 2). Scepti-
cism has centred on the suitability of transferring approaches
designed for private manufacturing industries to public sector
organizations, and more specifically to a museum environment
with its own peculiar organizational characteristics.

Leicestershire Museums Arts and Records Service (LMARS) is
currently the only known museum in the United Kingdom, and
probably globally, to have opted for TQM as a means of improv-
ing the overall quality and efficiency of its services (Gosling,
1994). This is an ambitious step, presenting a challenge for
LMARS, but also for the wider museum community. This paper
aims to evaluate the extent to which the ideas and methods of
TQM are of relevance to the museum sector. Authors, such as
Morgan and Murgatroyd (1994), have already embarked on the
TQM private versus public sector debate, and some of their argu-
ments, both for and against the approach, are pertinent to
museums. However, any serious attempt to evaluate its potential
may only be made through gaining an understanding of TQM's
key concepts and methods and by examining those in relation to
the specifics of museum culture and operation. The issues raised
provide the foundation for a critical analysis of TQM in opera-
tion at Leicestershire Museums, Arts and Records Service.

TOTAL QUALITY MANAGEMENT – CENTRAL CONCEPTS
The origins of TQM are complex and although there is no clear
definitive model, there are common central concepts. Haigh's
Seven Basic Principles of TQM (1993), in table 10.1, encapsulate
many of the broad assumptions associated with the approach.
These rather abstract statements may be seen to have been
assembled from a number of quality authors over a period of
some forty years (Morgan and Murgatroyd, 1994). Inclusion and
understanding of TQM's concepts and methods is critical in
assessing its applicability to the museums sector.

The intellectual foundations of TQM emerged in America in
the engineering industry. Deming, Juran and Feigenbaum are fre-
quently cited as the fathers of the quality movement (Bendell,
1991; Morgan and Murgatroyd, 1994). Deming's methods of
quality control, linked to Statistical Process Control (SPC), led to

TABLE 10.1 Seven basic principles of TQM

1.	The Approach	→	Management led
2.	The Scope	→	Organization-wide
3.	The Scale	→	Everyone is responsible for quality
4.	The Philosophy	→	Prevention not detection
5.	The Standard	→	Right First Time
6.	The Control	→	Cost of Quality
7.	The Theme	→	Continuous Improvement

From Haigh (1993) *Unpublished Manuscript*

enormous improvements in production costs and company output (Mortiboys and Oakland, 1991). He particularly stressed the importance of 'company wide' approaches to quality, whereby the elimination of faults could only be overcome by the 'combined' efforts of front-line operators and managers. In implementing quality improvements he encouraged organizations to use a mixture of scientific methods with teamwork, adopting a systematic approach to problem solving, with senior managers taking a lead in implementing Plan, Do, Check, Act (P-D-C-A) cycles (Bendell, 1991: 7; Deming, 1988).

Similarly Feigenbaum, the originator of Total Quality Control, and Juran believed in encouraging operator responsibility and interest in quality. Accompanying this philosophy was the importance of identifying external customers and their needs. A 'spiral of continual improvement' was sought through customer responsiveness and product development to ensure 'fitness for use'. Allied with this, the need for specialist knowledge, tools and training was recognised as a vital part of the process of 'getting it right first time' (Bendell, 1991).

The adaptation and development of these concepts by Japanese companies contributed to their pre-eminence in manufacturing in the 1970s. Ishikawa, Taguchi and Shingo are all attributed with elements of the TQM model. Ishikawa is most associated with the quality circle movement, *kaizen teian*, where emphasis was placed on open group communication, developing individual potential and good data collection (Oakland, 1995: 263; Bendell, 1991: 19). Seven techniques or 'tools' of quality were taught to assist groups with quality improvement: pareto charts, cause and effect dia-

grams, check sheets, histograms, scatter diagrams, control charts and graphs. These largely diagrammatic techniques were used to assist in mapping out factors affecting quality and were particularly useful in identifying trends or obstructions in the quality process (Morgan and Murgatroyd, 1994: 39). Both Taguchi and Shingo's methodologies focus on the cost efficiencies of preventing faults, as opposed to remedying them after detection. These developed through the realization that statistical quality control methods would not, in themselves, reduce 'defects to zero' (Bendell, 1991: 21).

These quality messages re-emerged in Western society through advocates such as Philip Crosby and Tom Peters. Peters particularly reinforced the organizational benefits associated with customer responsiveness, employee empowerment and strong leadership (Bendell, 1991; Peters, 1992).

In drawing upon the philosophies and techniques of the quality gurus, TQM may be seen to offer a fully integrated management approach, embracing organizational culture (i.e. the people), systems and tools. Although it is senior management led, its scope is organization-wide. It focuses on processes, believing that everyone has a critical part to play in the quality chain. It advocates systems of quality improvement and decision making based on facts, as opposed to opinion. TQM stresses the lower cost efficiencies of doing things right the first time, with improved quality leading to enhanced reputation and greater market share (Oakland, 1995: Chapter 1; Haigh, 1993). Haigh's comparison in table 10.2 defines many of the features which, he asserts, set a 'quality' organization apart from an 'ordinary' one.

TOTAL QUALITY MANAGEMENT – KEY MODELS AND APPLICATION METHODS

A useful model which helps illustrate how the key concepts and elements of TQM interact within an organization is supplied by Oakland (Oakland, 1995). Placed at the core of the model is the *process* and *customer/supplier interfaces*. TQM operates on the premise that quality is dependent on the successful workings of a number of complex internal and external interactions, and that prevention of failure in any part of a quality chain relies on a thorough understanding of all organizational processes. To

TABLE 10.2: Haigh's comparison between an 'Ordinary' and a 'Quality' organization

Ordinary organization	Quality organization
Customer satisfaction comes after profit	Profits come from customer satisfaction
Focus on detecting problems	Focus on preventing problems
Cost containment through cutting	Cost containment through disciplined approach to own operations and to the supply chain
Values numbers	Values people
Low spending on training	High spending on training
Vague about goals/roles standards at any level	Explicit and disciplined about goals/roles/standards at all levels
Treats complaints as a nuisance	Treats complaints as an opportunity to learn
In awe of technology	Uses technology selectively under management control
Runs by systems	Runs by people working with other people
Sees quality/productivity/cost reduction as separate endeavours	Restless search for improvements of the organization with quality/productivity/cost reduction as indivisible elements
People do not know where they fit in the Quality chain	Manages the Quality chain

From Haigh (1993) *Unpublished Manuscript.*

achieve this, organizations need to listen, and be responsive, to both the 'voice' of the external customer and the 'voice' of the process itself, the internal customer (Oakland, 1995: 97). The core is surrounded by commitment to quality, achieved through communication of the quality message and through cultural change within the organization. Oakland refers to these as the 'soft out-

comes'. In addition are required the 'hard management neces-
sities', the systems, tools (techniques) and teams.

The Soft Outcomes – Commitment, Communication and Culture
For an organization to implement TQM, it has to have a vision,
a common purpose, and a framework clearly stating its guiding
values, beliefs and objectives. A quality policy must be developed
to carry the quality philosophy throughout the organization. A
suitable infrastructure must be established to turn the quality
vision into a reality. A common operational model has at the
apex the Chief Executive, the highest level of management
support and involvement, which is crucial to the implementation
process (Haigh, 1995: pers. comm.). The Quality Council (QC) is
made up of top management levels whose objectives are to
provide strategic direction on TQM for the organization, to
establish quality plans, in line with business planning, and to
revise these, if necessary, in line with feedback from the Process
Quality Team (PQT) or steering committee. The process quality
teams provide top down support for employee participation and
development, via a two way communication process through
either Quality Improvement Teams (QITs) or quality circles
(Oakland, 1995: Chapter 10).

TQM recognizes that structure alone is not enough. For total
quality to succeed it needs to become a way of life for an
organization and, as quality is achieved through people, it is
entirely dependent on the commitment of individuals and on
transforming the culture of an organization (Armstrong, 1992:
Chapter 11). TQM aims to gain acceptance, or a culture of
consent, as Handy refers to it (1993), through adopting soft
human resource management approaches focusing on commu-
nication, participation and strong leadership qualities. TQM
should be built on foundations of openness, honesty and integ-
rity, sharing information and developing power, as opposed to
being founded on the more traditional principles of power and
fear. Emphasis is placed on the individual through both invol-
vement and a commitment to training and continuous learning.
TQM requires a long term management commitment. An esti-
mated cycle of five to seven years is required for the approach
to become fully integrated within an organization's culture
(Haigh, 1993).

The Hard Necessities – Systems, Tools and Teams

A quality system may be defined as an assembly of components, such as the organizational structure, responsibilities, procedures, processes, and available resources. Once the customer/ supplier relationships and needs have been defined, quality systems must be established which meet the requirements of both the customer and its internal processes; transforming a set of inputs into outputs (Oakland, 1995: 97). For systems to remain useful and efficient they must include a process of continuous review, facilitating monitoring mechanisms which may be accompanied by corrective actions programmes, such as Deming's P.D.C.A. cycle (Oakland, 1995: 98; Mortiboys and Oakland, 1991).

Measurement is an essential ingredient in the analytical process. It assists in identifying opportunities for improvement by comparing performance against internal standards (process control) or external standards with competitors (bench marking). The P.D.C.A. cycle of continuous improvement clearly requires measurement to drive it, in order to compare actual performance with objectives and standards, and to highlight gaps, if occurring (Oakland, 1995: 331). Oakland stresses the importance of performance indicators being designed by those people who actually work on the process. He terms this as 'voluntary accountability' (Oakland, 1995: 214). The use of statistical process control methods, together with the Japanese tools described earlier, provide part of the means for collecting, presenting, analyzing and interpreting data to inform decision making and action planning.

Quality improvement teams are brought together, usually on a project basis, to assist in solving problems and in generating and implementing ideas. They are generally made up of groups of five to ten people, co-ordinated by a team leader. The benefits of teamwork and of developing employee involvement are considered to be numerous, and have been reiterated by many authors (Adair, 1988; Armstrong, 1992; Handy, 1993). Team approaches are considered not only to provide better solutions, through encouraging cross-departmental working and the pooling of skills and resources, but may also assist in building trust and improving communication within an organization. Its individual motivational force is realised through enabling people to partici-

pate in the decision making processes, as Oakland comments 'responsibility and accountability fosters, pride, job satisfaction and better work' (Oakland, 1995: 270).

An initial overview would suggest that TQM has much to offer museums. Few could object to the fundamental aspirations of continuous improvement and quality, and with museums operating in an increasingly competitive environment, adoption of certain performance measurement and business management practices, are undoubtedly relevant and necessary. Further strengthening the relevance of TQM is its customer orientated focus and human relations slant. However, other concepts, such as 'zero defects' and some of the tools, seem more appropriate to singular product manufacture rather than public service industries. Indeed, it is the differences that exist in the aims and purposes of private manufacturing organizations, as opposed to public sector ones, that have perpetuated scepticism within the museum profession concerning the appropriateness of adopting private sector management practices wholesale (Davies, 1993). It is only through an examination of the differences that exist between the sectors, in relation to the TQM model, that an insight may be gained into the potential of TQM for museums.

Differences may be seen to fall within two broad categories: those primarily associated with complexities of the concept of product and the customer-supplier relationship, and those with the complexities of the process, influenced by the organizational nature of museums and their workforces. They are summarized, by way of introduction, in table 10.3.

The Product Concept and External Customer–Supplier Relationship

The customer–supplier interfaces lies at the heart of the TQM model. Product quality centres around defining who the external customers are, establishing their needs and expectations, and on the organization's ability to satisfy those needs. In a commercial manufacturing context this process is underpinned by tangible products, financial transactions, a clear exchange of goods and quantifiable data (Davies, 1994b: 11). However, in the museum

TABLE 10.3 Differences between commercial and museum sectors

Commercial sector	Museum sector
Tangible product	Intangible product
Homogeneous	Heterogeneous
Quantifiable	Difficult to quantify
Product pivotal	People and product pivotal
Profit making	Not for profit
Economic supremacy	Diverse socio-cultural role
Flexibility	Inflexibility/bureaucracy
Single purpose	Multifunctional
Unified teams	Individual specialists
Paid workforce	Paid and voluntary workforce
Reward systems	Few reward systems
Ability to invest	Poor investment opportunities

Adapted from Morgan and Murgatroyd (1994) and Davies (1994a)
Note: It is acknowledged that this table indicates a polarized view of the two
sectors and that some aspects may occasionally apply to both.

context, neither the product, market, nor motives are quite so
simple. Although there are tangible components in the museum
product such as buildings and facilities, the nature of the
museum experience as a whole is generally intangible (McLean,
1993: 14). Customer satisfaction is influenced by a complex
series of interactions comprising everything from initial aware-
ness, first impressions (sights, smells, sounds) attitudes of staff,
response to interpretation, or to type of visitor facilities. Failure
to satisfy in one area may negate the value of the entire experi-
ence (Middleton, 1990: 34). This complexity of the product may
be seen to add weight to the relevance of the quality chain
concept and of the importance of understanding customer needs
at every stage of the process, to ensure there are no obvious
weak links.

However, the concept of product quality is complicated by the
fact that consumers of the same service do not have the same
priorities and that quality is partially determined by the sub-
jectivity and input of the customer (Haigh, 1993). A museum
audience is certainly characterized by its diversity, with users who

are driven by different motives and armed with different expectations. The heterogeneous nature of the museum's market has, perhaps, in the past been used as an excuse for not making serious attempts to define the true requirements of users. However, this extreme diversity only tends to fuel arguments, in line with TQM, for increased and improved marketing activity in identifying and targeting audiences. As a report by the Office of Arts and Libraries states, 'spending money on provision is of little use if the level, mix and quality is at odds with the requirements and preferences of those for whom the service has been provided' (Museums and Galleries Commission, 1992: 1).

Actual consumption of the product is also fundamentally different in public service industry. Whereas in manufacturing, quality is engineered into the product at the manufacturing plant and then delivered intact to the customer, in service delivery, production and consumption are inseparable. Quality cannot be easily measured and tested in advance, and performance is judged on an immediate transaction between customer and deliverer (Morgan and Murgatroyd, 1994: 10, 44). This has focused attention on the pivotal role of the person at the point-of-contact. Whilst quality is defined to an extent by the customer, it has been acknowledged that there are generally accepted features of service quality, such as those defined by Parasuraman, which may usefully be applied to public services (Morgan and Murgatroyd, 1994: 11). The museum sector has also recognized the importance of customer oriented approaches (Museums and Galleries Commission, 1992) and the profession has witnessed, albeit slowly, significant improvements in the level of performance of front-of-house staff.

However, it is important to differentiate museums from other types of service industries. The standards of common courtesy, the 'have a nice day' approach, suited to some public services, are insufficient in catering for the diverse needs of museum users, where transactions are highly varied (Davies, 1995b: 11). It is at this point that TQM's dependency on consistency and elimination of variance must be questioned. Integral to service quality in a museum context is the ability to meet a wide variation in demand, which is more dependent on the skills and qualities of its staff, than on systems (Morgan and Murgatroyd, 1994: Chapter 10).

The issue of variety recurs in relation to museum programming. Whilst TQM does advocate continuous improvement in product development, museum exhibitions and events programmes are different both in terms of their rate of change and one-off nature. This also challenges TQM's philosophy of 'Right First Time' (Clay, 1995: pers. comm.). This may be well suited to some areas of museum activity, particularly collections management where consistency, accuracy and systems are essential, but its relevance to the more creative side of museum work is debatable. The success of events and exhibitions is often more dependent on elements of risk and innovation, than on working with the 'tried and tested'. In these respects it is valuable to look at some of Peter's management attributes which build on the qualities of service differentiation, innovation and market niches (Peters, 1987).

Definitions of quality become increasingly complex when it comes to forms of interpretation. Customer responsiveness in this sphere of museum operation has been a subject of much debate. There has been a growth in formative and summative evaluation in interpretive projects, assisting in determining demands and in supplying provision of the right level and mix. There has also been a general trend toward involving and opening up the exhibition process to the public (Bott, 1990). However, some curators have been reluctant to accept the pre-eminence of the customer in relation to 'product development', viewing it as an impingement on their domain. Community involvement in areas such as exhibition creation may, in fact, lead to a loss of quality. It is the quality of the experience gained by those taking part which is considered more important to the organization, as opposed to the end product.

A further argument in such a diverse sector is that being too responsive to customers may lead to loss of focus, thus weakening the product overall. Contradictions also occur with regard to the concepts of efficiency and cost effectiveness. Working with minority groups would rarely be deemed productive or cost effective in terms of resource input and output equations.

Internal Quality Chain and Process Management
TQM's organizational philosophy hinges on the successful synchronization of strategy, vision and operation (Morgan and Mur-

gatroyd, 1994: Chapter 1). Establishing a shared vision, values and goals is central to the process, and achievement of quality objectives is reliant on cultivating appropriate systems and cultures, the latter being encouraged through communication, and employee involvement.

This philosophy appears as relevant to the museum sector as to other types of organization. Museums, like all organizations, are goal orientated and aim to accomplish their goals through a group effort and through some form of organizational structure, usually based on the same functional types of structure found in commercial sectors (Sukel, 1974: 229). Although the nature of museum functions are very different from those of many other organizations, being characterized by their multiplicity and high level of specialization (Diamond, 1992: 162), the use of systems, such as Deming's P.D.C.A. cycle, would prove equally valid to the museum's sector for the effective management of their organizational processes. The complexity of internal museum relations and operations may be seen to reinforce the value of adopting a more analytical and cross-functional approach toward service delivery improvement.

Whilst the procession has acknowledged the value in planning, it has experienced greater difficulty with the issue of measurement, which underpins the TQM process. Arguments waged against the value of performance measures focus on the socio-cultural responsibilities of museums (as opposed to purely profit motives), the over-emphasis on quantitative as opposed to qualitative output, potential misinterpretation of measures and the time consuming nature of measurement (Walden, 1991: 27; Marson, 1993: 27). The relevance of benchmarking is certainly questionable in such a diverse sector where comparisons are difficult, but there is significant value in comparing performance against internal objectives and standards. Jackson (1994) and Spencer *et al* (1993) have demonstrated that there are no shortages of possible performance indicators for museums and museums should, like any organization, undertake evaluations of their outputs to justify their decisions. They are of value as a positive political tool, in addition to contributing to internal management. As Hatton emphasizes, forms of control are an essential part of management to ensure the realization of plans: 'planning can all too frequently be followed by precious little organizing and moti-

vating. Worse still, it can often be left completely uncontrolled' (Hatton, 1992: 35). Both Hatton and Davies (1992; 1994a) have argued the case for a holistic management approach, which TQM has the potential to deliver.

Motivation and commitment are key issues. The management of people has been a major area of neglect in museums. This is a serious oversight considering the museums' heavy reliance on human resources and the financial outlay involved (Friedman, 1982; Moore, 1994). The sector has benefited for many years from a workforce enthused by a strong sense of vocation and commitment. However, there is evidence to suggest that job satisfaction and levels of motivation are diminishing (Kahn and Garden, 1994). Museum management needs to reassess its relationship with its employees (Roodhouse, 1994) and take note of prevalent theory and practice in Human Resource Management (HRM) which view people as organizational assets (Handy, 1993: 222). As Armstrong clearly amplifies, 'HRM sees people as valuable human resources for the achievement of competitive advantage who should therefore be managed and developed to their full capacity and potential' (Armstrong, 1992: 9).

TQM acknowledges the important role of people in organizational effectiveness. The potential benefits associated with quality of work life and, more specifically, employee involvement, have a long pedigree in the fields of organizational psychology (Marchington *et al.*, 1992; Handy, 1993: Chapter 2). The museum community may be seen to have a particularly close affinity with McGregor's 'y' theory on intrinsic motivation in which the self-motivated individual is considered to gain most satisfaction from the work itself, from relations within the working group, and from an overall sense of purpose, i.e. an affiliation with the organization's goals. Allied with this, is the belief that this sort of individual prospers most in a co-operative environment which facilitates personal development and achievement, as opposed to a coercive and highly controlled environment (Handy, 1993; Chapter 2; Adair, 1988: Chapter 11).

There is a close correlation between these strong motivations and the type of environment TQM seeks to establish through its open and honest style of management, which values the individual and seeks to develop his/her capacity fully through inclusion and empowerment. TQM places a high priority on investing in

people through training as part of the empowerment process to ensure that employees are equipped with the necessary skills for the job.

Although limited research has been undertaken into HRM in museums, there is evidence to suggest that museum staff would respond favourably to a more open and inclusive style of management. Back in the 1980s Farnell highlighted discontent amongst the profession with regard to poor communication and lack of involvement in decision making (Farnell, 1984). More recent findings presented by Kahn and Garden, concerning job satisfaction and occupational stress, again cite 'lack of consultation and feedback' as the primary source of dissatisfaction (Kahn and Garden, 1994: 202). Communication, it would be thought, is even more critical during periods of change. However, cases highlighted by Davies (1990, 1991) illustrate that where attempts have been made to adapt and improve organizations through restructuring, they have not been accompanied by a process of consultation, reducing or negating the value of the process. TQM may appear to offer a far better alternative for handling the process of change, with its strong emphasis on communication.

Potential Blockages to the Implementation of TQM in the Museums Sector

In assessing the feasibility of implementing TQM in the museums sector there are several fundamental problem areas, which have constrained museum performance to date, and which have the potential to undermine the application of TQM. These include lack of clarity of purpose and primary goals, the complexity of management structures and resource constraints.

Conflict over definitions of purpose and unresolved differences in goal perspectives has dogged the museum profession for many years. Poor relations, often aggravated by unhappy departmental alliances and entrenched viewpoints, are particularly evident between governing bodies and museum management. Sources of conflict generally emerge from divergent ideologies, with professional goals and institutional goals frequently coming into opposition (Friedman, 1982; Dickenson, 1991). Divisions are not only evident outside the organizational boundary. Larger museum institutions have been characterized by their compartmentalism and ignorance of other departmental functions and needs.

Fleming (1992) has accurately described the type of discipline rivalries that may be found within certain unhealthy institutions, all of which further weaken the internal quality chain.

This is not the forum to enter into these debates, but it is fair to say that with the breadth of museum stakeholders, where politicking plays a part, accompanied by the lack of agreement over goals, the odds of achieving an organization-wide committed approach are significantly reduced (Locke 1995).

Beer has argued that it is lack of 'process' for creating and articulating goals that is more problematic than the more visible debate about what the goals should be. She believes, like the proponents of TQM, that the involvement of all constituencies in goal-setting exercises and developing common philosophy will help overcome both board membership and departmental dissent. As she states 'shared goals mean a unified approach to the museum's mission and help ensure that parochial interests, biases and "hidden agendas" do not dominate' (Beer, 1990: 16).

In addition to the problems associated with gaining commitment, the hierarchical management structures and bureaucratic procedures of local government establishments do not aid implementation. Museums do not always have the autonomous power to make radical changes in organizational structure and procedures whilst working within the wider government regime. Fowler (1988) has pinpointed many of the critical issues which affect organizational effectiveness. One of the central problems is the divisions that exist between the policy makers and those responsible for implementation, explaining frequency of drift between aims, needs and actions (Fowler, 1988; Hatton, 1992). Hierarchical, or tall structures, as Fowler refers to them, by their very nature remove or alienate management from front-line workers. To be effective TQM is reliant on the integration of policy and function and requires systems which promote this type of interaction and facilitate teamwork. In wider management practice, Peters (1987, 1992) has done much to promote the adoption of flatter structures to enable the pooling of resources and more responsive methods of working. There have also been movements within the museum sector toward team approaches, identifying the benefits of utilizing skills from below as well as above (Locke, 1992: 30; Knowles, 1991: 21).

However, this transition is not as simple as bringing together a group of enthusiastic and committed individuals. Adair's studies of the complexities of group dynamics in teamworking have dispelled any blurred visions of democratic entities. His action centred leadership model demonstrates that groups respond best to strong well directed leadership and defined tasks. Empowerment, Adair comments, requires particular leadership skills with the ability to adopt a progressively less directive role as the group grows in experience. Team co-operation is dependent on good team formation, providing the right blend of member characteristics and skills (Handy, 1993: Chapter 6). It is particularly important that individuals have an opportunity to show their potential, to take on responsibility and to receive recognition for their contributions (Adair, 1988: Chapters 2, 3 and 11).

The whole process requires a positive culture shift from management. Organizations need to move away from embedded role cultures and to adopt a more task orientated approach to working (Handy, 1993: Chapter 7). This ability to relinquish tight control and devolve power may prove difficult for some museum organizations accustomed to different ways of working. Indeed, one has to remain sceptical about how far certain senior executives or managers are prepared to go with the practice of empowerment. The qualities of senior management are critical to the process. Implementation needs sincerity, and as Reynolds (1993) has commented, organizations who have a management history of mistrust and poor levels of competence, are naturally liable to encounter problems implementing an approach founded on honesty and integrity.

The current economic climate, it must be stated, is not conducive to the culture of TQM. It could well be argued that an environment of budget cuts and redundancies, is unfortunately more likely to develop a breeding ground for infighting and back stabbing, than one of trust and co-operation. The TQM approach is also open to abuse. Certain authors have viewed it as potentially manipulative (Reynolds, 1993: Chapters 5 and 6). There is a fine line between job enrichment and exploitation, 'getting more for less'. The issues of recognition and reward management with regard to increased responsibilities are not easy to address (Armstrong, 1992: Chapter 15). They have to be balanced with that of survival. Certainly a culture of honesty may help reconcile some

of these problem areas. A better awareness of financial position-
ing is probably a good incentive toward improving performance
(Janes, 1994). However, the type of financial constraints museums
operate under may, in the longer term, undermine the application
and sustainability of TQM. It is questionable whether museums
really have sufficient financial or human resources to support its
high training and development requirements and to implement
improvements identified by teams, so important in maintaining
momentum.

In exploring the suitability of TQM for the museums
sector, whilst there are difficulties associated with the 'concept of
quality' and of securing organization-wide commitment, it does,
as established, demonstrate many favourable attributes. TQM
certainly appears to provide a better alternative than other
management practices derived from private industry emerging in
the sector. TQM is at the reverse end of the spectrum to pre-
valent trends for compulsory competitive tendering (CCT),
whereby client/contractor (purchaser/provider) splits tend to
divorce the individual from any form of control over process.
Whilst CCT has the potential to work, if undertaken through
open discussion and negotiation, relationships have a greater ten-
dency to become adversarial, with people working against, rather
than with each other (Shadla-Hall, 1995: pers. comm.). Policy
makers frequently do not have, or are unwilling to acquire, suffi-
cient knowledge and information of front-line operations to plan
effectively, whilst contractors are liable to suffer from demotiva-
tion following loss of ownership in their working processes. Once
specified, contracts tend to be difficult to amend, reducing
responsiveness to demand, with longer term cost and efficiency
implications.

Similarly, quality assurance initiatives such as the British Stan-
dard (BS) 5750, where rigid standards are applied and monitored
externally, tend to date rapidly, reduce decision making powers
and to diminish organizational flexibility (Smith, 1994). As Haigh
asserts, BS5750, unlike TQM, does not respond to changes in
market demand, does not attempt to change the culture of an
organization, and does not facilitate continuous improvement.
Braintree Museums' experience of BS5750, not unexpectedly,
highlighted the difficulties of using rigid standard assessments in
certain areas of museum work, such as exhibition organizing,

where 'tasks are never the same twice' (Smith, 1994: 23). Whilst the museum sector has acknowledged the relevance and value of standards developed internally within the profession, such as the Museum and Galleries Registration Scheme, it is questionable how much external quality initiatives or standards contribute to quality improvements or cost efficiencies. All too frequently nationally applied standards or achievement 'marks' seem to degenerate into meaningless checklists completed for bureaucratic or political reasons, without focusing on actual organizational betterment.

Investors in People, IIP, the national standard launched in 1991 to help employees link training to business needs, whilst sharing the common aim of TQM of developing the potential of the individual, is again not an integral part of the organization's growth. Its emphasis on training may ensure that staff are equipped to do their jobs but it does not ask fundamental questions about the relevance of the jobs they are doing (Broughton, 1995: pers. comm.). Also there is a risk that newly acquired skills may not be fully deployed if there are faults within the organization as a whole.

Although the philosophy of TQM is particularly attractive, as is the concept of quality driven internally, the practicalities of implementation have proved problematic. It must be noted that TQM's wider organizational application in this country has largely met with failure: Haigh (1995) estimates between 85–90 per cent. It has been considered that it may relate to national culture, but its success in British-based Japanese companies, like Nisson and Toyota, operated by British workers, suggest that this is not the case (Reynolds, 1993). A survey undertaken in 1990 reported that 91 per cent of companies experienced difficulty in achieving cultural change (Plowman, 1990: 217–19). Other report studies have identified specific problems at middle management level, where inadequate skills, training, support and resources have hindered employee involvement processes (Marchington, 1992: 57). Criticism has also been waged at TQM concerning the length of time required for implementation, claiming it to be too slow and unresponsive in a competitive environment.

Many assumptions have been drawn, and issues raised, both for and against TQM, in this exploration and debate. In undertaking a critical appraisal of TQM at Leicestershire Museums,

Arts and Records Service, the aim has been to challenge these assumptions and to establish whether, in fact, the perceived problems or merits associated with TQM approach are founded.

TQM AT LEICESTERSHIRE MUSEUMS, ARTS AND RECORDS SERVICE – A CRITICAL APPRAISAL

Backdrop to TQM and LMARS

LMARS is one of the departmental arms of Leicestershire County Council, currently a two tier authority responsible for delivering a broad spectrum of services usual for an authority of its size. LMARS, employing 190 staff, is a county-wide integrated service directly responsible for fourteen museums and five historic sites, a record office, an archaeological unit and an ecology unit, spread over a wide geographical region. It is also responsible for progressing arts and cultural development in the region. Its organizational structure is divided into two main spheres of operation, with the development and support services being split from collections and interpretation, the traditional curatorial heartlands.

The impetus for the implementation of TQM may be perceived as being partially visionary, partially political, and partially functional. Tim Schadla-Hall, the Director of LMARS, had been attracted to its integrated management philosophy following a presentation given by Professor Haigh, of Sheffield Business School, at the request of Leicestershire County Council. When, in the early 1990s, the County Council's Director wanted to introduce business units into the authority's operations, the management group of LMARS proposed that TQM be implemented as a stronger alternative for their services. LMARS is the only department within the authority to have opted for TQM. A range of different quality control initiatives, including BS5750, exist in other areas of operation (Broughton, 1995: pers. comm.).

TQM already shared many of the ideals expressed in the County Council's Corporate Plan, formulated in 1991, which emphasised the importance of customer responsiveness, quality service and efficiency of resources. TQM also, as Broughton asserts, had all-party appeal, appealing to the right through its emphasis on efficiency and cost effectiveness and to the left through its democratic ethos of involvement and empowerment (Broughton, 1995: pers. comm.).

The other major impetus prompting the application of TQM was its perceived potential for managing an increasingly unstable internal environment. Whilst customer expectations and demands were increasing, the service was suffering from a number of inter-related problems. These included fragmentation, poor communication, lack of shared values (worsened by geographical segregation) and low staff morale, influenced by progressive resource constraints and concerns over the pending local government re-organization with fears of job losses following proposals to split the integrated service into separate unitary authorities (Broughton, 1995; Shadla-Hall, 1995; Murdin, 1995).

The Implementation Process
It was in 1992 that the Director of Corporate Management agreed to support the TQM initiative within LMARS. A report, prepared for elected members in April 1993, clearly advocated the value and relevance of TQM's concepts and methods. Particular attention focused on the issue of performance measurement, as the report stated:

> performance measurement lies not only at the heart of TQM, but also at the core of much of the work of the Audit Commission, and is implicit in both the Citizens' Charter and in the Corporate Action Plan. (Schadla-Hall and Mathias, 1993: 4.1).

The report also demonstrated management thinking with regard to the multiple advantages of performance measurement to the department. In addition to aligning with political policies, measures were identified as a valuable tool for informing managers and elected members of concrete quality improvements, for encouraging staff through its involvement and achievement oriented approach, and for evaluating customer responses (Shadla-Hall and Mathias, 1993).

Professor Haigh was officially appointed in a consultant capacity to the role of facilitator in 1993. In preparation, the management group spent two days away with Haigh acquainting themselves with the quality process. Similarly Haigh made preliminary visits to some of LMARS's sites. Few modifications appear to have been made to the standard TQM induction training programme prepared by Haigh for other public sector initiatives. LMARS's training budget has been cut from £25,000 to

£5,000 in recent years, so funding for the training programme came directly from the Chief Executive's budget which facilitated full induction of all staff within the service in 1993. Training was also offered to any elected council members who expressed an interest. A series of review meetings was held between Haigh and the management group in 1994, but LMARS have now taken over the role of facilitator, being of the opinion that they are now in a better position to align training closer to their needs.

The Quality Council (QC) comprises the three members of the management team, an elected council member and three members of staff, including a front-of-house representative. Members stay on the QC for a period of fifteen months (Gosling *et al.*, 1994). Quality Improvement Team members (QITs) were initially nominated by the QC. However, this exacerbated 'them and us' divisions (Clay, 1995: pers. comm.). Teams are now partially selected, but there are opportunities for staff to put their names forward or to volunteer for existing vacancies.

The project teams are multidisciplinary. Each team at LMARS has a team leader (the facilitator) and a chair to assist with control and direction of the team. The early sessions concentrated on formulating a shared vision for the department. Wide consultation took place in this process (Clay, 1995: pers. comm.). The formulated vision, mission and value statements illustrated responsiveness both to internal and external users of the service. An earlier internal quality initiative, together with a major survey of users and non-users, led by Prince Research (1992), provided the basis for the first two quality initiatives aimed at improving the quality of retail outlets and the first point-of-contact between visitors and the service. Areas identified for improvement by the QITs are either put forward by the QC, informed by other QIT's, or taken up from staff suggestions. A total of thirteen improvement teams are now in operation, as detailed in figure 10.1, which illustrates the progress of the teams to December 1995 (*Discover*: December 1995). The horizontal axis clearly demonstrates the steps taken in the improvement process from the formulation of the brief, through the various stages of process definement, using various forms of data collection and analytical methods to inform strategies and actions.

The progress and results of the teams are communicated through the department via the use of minutes, pin boards and a

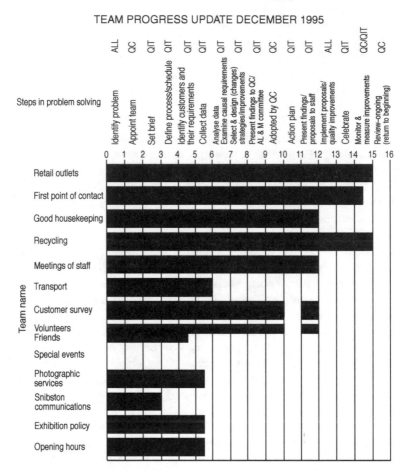

Figure 10.1: LMARS QIT Team Progress

From *Discover*, December 1995, Leicestershire Museums, Arts and Records Service.

newsletter. The newsletter's format and name was changed from 'Quality MARS' to 'Discover', aiming not to alienate those perceived to be uninterested in the quality initiative or tiring of the 'quality' label (Broughton, 1995: pers. comm.). It now has a wider remit including general/social news together with reporting on the progress of quality initiatives.

Materials from the first two initiatives illustrated the type of investigative and analytical approaches used by the QITs in problem solving. In addition to collecting statistical data, a significant amount of research for projects was undertaken through direct consultation with those most closely aligned with the process. A report from the Retail QIT made comment on the 'positive attitudes' and 'co-operative spirit' of the museum assistants who operate the front-of-house activities; reflecting obvious enthusiasm to be involved in the organization's activities in a more proactive and influential way. The comparative retail sale figures between 92/93 and 93/94 do reveal an upsurge in the majority of LMARS's retail outlets (Bowsher, 1995).

The first point-of-contact group investigated improvements to be made from all first points of contact within the service, whether communicating via postal systems, the telephone or through direct contact with service buildings. The use of flow charting to analyze existing postal routes may be seen as providing a useful tool for defining weaknesses in the systems (Bowsher, 1995). All the improvement recommendations, put forward by the first point-of-contact QIT, highlighted the value of a holistic approach to problem solving with actions required in multiple areas, from the upgrading of equipment, to the identification of training needs and changes in work patterns (see Bowsher, 1995, for fuller descriptions).

Survey and Interview Research Findings
Questionnaire surveys and focus interviews were designed to gain a wider view on the impact of TQM at ground level. The questionnaire survey was distributed internally throughout LMARS. It aimed to explore TQM in relation to staff attitudes, levels of staff involvement and commitment and quality improvements, both internally within the organization, and externally, in terms of services delivered to the public. It also sought considered opinions on its strengths and weaknesses with the aim of establishing the potential of TQM for the wider museums sector. The questionnaire survey, detailed in table 10.5 offered multiple choice selections in most categories. Where respondents identified categories in addition to those listed, these have been included in the research presentations, as in Questions 1 and 7. There were 32 respondents from a potential 190, amounting to a low return rate

of 17 per cent, and as such, views may or may not therefore be a true representation of opinion. Reasons for the low return rate could be related to workload, timescale, distribution difficulties, or it could suggest a lack of interest within a large portion of the workforce. The focus interviews aimed at assessing the impact of TQM through its hierarchical structure, and to explore in greater depth potentially problematic issues associated with its implementation. Salient points have been extracted from the interviews which add greater insight to the questionnaire survey findings. In analyzing the responses, it is important to consider that LMARS is only in its third year of the recommended five to seven year implementation cycle.

Questionnaire Survey findings
Q1 What do you perceive TQM to be about?
The responses shown in figure 10.2, illustrate that the majority, 78 per cent, perceived TQM to be about improving quality, followed by 66 per cent improved efficiency. A fair proportion, 44 per cent associated TQM with better working environments. The additional comments also reflect the type of improvements staff perceived it to bring to the quality of working life in the areas of empowerment, participation and motivation, 38 per cent perceived TQM to be about cost savings and 31 per cent about performance measurement or quality control. Perceptions were generally associated with positive traits of the approach as opposed to the more negative ones, such as control and cost savings, which may have had the potential to undermine commitment to the process.

Q2 What were your original thoughts about the implementation of TQM at LMARS?
Of the respondents the majority, 56 per cent were open minded, 38 per cent were in favour and a small minority, 6 per cent opposed. Of those in favour, the general consensus reasoning was related to the opportunities TQM presented for communication, inclusion and involvement in the decision making process. One respondent viewed TQM as a valuable method of re-evaluating the efficiency of operational processes. Two respondents were in favour following their experiences of TQM in industry or the private sector. Of the minority who were opposed, scepticism was

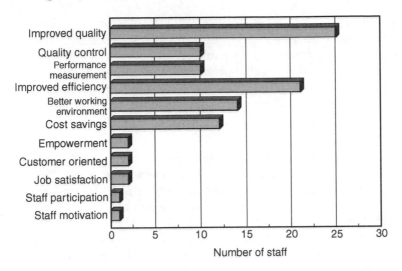

Figure 10.2: Perceptions of TQM

expressed concerning the feasibility of implementing improve-
ments with already overstretched resources. Scepticism was also
evident in those who were open minded with reference to its sus-
tainability, viewing it as, perhaps, one of a series of management
'quick fix' formulae.

*Q3 Do you know and agree with the vision, mission and value
statements of LMARS?*
100 per cent knew what the vision, mission and value statements
were and 91 per cent agreed with them. The others reveal pro-
blems associated with formulating a vision to suit such a broad
service, inevitably leading to a more woolly statement, focusing
less on the specifics of individual services or sites. References were
also made to the political, pretentious and patronizing nature of
the wording.

Q4 Do you feel part of your organization?
Two comments were related to lack of participation in the deci-
sion making process, one at strategic level. Most respondents did
not feel the need to comment and may be assumed to be reason-
ably content with their organizational role.

Q5 What is your involvement in the TQM process?
There was a fair cross section of respondents representing the different tiers of the quality structure. Whilst some respondents were represented in more than one category of the structure, quite a high percentage, 34 per cent, of those interested enough to respond had not yet been directly involved in the implementation process.

Q6 How effective have you found team working?
23 per cent rated the quality of team working as good. Positive comments referred to good productivity, strong leadership and the advantages of its cyclical nature – with the formation of one QIT leading to the formation of another. The majority, 38 per cent, rated the effectiveness as fair and found the process to be retarded by members' characteristics and divergent views. One respondent found the experience of chairing difficult through a lack of specialist knowledge in the subject area and through controlling other team members, suggesting further training would prove beneficial. Other problems related to communication difficulties and the practicalities of attending team meetings with heavy workloads. 35 per cent did not respond suggesting their lack of involvement in a QIT to date. 4 per cent rated team working as poor.

Q7 In what area/s of the service, if any do you feel quality improvements have been made since the implementation of TQM?
The majority considered TQM had been most effective in delivering quality improvements to the external customer: 63 per cent through direct improvements in the quality of customer care and 59 per cent in the quality of the museum product, i.e. buildings, shops, signage, etc. A significant proportion also felt it had led to improvements in the internal efficiency of operations, see figure 10.3.

Q8 What do you feel, if any, are the strengths of TQM? Please comment.
The majority of comments in this section related to specific improvements in human resource management issues. Its overwhelming strength was seen to focus on its organization-wide

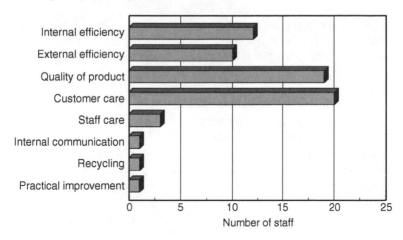

Figure 10.3: Quality improvements

From Bowsher, C. (1995: 40,42) *Total Quality Management in Museums*

spirit of inclusion and involvement at all levels, encapsulated in this statement 'Any member of staff can be part of a QIT ... (it) makes members who don't have academic qualifications feel of value to the LMARS organization. Everyone has something to offer'.

The listening and open style of management and willingness to involve staff at all levels was seen to encourage team spirit, improve morale and break down hierarchical barriers.

Other strengths related to the value of the process. Its strategic and problem-solving methods were acknowledged as a positive way to go about implementing improvements in the museum sector. Several references were made to the value of adopting a cross-functional approach for pooling the skills and resources of staff from different sections and for raising awareness of their operations and needs. TQM's customer orientation and responsiveness was highlighted as a strength, being seen as a definite channel for improving the quality of service to the public, as well as providing a valuable approach for raising the museum's own political profile.

Q9 What do you feel, if any, are the weaknesses of TQM? Please comment.

Weaknesses or potential barriers to the successful implementation of TQM were seen to fall into two main categories: resources and culture (attitude). Both issues are often strongly interrelated. The cost of implementing recommendations, both in terms of financial and human resources, was seen as a potential threat to the process. Some felt improvements to date had only addressed peripheral issues rather than tackling core problems. The lack of resources, and slow appearance of results, could, it was felt, lead to a loss of enthusiasm and momentum. Some commented on the risk of this situation snowballing, providing fuel for the organization's cynics. Comments were made with regard to the type of environment in which TQM was attempting to operate, with specific comments made concerning lack of material incentives and the issue of job insecurity.

Q10 What improvements do you think may be made in its implementation?

Responses reveal that the induction process was perhaps not as successful as it might have been, with some staff expressing a lack of understanding of the basic concepts. Several references were made to the need for more training or further systems to be introduced to assist the implementation process and in maintaining momentum. These included specific section head training, annual refresher courses, improved methods to involve more staff and different forms of communication to inform of progress (too much current emphasis on the written word). One respondent felt restructuring would help to achieve the flexibility required to meet the objectives of TQM and the organization, particularly the removal of the split between the curatorial and support service functions: i.e. secretarial, personnel, information systems, marketing, etc.

Focus Interviews

The interviews provided a clearer indication of the problems specifically related to the organization's culture, in particular of the historical divisions between the curatorial sections, as well as the divisions between curatorial and support staff (Vasey, Betts, Mastoris, 1995: pers. comm.). It was these deeply rooted divergent

cultures which generated the most scepticism from interviewees with regards to TQM's ability to achieve a service-wide approach to quality. Some felt the initial input of the external consultant had damaged the implementation process, alienating many through its academic style of presentation and jargonistic use of language (Vasey, 1995: pers. comm.). Change in attitude was perceived as being the crux of the matter with regard to successful implementation. People had to 'want' to change within the changing environment (Mastoris, Clough, 1995: pers. comm.).

Unresponsiveness to TQM within the service was linked to various factors from fear of change, unhappiness about taking on responsibilities, and lack of financial reward, questioning how much commitment could be expected for low pay (Mastoris, Clough: 1995 pers. comm.).

In certain areas of the service a positive shift in culture was evident. Many of the interviewees who had expressed reservations believing, at the outset, that 'it would not work' had revised their opinions (Vasey, Betts, Marvin, Welford, 1995: pers. comm.). However, its influence correlated to some extent with geographical location. Lack of co-operation and negative staff attitudes were proving a powerful block to its adoption on one particular site, where it was felt new staff were being 'indoctrinated' against the initiative before any induction could take place (Cartlidge, 1995: pers. comm.). Insufficient training and the slow working of the implementation process were highlighted as problems in securing commitment, with an insufficient amount of the workforce being involved in the working processes (Marvin, Betts, Mastoris, Cartlidge, 1995: pers. comm.).

All the interviewees had been involved in a QIT in some capacity. Responses were generally positive. As in the survey's responses, cross-departmental working was highlighted as one of the major benefits for developing greater awareness, and understanding, of the workings of other departments (Mastoris, Betts, Clough, Welford, 1995: pers. comm.). The conflict between the demands of the QITs and normal working duties was again cited as problematic. Variations were reported in the levels of team progress. Whilst the retail team reported significant advances, difficulties had developed with the Staff Meeting and Customer Survey teams due to poorly defined briefs (Marvin, Betts, 1995: pers. comm.). Betts, the Finance Officer, recalled specific pro-

blems with the customer survey team due to loss of key staff and subsequent loss of continuity and direction. She felt the situation had been aggravated by an inappropriate mix of skills, as she states 'A lot of effort has to be put into team formation and clearly defining the brief ... (deciding) who are the best members to deal with that problem, as opposed to throwing a wild card'. Similarly she felt the lack of a financial representative on the good housekeeping team led to recommendations which were impractical to implement (Betts, 1995: pers. comm.).

Irrespective of the difficulties encountered, the consensus of opinion was that the benefits of teamworking outweighed the negatives. In general, it was felt that TQM had much to offer the sector as a management approach. Favourable reports were made, in the main, of management's commitment and co-opera-tion in the implementation process and of their increased accessi-bility. Although it was felt improvements could still be made in communication, staff appreciated being kept informed and the culture of involvement, it was felt, had done much to erode the 'them and us' syndrome (Vasey, Cartlidge, Mastoris, 1995: pers. comm.). Dudley Welford, a Senior Museum Assistant represented on the Quality Council, commented that his involvement in the process had generated a 'certain amount of pride' (Welford, 1995: pers. comm.). Its customer orientation was noted as a strength and several considered it to be a good 'common sense' approach (Welford, Betts, Mastoris, 1995: pers. comm.). Substantive and direct results were reported to have emerged, and, although some thought the improvements may have taken place in the longer term without TQM, others believed they would not have hap-pened under 'the old system' and without the new framework (Welford, Vasey, 1995: pers. comm.).

In terms of weaknesses, some felt improvements were restricted due to local government structure and bureaucracy. One respon-dent felt that she could deliver a more efficient service for the department if she could sever ties with the rest of the County Council. Welford was also disappointed by the QC's decision making process, feeling that recommendations could only go so far. As he commented, 'the quality council does not have the power it should have to exist as a TQM establishment' (Welford, 1995: pers. comm.). Mastoris expressed concerns about the ability of TQM to quantify qualitative outcomes adequately. He also felt

the culture to be overly preoccupied with success, feeling a culture of honesty should admit equally to failure (Mastoris, 1995: pers. comm.). Both Mastoris and Clough felt that TQM, to date, had proved more successful in implementing minor rather than major changes. However, Clough noted the wider implications in terms of overall staff morale 'if by getting rid of some of the smaller things that have been irritating people for years, you can improve the flavour/quality of life, then that is going to be of benefit' (Clough, 1995: pers. comm.).

The distinct differences in funding bases between private and public sectors, with the lack of correlation between performance and profit, was seen to have had an undermining effect, creating a sense that things were out of the organization's overall control (Clough, 1995: pers. comm.). All interviewees were very conscious of the vulnerability of the service with regard to local government re-organization and of the problems of trying to operate TQM under the threat of service disintegration. Vasey felt that management restructuring would prove catastrophic for TQM, both in terms of the potential loss of a key member of the management group and in attempting to drum up enthusiasm in an environment of redundancies, 'People will not have the energy or morale to think about TQM' (Vasey, 1995: pers. comm.).

In summarizing the overall findings, initial staff attitudes revealed no particular aversion to the adoption of new management practices, rather the reverse. TQM has the potential, as demonstrated by staff comments, to contribute significantly to the quality of management of human resources, with particular benefits to be gained by people working together through processes and across departments, reaffirming Deming's original ideology (Deming, 1988). Its inclusive and empowering spirit was particularly valued by those lower down the hierarchy. The 'good common sense' comments also suggest the relevance and usefulness of its systems and tools, and quality improvements in both products and services were evident.

However, TQM's ability to transform the culture of LMARS remains questionable. One can only speculate as to the true levels of commitment, but comments do suggest there were not enough converts in the first instance, perhaps highlighting inadequacies in the induction process. Shadla-Hall (1995) noted resistance at middle management level associated, in certain cases, with con-

cerns over power shifts. There was also evidence to indicate that improvements could be made with the underlying systems of project selection, team formation and team briefing. Allied with this, further training was needed to equip staff with the adjustment to team working. Primary challenges for the management group, at this stage of the implementation process, rest with their ability to address these further training needs and of seeking new ways to engage a larger proportion of the workforce. This has to be reconciled with the backdrop of diminishing resources and organizational instability.

CONCLUSIONS

An exploration of TQM's basic concepts and elements revealed no inherent reasons why TQM could not be adopted by the museum sector. Indeed, many of its key features are certainly not new or radical but do in fact concur with trends already prevalent in the profession (Bowsher, 1995). TQM does appear to have distinct advantages over other management approaches derived from industry, where the relevance of control standards is questionable and where implementation methods are potentially more liable to alienate the workforce. The high levels of good will still prevalent in the museum profession, together with the amount of voluntary support received, reinforce the unsuitability of contract and strict standard methods. Museum workforces need co-ordinated direction, as opposed to coercion.

A summary of TQM's perceived strengths and opportunities, together with its weaknesses and potential threats to its successful implementation, informed by the experiences of LMARS and the wider debate, is supplied by the SWOT analysis in table 10.4. Its primary strength may appear to lie in its holistic nature, both in terms of its strategic approach and its all inclusive spirit. Many of the ills associated with the sector stem from conflicting organizational objectives, fragmentation and conflicting tasks. All of which, as Kahn and Garden's (1994) survey revealed, may contribute to job dissatisfaction. Lack of consultation has been identified as a consistent feature in undermining attempts to improve organizational effectiveness, as have hierarchical structures, where policies emanate from the top and cascade down the structure. TQM through its philosophy of

TABLE 10.4 SWOT analysis of TQM in the museums sector

Strengths	Weaknesses
Holistic	Jargonistic
Inclusive (HRM)	Difficult to transform culture
Empowering (HRM)	Difficult to integrate
Customer orientation	Requires significant training effort
Long term perspective	Too slow
Clarity	Time consuming (data collection)
Informed by facts	Rigidity
Performance measurement	
Continuous review/improvement	
Task oriented	
Alignment of strategy and operations	

Opportunities	Threats
Improved quality	Loss of innovation/creativity
Improved communication	Resource constraints
Improved cost efficiency	Management instability (LGR)
Greater organizational cohesion	Lack of management control
Improved morale/raised motivation	Marginalization
Raised organizational profile	Potential for misinterpretation of data

organization-wide involvement has the potential to counteract some of these problems.

TQM, in focusing on understanding organizational interrelations (customer-supplier chains) and process capability, offers a major step forward for museums in seeking to align policy with operations. It may also assist in clarifying task objectives, responsibilities and, perhaps most importantly, priorities. As resources within the museum sector get tighter, problem solving and anaytical skills will become increasingly relevant, as will the use of performance measurement to assist in the effective allocation of scant resources.

In terms of the efficient utilization of human resources, TQM provides a valuable channel for drawing out the skills, creativity and knowledge of its workforce, an area so neglected in other

management systems. Although team working has previously taken place in the sector, it has generally been between colleagues of equal status, near the top of the hierarchy.

TQM provides a channel for multilateral representations and for those most closely aligned with the process to contribute to strategic decision making. Certainly the findings from LMARS support previously held opinions of the motivational force of employee involvement, improving morale through promoting a sense of being 'valued' by their organization.

However, fundamental questions have been raised concerning TQM's ability to transform the cultures of organizations which have been reinforced by experiences at LMARS. Perhaps LMARS was overly optimistic to introduce an approach advocating 'total commitment' at a time of such insecurity with the shadow of redundancies overhead. However, even in times of severe change there is much to be said for maintaining a communicative and open style of management (Janes, 1994). People are less resistant to change and more receptive to decisions if they can understand the thinking behind them, or be directly involved in the change process (Kotter and Schlesinger, 1989). Unfortunately the primary messages and jargonistic language used by TQM has, perhaps, shrouded what are essentially good attributes and has obscured the plain fact that quality, efficiency and responsiveness may assist survival.

LMARS's ability to transform its organizational culture and continue its cycle of improvement hinges on a number of factors. At present, for TQM to progress, the organization must seek to gain the trust of all staff. This will require more effective training and a sustained effort by the senior management group, as well as gaining the commitment of middle management. However, with the approach being so heavily dependent on the commitment and drive from the top, questions emerge as to how management will cope with the continued expansion of the QIT framework and with meeting training needs. The initiative, as a whole, is currently operating on a significant amount of good will. There is also a risk that TQM will become marginalized and lose momentum as more pressing matters overtake the organization, such as local government re-organization. The most obvious threat to the TQM initiative is a change of management and the advent of a new 'fix it' solution.

Certain management authors are already keen to bury TQM, to move 'beyond TQM' (Lenz and Lyle, 1989; Reynolds, 1993; Peters, 1994). They perceive the planning systems and techniques to be excessively rational and burdensome, risking paralysis through analysis. Peters considers the approach too inflexible and unresponsive for today's rapidly changing environment. He is now advocating complete organizational abandonment and constant innovation (Peters, 1994). Whilst this sound wonderfully dynamic, it also appears to run the costly risk of losing the good along with the bad. 'Quick fixes' have tended to cause more harm than good. TQM does, in any case, facilitate a continuous reassessment of the total organization, its capabilities, and its relation to its surrounding environments, but it does so in an informed and incremental manner. TQM is not prescriptive in its use of analytical and measurement methods. It is up to organizations to balance the needs of data collection with the business of getting on with the job. Similarly, careful consideration needs to be given as to which areas of museum work actually benefit from team working. Democracy is time consuming and costly and should be put to good effect.

What TQM does is provide a sound overall management framework, with essentially the right ingredients. It acknowledges the importance of vision and strong leadership, and of the benefits of leadership guided by a good understanding of organizational processes, together with the understanding that improvements can only be effectively implemented with the support of the workforce; a guiding philosophy which is as valuable to the museum sector as to any other form of organization and one well worth adopting.

Unfortunately, it is difficult to envisage the breakdown of entrenched power and role cultures that exist in many museum organizations. The fact that TQM has not been adopted more widely, perhaps provides an indication of the uneasiness felt by management with regard to implementing an approach which encourages the workforce to question authority. It is easier and less risky not to consult. However, the findings suggest that organizations will not achieve the best from their workforces and will subsequently not be operating to full effect. In a competitive environment, the interests of the individual are liable to take precedence over the interests of the organization, regardless of

operational efficiency. TQM will need to strive hard to retain a co-operative team spirit and the approach will always need to become accompanied by some single minded decision making. For TQM to succeed, as with any management approach, it is heavily reliant on the qualities of its leaders. It is their qualities that will pervade the organization and influence overall levels of support and quality. Do museums have the leadership qualities and powers to be able to rise to this challenge?

Postscript
After months of wrangling between Leicestershire County and Leicester City Councils, and a debate in the House of Lords, in August 1996 the County's Policy and Resources Committee made a decision to run its own service, alongside that of Leicester City and Rutland, which will receive unitary status. The remainder of Leicestershire County will retain the same status and continue to operate a two tier structure of county and district councils (Broughton, 1997: pers. comm.). Leicestershire Museums, Arts and Records Service has continued with the implementation of TQM through the change process, with the Quality Council meeting on a fortnightly basis up until March 1997. A new Quality Council is established to take effect from April 1997 in the County Service. Broughton considers TQM's continuation throughout the changes to be a testament to its successful integration into the services planning and service delivery. She is hopeful that the recognized benefits/achievements of TQM to date, will perhaps influence management approaches in newly established services and that existing data will be put to good use in the improvement of future services (Broughton, 1997: pers. comm.). It will be interesting to note whether TQM may capitalise on its achievements, or whether, as Vasey (1995) suggested, the process of restructuring will have a detrimental impact on energy and morale. A future evaluation of the three authorities would provide a useful indicator of TQMs sustainability and impact.

ACKNOWLEDGEMENTS
Thanks are due to all the staff at Leicestershire Museums, Arts and Records Service who contributed their time. Particular

thanks extend to Tim Shadla-Hall, previously Director of LMARS and Heather Broughton, Deputy Director, for their informative and open opinions on museum management and the implementation of TQM at LMARS. Thanks are also due to those staff who were willing to be interviewed, and whose contributions added considerable insight into the workings and impact of TQM at ground level. These include Jane Betts, Judy Marvin, Dudley Welford, Tim Clough, Miranda Vasey, Maureen Cartlidge and Steph Mastoris.

Thanks are also due to Professor Robert Haigh, Head of Staffing Research Policy at Sheffield Business School, for an interesting debate and for his comments of experiences of TQM within a broader management context, and to Kevin Moore for his continued encouragement and comment.

BIBLIOGRAPHY

Adair, J. (1988) *Effective leadership* (London: Pan).
Addison, E. (1993) 'Museum marketing: A tool for survival', *Muse* summer: 2–4.
Aherne, M. (1991) 'Managing employee motivation', *Training and Development* August: 12–14.
Armstrong, M. (1991) *A Handbook of Personnel Management Practice* (London: Kogan Page).
—— (1992) *Human Resource Management Strategy and Action* (London: Kogan Page).
Audit Commission (1991) *The Road to Wigan Pier?* (London: HMSO).
Beer, V. (1990) 'The problem and promise of museum goals', *Curator* 33 (1): 5–17.
Bendell, T. (1991) *The Quality Gurus: What can they do for your Company?* (Department of Trade and Industry [DTI]).
Bradford, H. (1991) 'A new framework for museum marketing', in Kavanagh, G. *The Museums Profession: Internal and External Relations* (Leicester: Leicester University Press) Chapter 7, pp. 85–98.
Bud, R. *et al* (1991) 'Measuring a museums output', *Museum Journal* January: 29–31.
Combe McLean, F. (1993) 'Marketing in museums: A contextual analysis', *Museum Management and Curatorship* 12: 11–27.
Dale, B. and Plunkett, J. (1992) *The Case for Costing Quality: A Management Overview* (Department of Trade and Industry).
Davies, M. (1990) 'Glasgow belongs to...', *Museums Journal* July: 27–29.
—— (1991) 'Lifting the fog on the Tyne', *Museums Journal* July: 29–32.

Davies, S. (1993) 'Planning in a crisis', *Museums Journal* July: 31–3.

——— (1993) *Debating the Future of Museums* (Unpublished manuscript).

——— (1994a) 'Strategic planning in local authority museums', in Moore, K. *Museum Management* (London: Routledge) Chapter 5, pp. 52–71.

——— (1994b) *By Popular Demand: A Strategic Analysis of the Market Potential for Museums and Art Galleries in the U.K.* (Museums and Galleries Commission).

Deming, W.E. (1986) *Out of Crisis* (Cambridge, MA: MIT Centre for Advanced Engineering Study).

Department of Trade and Industry (1995) *Quality Circles: An Executive Guide* (DTI).

Diamond, M. (1992) 'Personnel Management', in Thompson, J. *The Manual of Curatorship*, Chapter 16 (London: Butterworth-Heinemann).

Dickenson, V. (1991) 'An inquiry into the relationship between museum boards and management', *Curator* 34(4): 291–303.

Ellis, A. and Allden, A. (1990) 'Management: the flavour of the month', *Museum Development* November: 35–9.

Farnell, G. (1984) 'Team briefing: a means of improving communicating within the museum', *The International Journal of Museum Management and Curatorship* 3: 153–7.

Fleming, F. (1992) 'Its nothing personnel: museum and gallery services', *Museum Professionals Group Transactions* No. 27: 12–15.

Fowler, A. (1988) *Human Resource Management in Local Government* (London: Longman).

Friedman, R. (1982) 'Museum people: the special problems of personnel management in museums and historical agencies' History News 37(3): 14–18.

Gosling, K. *et al* (1994) 'Quality control', *Museums Journal* Jan: 22–5.

Greene, J.P. (1989) 'Museums for the Year 2000 – A case for continuous revolution', *Museums Journal* (88 (4): 179–80.

Haigh, R. (1993) *Total Quality Management* (unpublished manuscript, Sheffield Business School, Sheffield Hallam University).

Handy, C. (1989) *The Age of Unreason* (London: Business books).

——— (1993) *Understanding Organisations* (London: Penguin).

Hatton, A. (1992) 'Museum planning and museum plans', *Museum Development* January: 32–9.

Jackson, P.M. (1994) 'Performance indicators: promises and pitfalls', in Moore, K. *Museum Management* (London: Routledge) Chapter 16, 156–72.

Janes, R. (1994) 'Beyond strategic planning: The Glenbow example', *Muse* Winter: 12–16.

Kahn, H. and Garden, S. (1994) 'Job attitudes and occupational stress in the United Kingdom museum sector, A pilot study', in Moore, K. *Museum Management* (London: Routledge) Chapter 18, 193–211.

Knowles, L. (1991) 'No more heroes', *Museums Journal* October: 21.

Kotter, J. and Schlesinger, L. (1989) 'Choosing strategies for change', in Asch, D. and Bowman, C. *Readings in Strategic Management* (London: Open University) Chapter 21.

Lenz, R.T. and Lyles, M.A. (1989) 'Paralysis by analysis: is your planning system becoming too rational' in Asch, D. and Bowman, C. *Readings in Strategic Management* (London: Open University Press) Chapter 2.

Locke, S. (1995) 'Shadows and fog', *Museums Journal* December: 33–4.

Locke, S. *et al* (1992) 'The county team', *Museums Journal* October: 29–31.

Marson, G.A. (1993) 'Measure the ecstasy', *Museums Journal* July: 27–8.

Marchington, M., Goodman, J., Wilkinson, A. and Ackers, P. (1992) *New Developments in Employee Involvement* (Manchester: Manchester School of Management UMIST).

Middleton, V. (1990) 'Irresistible demand forces', *Museums Journal* February: 31–4.

Moore, K. (1994) *Museum Management* (London: Routledge).

Morgan, C. and Murgatroyd, S. (1994) *Total Quality Management in the Public Sector* (London: Open University Press).

Mortiboys, R. and Oakland, J. (1991) *Total Quality Management and Effective Leadership* (Department of Trade and Industry [DTI]).

Murdin, L. (1995) 'An alliance in Leicester?' *Museums Journal* September: 13.

—— (1996) 'LMARS survives', *Museums Journal* April: 7.

—— (1996) 'Leicestershire splits', *Museums Journal* September: 7.

Museums and Galleries Commission (1992) *Quality of Services in Museums and Galleries* (London: MGC).

Museums Association (1994) *Performance Management*, Museums Briefing 5, March (M.A.).

Oakland, J.S. and Porter, L. (1995) *Total Quality Management: text with cases* (London: Butterworth Heinemann).

Office of Arts and Libraries (1991) *The Development of Performance Indicators for the National Museums. Commenting on the Requirement for Feedback on Users* (OAI).

Peters, T.J. (1987) *Thriving on Chaos. Handbook for a Management Revolution.* New York: Alfred A. Knopf).

Peters, T.J. (1992) *Liberation Management. Necessary Disorganization for the Nanosecond Nineties* (London: Macmillan).

Peters, T.J. (1994) *The Tom Peters Seminar. Crazy Times call for Crazy Organisations* (London: Macmillan).

Peters, T.J. and Waterman, R.A. (1984) *In Search of Excellence* (London: HarperCollins).

Plowman, B. (1990) 'Management behaviour', *TQM Magazine* 2:4.

Reynolds, R. (1993) *Beyond Total Quality Management* (London: Sheldon Business Books).

Roodhouse, S. (1994) 'Training matters', *Museums Journal* January: 28–33.

Smith, A. (1994) 'Meeting the standard', *Museums Journal* January: 23.

Spencer, P. *et al* (1993) 'Feel the width', *Museums Journal* July: 29–30.

Spilsbury M *et al* (1995) *Evaluation of Investors in People in England and Wales, 1994–1995*, report summary 289 (The Institute for Employment Studies).

Sukel, W.M. (1974) 'Museums as organisations', *Curator* 17 (4): 299–301.

Walden, L. (1991) 'Qualities and quantities', *Museums Journal* January: 27–8.

Williams, R. (1994) *What does Total Quality Management Offer to Museums?* (unpublished essay).

CASE STUDY – RESEARCH SOURCES

Interviews:

Professor Robert Haigh, Head of Staffing and Research Policy, Sheffield Business School, Sheffield Hallam University, 18/10/95.

Leicestershire Museums, Arts and Records Service (LMARS).

Heather Broughton, Deputy Director, LMARS, 31/8/95 and 18/12/95.

Jane Betts, Finance Officer, LMARS, 5/10/95.

Judy Marvin, Deputy Director's Secretary, LMARS, 5/10/95.

Dudley Welford, Senior Museum Assistant, LMARS, 5/10/95.

Tim Clough, Keeper, Rutland County Museum, LMARS, 5/10/95.

Miranda Vasey, Marketing Manager, LMARS, 6/10/95.

Maureen Cartlidge, Museums Assistant, Wygston's House Museum of Costume, LMARS, 6/10/95.

Steph Mastoris, Curator, Snibston, LMARS 6/10/95.

Seminars

Broughton, H., 'Total Quality Management', Deputy Director, LMARS, 17.6.94.

Clay, P., 'Total Quality Management', previously Field Archaeological Officer, LMARS, 10.3.95.

Written sources:
Schadla-Hall, T. and Mathias, J. *Total Quality Management, Performance Measurement and the Corporate Action Plan*, 23/4/1993, a report for the Arts, Libraries and Museums Committee, LMARS.
Schadla-Hall, T. and Broughton, H., *Vision and Mission*, 3/9/1993, a report for the Arts Libraries and Museums, Committee, LMARS.
Lott, Derek., Point-of-Contact Q.I.T., *Access of Services through the Telephone*, 10/8/1993, LMARS.
Clay, Patrick, Point-of-Contact Q.I.T., *Contact with the Museum Building's Environment*, 15/9/1993, LMARS.
Point-of-Contact Q.I.T. *Using the Post as First Point of Contact*, 1993, LMARS.
Retail Outlets Q.I.T. *Review of Displays and Facilities at Retail Outlets in the Service. Quality mars*, No. 2, May 1994, LMARS.
Discover, June, July, October, December 1995, LMARS.

TABLE 10.5 Questionnaire Survey

TOTAL QUALITY MANAGEMENT AT LEICESTERSHIRE
MUSEUM, ARTS AND RECORDS SERVICE
Questionnaire Survey, October 1995

Name

Position

Organisation

How long have you worked for Leicestershire MARS.

(If you wish to remain anonymous you may leave the above section
blank)

Please tick appropriate box/es, thank you.

Q1 What do you perceive T.Q.M. to be about?

☐ Improved quality
☐ Quality control
☐ Performance measurement
☐ Better working environments
☐ Improved efficiency
☐ Cost savings
☐ Other, please state briefly

Q2 What were your original thoughts when you heard about the
implementation of T.Q.M. at Leicestershire MARS?

☐ Opposed
☐ Neutral/open minded
☐ In favour

Please state your reason for the above selection

Q3 Do you know what the vision and value statements of
 Leicestershire MARS are?

 ☐ Yes
 ☐ No

 If yes, do you agree with them?

 ☐ Yes
 ☐ No

 If no, please give reasons.

Q4 Do you feel part of your organization?

 ☐ Yes
 ☐ No

 If not why not.

Q5 What is your involvement in the T.Q.M. process?

 ☐ Member of Quality council
 ☐ Quality improvement team leader
 ☐ Quality improvement team member

Q6 How effective have you found team working

 ☐ Good
 ☐ Fair
 ☐ Poor

 Please give reason for selection.

 Please state nature of improvement project initiative.

TABLE 10.5 (*continued*)

Q7 In what area/s of the service, if any, do you feel quality
 improvements have been made since the implementation of
 T.Q.M.?

 ☐ Internal efficiency of operations.
 ☐ External efficiency, delivery of services to public.
 ☐ Quality of tangible product, i.e. buildings, exhibitions, shop,
 signage etc.
 ☐ Quality of customer care.
 ☐ Quality of staff care.
 ☐ Other, please state

Q8 What do you feel, if any, are the strengths of T.Q.M.
 Please comment.

Q9 What do you feel, if any, are the weaknesses of T.Q.M.
 Please comment.

Q10 What improvements do you think may be made in its
 implementation?

I would be most grateful if all forms could be returned to me
by Tuesday 31st October 1995.
THANK YOU FOR YOUR ASSISTANCE – CAROL BOWSHER.

Editorial Policy

New Research in Museum Studies is a refereed publication and all papers offered to it for inclusion are submitted to members of the editorial committee and/or to other people for comment. Papers sent for consideration should be between 3,000 and 10,000 words in length, and may be illustrated by half-tones or line drawings, or both. Prospective contributors are advised to acquire a copy of the *Notes for Contributors*, available from the editor, at an early stage.

New Research in Museum Studies has a policy of encouraging the use of non-sexist language, but the final decisions about the use of pronouns and so on will be left to individual authors. However, the abbreviation 's/he' is not to be used.

The editor wishes it to be understood that he is not responsible for any statements or opinions expressed in this volume.

Notes on Contributors

Dr Robert R. Janes has been President and Chief Executive Officer of the Glenbow Museum, Art Gallery, Library and Archives in Calgary, Alberta, Canada since 1989.

Julian Spalding has been Director of Glasgow Museums since 1989.

Des Griffin has been Director of the Australian Museum since 1976. M. Abraham is at the University of Technology, Sydney, Australia.

David Fleming is Director of Tyne and Wear Museums.

Staurt Davies is Lecturer in Strategic Management at Leeds University Business School.

Loraine Knowles is Keeper of Liverpool Museum, part of National Museums and Galleries on Merseyside.

Kate Osborne is County Museums Officer for Wiltshire.

Maggie Blake is Manager of Moyse's Hall Museum, St Edmondsbury Museum Service.

Alf Hatton is a consultant in heritage and tourism.

Carol Bowsher manages Bewdley Museum in Worcestershire.

Index

7/5/2005
FRA É STATO
qui.

chiuso quando
ci risbocemi.